GALA
BOOKS

# Fresh Perspectives on Grant Wood, Charles Sheeler, and George H. Durrie

James H. Maroney, Jr.

# Contents

# Hiding in Plain Sight

*Decoding the Homoerotic
and Socio-Political Imagery
of Grant Wood*

*For Ken & Nancy
with affection*

*James Maroney*

*"Irony prompts some laughter and a nod of comprehension; for irony involves absurdities that cease to be absurd when fully understood."*

—Reinhold Niebuhr*

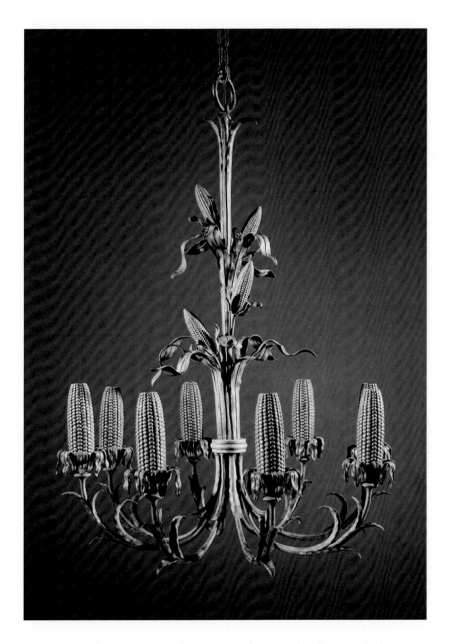

*Corn Cob Chandelier*, 1925–26. Design by Grant Wood, forging attributed to George Keeler (1908–44). Formed brass sheet, cast and machined iron, and copper wiring, 94 × 32 × 34 in. (Cedar Rapids Museum of Art, Gift of John B. Turner, II, 81.17.3) Photo by Charles Walbridge.

* Reinhold Niebuhr, *The Irony of American History* (New York: Charles Scribner's Sons, 1952).

*For Pieter Broucke*
*Dean of the Arts, Middlebury College*

# Contents

# Summary

The image we have today of Grant Wood, the "satirical yet sturdy son of the soil who lovingly holds humanity up to scorn," is at once the basis for his wide acclaim and for his enduring ridicule. Yet those holding either view are wrong. With facts gleaned from Wood's various biographies and with knowledge of the broad, cultural, economic, and political fabric into which Wood was woven, the author makes the case that Wood, fiercely intelligent and exceedingly well educated, was, in Robert Hughes's words, a "timid, deeply closeted homosexual," an orientation that would naturally have informed his art.* Yet Hughes provides neither background nor explanation for his claim: the words "homosexual" and "gay" do not appear in the pre-1997 Wood canon.

In 2010, R. Tripp Evans[1] uncovered some documentary evidence to support Hughes's claim. But no one had yet seen that Wood embedded clues about his sexual orientation, all carefully hidden behind a catalog of symbolism, in almost all his work from *Corn Cob Chandelier*, 1925–26, on.

Coming of age in the "Anything Goes" era—but in Iowa, far from the decadent, urban centers—Wood instinctively concealed his homosexuality. When, in his early twenties, he traveled alone to Europe, away for the first time from his domineering mother and sister, Wood was astonished to see that mainstream society tolerated a variety of outlandish behaviors and that Bohemianism was not conducted secretly but openly. On his visit to Munich in 1928, he experienced—and all at once—sexual liberation, the Verist painters satirizing the demimonde of the Weimar Republic, the rise of Nazism, and the persecution of the Jews. Consequently, Wood's interest in living a liberal lifestyle developed along with an abiding empathy for other pariah groups—Jews, Catholics, blacks, and gays—whom the Nazis were so cruelly marginalizing. When he returned home, the end of Prohibition ushered in a similar climate of xenophobia, which again sought to root out "undesirables" from his own society in America.

Knowing himself to be a member of one of these despised minorities, Wood was forced to develop a mawkishly corny public persona to conceal his true nature. In order to survive, he outwardly aligned himself with the wholesome values of his persecutors and, in many cases, of his patrons on the political and social right. Art

---

* Robert Hughes, *American Visions: The Epic History of Art in America* (New York: Alfred Knopf, 1997), p. 439. On April 7, 2007, I received this response from Hughes, to whom I had sent my paper: "Dear Mr. Maroney, I did indeed receive your Grant Wood piece, and read it with much interest; I am sure you are right about many of the interpretations, although some of them do strike me as a little overstretched. But I am very busy with a book of my own, and cannot take time off to write detailed responses to unsolicited mail, or critiques of essays (however intelligent, as yours of course is). With good wishes, Robert Hughes." In other words, it is fine for Mr. Hughes to suggest without any substantiation that Wood was gay, but when I locate in his work substantive reasons for asserting the same, I am "overstretching."

scholars have taken the bait: ever on the hunt for some inscrutable meaning in his work, they have not recognized that Wood's homespun, all-American image was but a cover for his homosexuality, which he obscured so successfully that it still remains hidden seventy-seven years after his death.

This paper decodes Wood's symbols, and each of the observations regarding their meaning originates with me. My argument is analytic, i.e., it is not an empirical composite of facts about the artist and his life gleaned from documents found in the literature, the corpus of which I have read. The paper derives its legitimacy from direct observa-tion of certain objects that appear repeatedly yet seemingly out of context in Wood's work.

Not everybody will see these items as symbols and many will find my explanation for them untenable or even fanciful. But I invite those who, after reading my paper, are still unconvinced to come up with another explanation for the prolif-eration of these objects and their peculiar context in Wood's mature work.

1  R. Tripp Evans, *Grant Wood: A Life* (New York: Alfred A. Knopf, 2010).

# Author's Note

This paper has its genesis in a trip I made to Cedar Rapids, in 1970, when as head of American Paintings at Sotheby Parke-Bernet, I accepted an invitation from John Turner to appraise his collection of paintings by Grant Wood, which he was giving to the Cedar Rapids Art Center. This led me to meet art scholars James Dennis, whose biography of Wood came out in 1975, and Wanda Corn, who would write the exhibition catalog for Grant Wood organized in 1983 by the Minneapolis Institute of Art.

In the run-up to her exhibition of Wood's work at the Whitney Museum, Wanda and I spoke frequently about Grant Wood and what we and others suspected about his sexual orientation. But Wanda would not put this in her book. She had relied on and befriended Nan Wood Graham, the artist's sister, who had spent her life defending Grant against this charge. Nan did not want Wanda to broach the subject.

I had handled a few works by Wood at SPB prior to meeting John Turner and I actually bought two of his drawings, *Honorary Degree* and *O, Chautauqua*, for my private collection. I cannot say now what it was exactly about these works that intrigued me then, only that it was not what I see in them today. Over the next thirty years, I owned or sold several of Grant Wood's greatest works, among them *Birthplace of Herbert Hoover*, *Spring Turning*, *Return from Bohemia*, *Spring Landscape*, and *Arbor Day*, the drawings for *March*, *Parson Weems' Fable*, and *Death on the Ridge Road*. My theory about Wood's work and his message is the result of spending many hours with each of these pictures, wondering how this or that element, seemingly a part of yet curiously incongruous with the narrative, found its way into the composition, and why the same element appears again in subsequent works.

While my paper has been germinating in my head since the early 1970s, I only began to write it in 2000. It was substantially completed in 2004 to 2005, when I set about showing my manuscript to art scholars and publishers. Their responses were disheartening; my work was "interesting," they all said, but "speculative." Discouraged, I put the project up on my mind's shelf, where it languished for several years. In about 2012, I uploaded it to my website, where it also attracted very little notice.

Barbara Haskell's Whitney catalog has just arrived. In a footnote, she cites my unpublished paper and credits me with being "the first to claim that Wood was a homosexual, setting in motion assertions by Henry Adams and Robert Hughes."[1] I appreciate the recognition; but the honor of being the first to state in print that Wood was gay belongs to Hughes, who gave no source for the allegation. Haskell is, however, correct that the discovery of homoerotic imagery in Grant Wood's work is original to me, and I will accept whatever credit and whatever opprobrium accrues to me for it.

Noting that I see homoerotic imagery in the frequent appearance of corn among other things in Wood's work, Richard Meyer, one of Haskell's coauthors, dismisses my entire book by reminding us that "sometimes an ear of corn is just an ear of corn."[2] I do wish I'd thought of that!

In publishing my book, I am not unaware that my postulations will disrupt the wholesome image of Grant Wood so many people—which apparently includes Richard Meyer—hold of him. But it is time for these people to realize that as a gay man living and working in Iowa in the 1920s and '30s, Wood was forced to get up a façade simply to survive. It is also time to realize that the persona he created is not only a ruse, but that there is so much more to Wood than the man he contrived for us all to see, the man he succeeded in convincing his many biographers to help him conceal. That persona, so artfully created and so deeply ingrained in our collective consciousness, must now be understood if only for the reasons Wood felt it necessary to create him. I have provided as many of these reasons as I could, and I hope my effort will begin to bring the real Grant Wood out of that other man's shadow.

—James H. Maroney, Jr.
Leicester, Vermont
March 2019

1 Barbara Haskell et al., *Grant Wood: American Gothic and Other Fables* (New Haven: Yale University Press, 2018), 35.

2 Ibid., p. 85.

# Art Historical *Methodology* and *Gender Issues* as Scholarly Thickets; the Author's Methodology Explicated

Jonathan Weinberg notes that when, in the process of analyzing the work of homosexuals, art historians have often yielded to the temptation to look the other way, to purposely not look at their subject's art through that lens.[1] Marcel Duchamp, who once famously appeared in drag, insisted that "the work of art is undermined by too-close scrutiny of the sexual identity of its creator."[2] In an oft-cited critique of Charles Demuth, Duchamp even attempts to diminish whatever influence sexuality might have had on work that is patently homoerotic. Henry McBride, himself a homosexual, does much the same thing, sarcastically decrying the presence of people of various races and colors who scandalously drank and danced together at Barron Wilkins's Savoy in Harlem, an infamous watering hole frequented by artists.* "I think it was entirely right for Mr. Demuth to study it, so evidently in the interest of higher morality."[3]

But Weinberg lifts the polite veil of false decency practiced by twentieth-century art historians to discuss openly the appearance of homoerotic imagery in the work of Marsden Hartley and

Pablo Picasso (Spanish, 1881–1973), *Head of a Woman Boisgeloup*, 1931. Bronze, 34 × 14³/₈ × 19¹/₄ in. (86 × 32 × 48.5 cm). (Musée National Picasso). Photo: Mathieu Rabeau © RMN-Grand Palais/Art Resource, NY.

---

* Barron Deware Wilkins (1867–1924) owned an exclusive club called the Savoy on 134th Street and Seventh Avenue in Harlem, where he catered exclusively to upper-class whites. Wilkins was a financier of black baseball teams, and an early backer of boxer Jack Johnson. Wilkins had political clout and kept up good relations with the police so that his club would not be closed for serving alcohol during Prohibition. http://www.ipernity.com/doc/285591/36885692

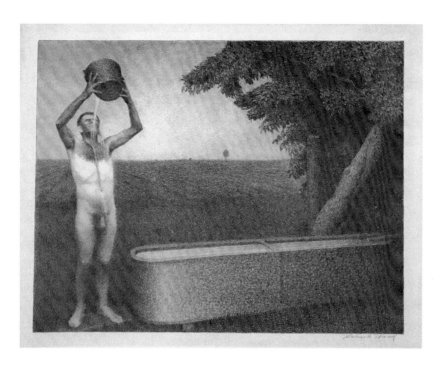

*Sultry Night*, 1937. Lithograph 16 × 20 in. (Cedar Rapids Museum of Art, Gift of Peter O. Stamats, 85.3.7.)

Charles Demuth. Weinberg posits that "homosexuality, where it appears, is at issue not merely by virtue of connections to particular events in an artist's life but because that artist has made a deliberate choice to include it as a subject."[4]

Weinberg makes the argument that because sex is a vital component of the "primacy of human relationships, sexual preference is not incidental to understanding human expression." Yet he insists that merely identifying homoeroticism in an artist's work does not explain his or her paintings or his or her sexual orientation.

I am also grateful to Weinberg, who read an early draft of this paper, for pointing out that the presence of veiled—or deliberate—phallic imagery does not automatically make that painter homosexual. Picasso, a man as famous as a womanizer as for his art, is a case in point. Just as important to understand, Weinberg says, being homosexual does not automatically make one misogynistic. These two traits, he suggests, coexist in some persons and are singularly peculiar to others, but they are always best understood as distinct.

While today it is thought of as but a preference, Weinberg throws open to question the working definition of homosexuality, noting that in Hartley's and Demuth's time the still nascent psychiatric association listed it first as an illness,

then as a disorder. Clearly, one who, in Wood's era, knew himself to be homosexual would not have elected to have either, especially one that presumably he could "cure." The medical community's inability to get a grasp on people whose sex was so-called inverted or, alternatively, on those who were of the so-called third sex,* made it the more exasperating for those actually in these populations to know their own "condition." Where sexual orientation was concerned, mendacity, bewilderment, and hypocrisy reigned for all of the twentieth century.

Eve Kosofsky Sedgwick (1950–2009), an early scholar in gender studies and the author of *Epistemology of the Closet* (1990), asserted that assigned categories like "homosexual" and "heterosexual," not to mention "male" and "female," don't capture reality. Sexual desire and sexual identity, she insists, exist on a continuum, spilling over the neat boundaries we create to contain them. She goes further: the failure to openly acknowledge the limitations of these flawed definitions impairs "an understanding of virtually any aspect of Western culture."[5]

In sum, "homosexuality" is a complex issue quite outside the scope of this book, which, after all is said and done, is not a treatise on gender studies: it is unimportant to me whether Wood was exquisitely a member of one or more of the classifications known by the acronym LGBTQ. Consequently, I hope readers will forgive me for reverting to a neat system of classification acknowledged by those in my peer group, permitting me on the evidence presented here to label Wood a homosexual and a misogynist, leaving modern university professors and students to break gender issues into as radiant a kaleidoscope of nuances as they may feel it necessary to do.

That out of the way, it does seem odd, does it not, that even as recently as 1983 to 1985, Hartley's, Demuth's, and Grant Wood's biographers all seemed content to ignore or excuse sexual

* Henri Gauthier-Villars (a.k.a. "Willy"), *Le Troisieme Sexe*, Privately Printed, Paris, ca. 1927. First translated into English by Lawrence R. Schehr (Chicago and Urbana: University of Illinois Press, 2007). Willy was a notorious rake and the first husband of Colette, who, unbeknownst to each other, had an affair with the same woman, the American socialite Georgie Raoul-Duval, née Urquhart. Upon discovery, they made it a threesome.

orientation when, to skirt it during an otherwise thorough analysis of an artist's work, would seem to risk missing something pretty important.

Unlike Robert Hughes, who applied the label apparently without substantiation and with impunity, I have built my case on visual analysis, prompting scholars to question my "methodology," asking, even as they admit the force of my argument, where is the proof? And I ask why would Wood, given the social milieu in which he was reared, tell anyone not involved that he were gay, let alone write it down?

Documentary, primary proof does not need to be textual to be admissible. Photographs are universally regarded as evidentiary proof, and does not every artist in the act of creating, de facto, divulge primary information about himself?

At the lowest level, Wood provided us with intimations of his message through his choice of suggestive or "hot" language titles: *Adolescence, Fertility, Arnold Comes of Age, Fall Plowing, Plowing on Sunday, Spring Turning, The Way of the Transgressor Is Hard, Seed Time and Harvest, The Midnight Ride of Paul Revere, Arbor Day* (*arbor*, the Latin word for "tree," is also the rotating shaft of a drill) and, yes, even *American Gothic*. At the next level, Wood takes a page from Raskolnikov, who, in the hope that the truth will distract his pursuer, offers proof of his guilt directly to Porfiry. Thus did Wood appear to offer "proof" of his sexual orientation with *Sultry Night*, 1937, a full-frontal, male nude, which draws our attention away from his self-styled iconography—that long, phallus-like horse trough. But the nude farmer, who decorously douses himself beneath the cover of darkness, upstages the trough. And he is so alone, so palpably unerotic, so workaday, as to be above suspicion.* At the next level, in 1924, while studying at the École des Beaux Arts, in Paris, Wood painted *The Spotted Man*, in a pointillist

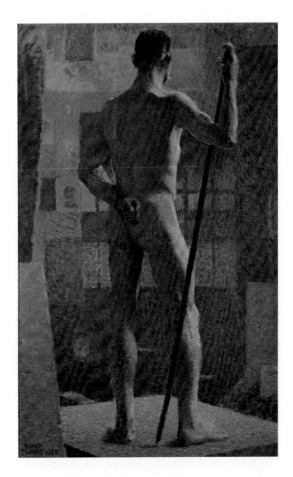

*The Spotted Man*, 1924. Oil on canvas, 32 × 20 in. (Figge Art Museum, City of Davenport Art Collection, Museum Purchase: Friends of Art Acquisition Fund, 1975.14)

style. Aside from the curious way in which the man holds his hand behind his back, as if he had been holding in that hand the shaft he now holds before him in the other, there is nothing particularly homoerotic about the picture. Nor is there in the extant literature any curiosity expressed about why this man is covered in blue spots or, if he were not, why Wood painted him that way. But by his choice of title and style, and ever looking for opportunities to pun, Wood suggests that as a homosexual he was ever conscious that he was himself a "spotted" i.e., marked man. He kept the picture until his death.

One can, of course, be misogynistic and never divulge this to anyone. But one cannot be gay alone. Arguably, Wood and his partner/confidants knew how society—early, twentieth-century, Midwestern American society—punished gays. It was vital in the 1920s to '40s to keep one's cover. He succeeded brilliantly: according to his biographers, Wood was just "a Midwestern farm boy who had gone to Europe to study art, briefly taking up foreign ways—loose living and loose

---

* In his compendious treatment of homoerotic imagery in American art, which spans a period from the early nineteenth century to the present, Jonathan Weinberg illustrates *Sultry Night* as Wood's only qualifying entry in the class. *See* Jonathan Weinberg, *Male Desire: The Homoerotic in American Art* (New York: Abrams, 2004). Wood's dealer, Reeves Lewenthal of the Associated American Artists, advised Wood that *Sultry Night* was too obscene to go by mail and that he would only sell it "under the counter."

painting—until realizing his error and returning from Bohemia to his wholesome origins."[6] There are many today who fervently believe him to have been this—and only this. He spent his entire life fully covered, basking in the attention *Time* and *Life* magazines and the Hollywood movie industry paid to him as the embodiment of the pure-minded, American homeboy. In death, he is even classed alongside Andy Wyeth and Norman Rockwell as the premier chroniclers of bedrock, American, family values.

It was, oddly enough, Henry Luce, the patrician founder of *Time*, who contrived the wholesome image we have come to know as Grant Wood when, on Christmas Eve 1934, *Time* published a cover story by Hudson Walker featuring Wood, Thomas Hart Benton, and John Steuart Curry, all then but regionally known.* Writes Walker: "These earthy Midwesterners . . . through their art were restoring American values in the face of outlandish foreign imports [i.e., that abomination called Modernism]." Luce and Walker, with the stroke of a pen, had just created *Regionalism*, a movement Hughes refers to as "the first, full-scale, American art world hype, a Depression-era, anxiety-laden, xenophobic appeal to bedrock, American values."[7] Walker was an art dealer with mercenary interests. But Luce knew that his readers, the high-minded members of the upper-middle class, would like the America described in the article. Grant Wood liked it too, and outwardly, he sought to appeal to, even to belong to, this group. But inside he knew that—if it were not a fiction—the America of straight, wholesome, un-conflicted country folks whose lives were characterized by regular attendance at church, hard work, and sobriety did not entail him. We, in the American art world, are pleased that Luce and Walker put Grant Wood on the map. But my heavens: one would have thought that in 1934, *Time* had far more important things to report in its Art Section.

In March, the Nazi-controlled Reichstag had installed Hitler as Führer und Reichskanzler.

By his command, in a quest for racial, social, and cultural "purity" targeting in particular Jews, cripples, Gypsies, Jehovah's Witnesses, and homosexuals, the Nazis quickly initiated a series of coercive measures to cleanse German society. Hitler declared that modern, abstract, or Avant-Garde art and literature was degenerate, and his soldiers confiscated all such art held in private collections and burned thousands of books and paintings held in the libraries and museums. There was no mention of these faraway events in the December 24, 1934, issue of *Time*.

Neither is there, in the extant Grant Wood literature, any connection drawn between Wood's parochial development as an artist in Iowa and these momentous world events. It is, however, improbable that Wood, so recently in Germany, would have been unaware of them.

Indeed, all Wood scholars lavish praise on Wood's illustrations for Sinclair Lewis's *Main Street*, interpreting the drawings, as Corn does, as another indication of Wood's "unquestioning affection" for Main Street American values. Dennis sees Wood's *Main Street* illustrations as "attacks on . . . provincial complacency," but he reads these attacks as "amiable," the result of Lewis's "refraining from overcoloring his characters with a uniform intensity of satire."[8]

Is it possible to read *Main Street* and miss that Lewis is not "elevating" his characters but cruelly satirizing them? Perhaps that would become clearer if they read Lewis's *It Can't Happen Here*, a semi-satirical 1935 political novel in which Berzelius "Buzz" Windrip, after fomenting fear and promising a return to Main Street, "traditional" values, defeats Franklin Delano Roosevelt and is elected president of the United States. Windrip, in the manner of Adolf Hitler and the SS, then takes complete control of the government and imposes a totalitarian rule with the help of a ruthless paramilitary force. It is only a work of fiction, but Lewis's warning about fascism was prescient: in 1939, on the eve of the Second World War, the German American Bund packed 20,000 Main Street Americans into Madison Square Garden in New York for a pro-Hitler rally, where to the accompaniment of wild applause, their leader, Fritz Kuhn, derided the US president as Franklin D. "Rosenfeld."[9]

* In 1930, *American Gothic* won the Norman Walt Harris Medal at the *Forty-Third Annual Exhibition of Painting and Sculpture* at the Art Institute of Chicago, affording Wood instant celebrity status. But real national fame would not arrive until the 1934 article in *Time*.

There is more work to do on Wood's sexuality, and what influence it might have played in the formulation of *American Gothic*, not to mention the rest of his curiously compelling oeuvre. That, in a nutshell, is my rationale for reexamining the work of Grant Wood, not to categorize him according to his sexual preference, but to recontextualize his work for the benefit of his already impressively large audience.

Before we strike out on the trail looking for the hidden Grant Wood, we must acknowledge that for any realist artist inclined to conceal his or her true intentions behind symbols, there is a virtually limitless store of objects available for use. To each of these, there is an infinite array of meanings that an artist is free to assign. We must also acknowledge that as a "Regionalist" painter working in a rural, Midwestern setting, the presence of objects such as those Grant Wood employed would not, in themselves, be entirely unexpected. These factors make the job of decoding him potentially hazardous if not impossible.

Yet, as everyone knows, a secret too closely, or too long kept is no fun. Success as a symbolist depends upon the artist's skill in delivering his message while flouting two precepts: (1) objects have *only* the associative meanings we commonly assign to them and (2) encryption is rational.

Grant Wood excelled in his understanding of these precepts, but I must make this crystal clear: I do not claim to have any knowledge that the objects Grant Wood chose connote exactly this or that alternative meaning and I do not presume to have cracked the code just as he devised it. I began by making note of the frequency with which certain objects appear in Wood's work, of the curious way in which they are rendered, placed or juxtaposed on the page, which, in the absence of symbolism, is otherwise hard to explain. Then, with facts gleaned from Wood's various biographies, and from a somewhat imperfect knowledge of the broad, social fabric into which Wood was woven, I asked myself while looking intently at his paintings, how these objects, all commonly found in the Iowa countryside, might transmit another message hidden below the one he placed on top for us to see.

Wood's lifetime output was exceedingly small, +/− 183 images comprising oil paintings, sculpture, lithographs, and preliminary drawings. When he chose to express his sexuality, Wood used an argot of symbols known perhaps to a very small coterie of friends, or more probably to none but himself. These symbols include (in the order of the frequency of their appearance): corn, either as ears, young shoots, stubble, or stalks gathered in shocks (18); windmills (16); fence lines (16); overalls (16); references to the harvest (14); a zigzag pattern (14); chickens, hens or cocks (8); plows or plowing (7); phallic symbols (other than corn), usually presented in outlines around erect female figures, steeples, silos, rabbit tracks (8); "mannered" hands (7); hand pumps (4); acorns (4); snake plants and begonias (2). There are other, curious objects making cameo appearances: crosses, rivers, culverts, chimney openings, black holes, door and window openings; women in unflattering, stereotypical or satirical poses; fabrics in tessellated patterns, horses, etc. We will get into my interpretation of these symbols one at a time.

Next, I divided Wood's work into three categories (A, B, and C) and, since my taxonomy was designed to comprise all works, I have forced a letter designation onto each of the 183 works listed in my inventory:

| TYPE | DESCRIPTION | COUNT | % |
|------|-------------|-------|---|
| A | No symbols | 135 | 75% |
| B | Malevolent images of women or unkind, Midwestern stereotypes | 14 | 7% |
| C | Homoerotic or socio-political imagery | 34 | 18% |
| | | 183 | 100% |

By my count, only 26 percent of all Wood's works contain symbols, manifestly homoerotic or socio-political. Sorting the work by date reveals that, with the exception of some corn and an isolated chicken or barn, symbols do not appear before 1925 to 1926; and if these objects chance

to, they do not rise to the level of interest that is the subject of this paper. Between 1925 and 1929, just prior to Wood's final *Return from Bohemia*, two inchoately "C" subjects appeared. Between 1929 and 1931, "C" subjects built momentum, until the period from 1931 until his death in 1942, when 40 percent of his output was "B" or "C" work. Consequently, allowing only for the two important exceptions just mentioned, we shall confine our exploration of symbols to Wood's post-1929 work and, much to the dismay of traditional Wood scholars, ignore roughly three-quarters of his life's output.*

1 Jonathan Weinberg, *Speaking for Vice* (New Haven: Yale University Press, 1993, xiii)

2 Ibid., p. xiii.

3 Ibid., p. xiv.

4 Ibid., p. xiv.

5 Patricia Cohen, "Lit Critics Who Peer Under the Covers," *New York Times*, April 19, 2009.

6 Taylor, *op. cit.*, 90.

7 Hughes, *op. cit.*, 438.

8 Corn, *op. cit.*, 3; Dennis, *op. cit.*, 109, 121.

9 Jules Stewart, "The 1935 novel that predicted the rise of Donald Trump," *The Guardian*, October 9, 2016. https://www.theguardian.com/us-news/shortcuts/2016/oct/09/it-cant-happen-here-1935-novel-sinclair-lewis-predicted- rise-donald-trump

* In 1924 to 1926, Wood had a very brief fling with surrealism or with, as the one work is described, Orphism.(*See* Garwood, *op. cit.*, 83.)

# Google Links Grant Wood
# to *Brokeback Mountain*

In *Return from Bohemia*, 1935, Grant Wood presents a head-and-shoulders portrait of himself at work at his easel, while five presumably local people look on from behind. The end of a red, gambrel-roof dairy barn neatly frames the group. Wood conceived *Return from Bohemia* for the cover of his never-written autobiography, underscoring the significance of the drawing to his life and his oeuvre. And to *covers*.

The title of the work is said to refer to the artist's decision, in the late 1920s, to quit his pursuit of plein air Impressionism and return, from the profligate, Bohemian life he had found in Paris and Munich, to his roots, to local subject matter in Iowa. The good people now behind him, who will henceforth be both his subject and his audience, are they to whom he has ostensibly returned.

In her landmark 1983 survey of Grant Wood, Wanda Corn suggests that in spite of his momentous return to his roots, Wood and his audience are somehow "not reconciled."[1] Sue Taylor observes that the folks in Wood's audience have their heads "bowed in reverence," an indication that, in her view, Wood "wants more than anything the approval of his community."[2] Beyond these observations, neither Corn nor Taylor provides any foundation from which to decipher this perplexing picture.

In my view, Wood presents his onlookers not in a state of reverence but as if encased in sleep:

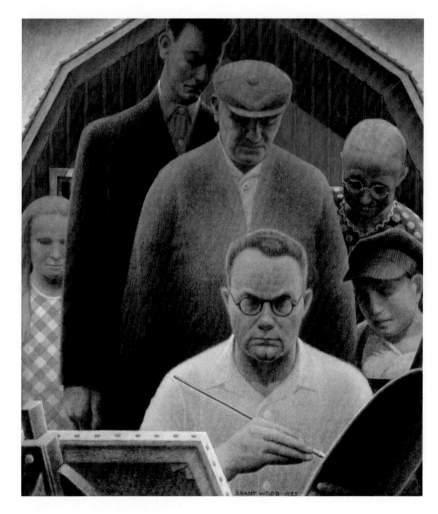

*Return from Bohemia*, 1935. Pastel, gouache, and pencil on paper, 23¹/₂ × 20 in. (59.7 × 50.8 cm). (Courtesy Crystal Bridges Museum of American Art, Bentonville, Arkansas. Photo courtesy of Alexandre Gallery, New York.)

their heads are bowed, yes, but their attention is not focused approvingly on Wood's work and, in fact, their eyes are closed. Wood presents himself wearing a very stern countenance and a plain shirt, without his trademark overalls; perhaps he is telling us that his art is neither of these people nor for them—that he is *apart* from his community, *not connected* to it. These folks are, in a word, blind to his message. Or was he purposely hiding something to keep them in the dark?*

Thinking about what it might have been that Grant Wood had to hide, I typed "Grant Wood" and "Homosexuality" into Google. Up came countless hits linking *Brokeback Mountain* and Grant Wood's painting *American Gothic*, 1930. Aside from wondering why, in 2005, a story so unremarkable except that its main characters were gay cowboys should be news, I was curious to know how movie critics were making the leap that art historians had not.

The easy answer is not that some cowboys are gay; it was their identification in 2005 as gay *back then* that intrigues. Timing is everything: Annie Proulx frames her short story "Brokeback Mountain" not in 1997, when she wrote it, but in 1965, at a time when her audience would have thought sex between cowboys was unimaginable. Packing the setup for the improbable affair into the story's first few pages, Proulx relieves her characters—and her readers—of complicity in the outcome. These two, otherwise normal, young ranchmen wouldn't have expected to have sex on the mountain. And we wouldn't have thought it possible either: not in 1965. There's the irony of it—and irony is how Google links *Brokeback Mountain* to *American Gothic*.

Dr. John E. Seery, professor of politics at Pomona College, whose main expertise is irony, says he finds irony in *American Gothic*—or is it satire or parody? In any case, he finds *something* resonating out from the dour faces of this unappealing couple, who are—husband and wife? Or are they father and daughter? Just two Midwestern folks?* Wood himself dissimulated on the question. He was never quite clear about whether he was satirizing his characters or, as his boosters—including his sister and all of his biographers—have contended, simply portraying straight, hardworking, Midwestern ideals. He hadn't meant to comment one way or the other on their relationship and he certainly wasn't holding them up to scorn. For his part, Wood insisted that his portrayal of the man and his daughter/wife was a loving one, and yet, patently, he rather rudely lampooned them. Is it fair to ask if he could do both at once? And be she wife or daughter, we have here a man and woman: Where does homosexuality come into it?

Robert Hughes was the first art historian, in 1997, to refer in print to Grant Wood as a homosexual. Hughes ridicules the traditional art historian's assessment of the artist as a "gently satirical, yet sturdy son of the soil, who lovingly holds humanity up to scorn," instead calling Wood "a timid, deeply closeted homosexual [whose] expression of gay sensibility prevented him from mocking his subjects openly."[3] Hughes provides neither background nor explanation for his assertion. Hughes's boldness aside, many scholars, long suspicious that Wood was gay, have searched the record for a "smoking gun." Where, they have always insisted on knowing, is the proof, without which no such claim could they commit to print? Alas, there is no documentary evidence: no "hot" private diary, no recently discovered letters to male lovers, no dishonorable discharge from the army, no police reports.[†] Wood is not known to have hung out in late-night gay haunts or to dress or act in a conspicuously flamboyant fashion. Wood was, after all, a schoolteacher in Ames, Stone City, and in Cedar Rapids; he had to keep his nose very clean.

---

* Cirrhosis of the liver derives its name from the Greek word for "orange," *kirrhos*, the color of the diseased liver in this state. If, as early as 1934, Wood received a warning from his doctor that continued, heavy consumption of alcohol would be ruinous to his liver, it might account for the curious orange cast he threw over *Return from Bohemia* and *Dinner for Threshers*, for a discussion of which see pages 65–69.

* An autograph note from Wood, recently discovered, has settled for all time the much-debated question of the nature of the relationship between the two characters. "I induced my sister to pose and had her comb her hair straight down from her ears, with a severely plain part in the middle. The next job was to find a man to represent *the husband*." [Emphasis added.] Cited in Seery, *op. cit.*, p. 9; "An Iowa Secret," in *Art Digest* 8 (October 1933): p. 6; Brady Roberts, *The European Roots of Regionalism*, p. 41.

† A Freedom of Information request and a subsequent appeal from this author to the FBI turned up no records on Grant DeVolson Wood.

So let's be clear: there just isn't any empirical, documentary proof and, consequently, no one is going to find the terms "gay" or "homosexual" anywhere in the pre-1997 Grant Wood literature.

This didn't stop Seery. In an effort to pin the label on his quarry, he notes that the artist's father died when Wood was ten, that he spent most of his life living alone or, for eleven years, with his mother and sister in a one-room apartment, that very late in life he was married, with no relatives or friends in attendance, to a woman who was already a grandmother.* The match, in 1935, the same year his mother died, had "taken everyone by surprise"; he was forty-four, she, near fifty. But the relationship, during which he and his bride, Sara Sherman Maxon, cohabited with Park Rinard, gave him "anxiety" and lasted for only three years. It was, perhaps not coincidentally, the same year he became the target of a torrent of animated and vicious accusations about his sexuality from his students, his colleagues, and the federal government, his employer under the PWAP program.

Corn demurs: "Although the Cedar Rapids press occasionally deemed him one of Cedar Rapids' most eligible bachelors, Wood never took the time for romance." David Turner, Wood's major patron, and other friends, viewed Grant and Sara as "badly mismatched." Darrell Garwood, a friend and the first Wood biographer, reports that Wood had "no friends among girls and seldom spoke to women," that he suffered from "lack of self-confidence . . . fevers of mortification . . . an inability to meet people on an equal footing" and from "an inferiority complex": there were "plenty of girls who would have liked to keep house for him but he was . . . just not interested in women."[4] Seeming to know something he preferred not to say plainly, Garwood resorts to sarcasm: "There were times when people thought Wood might marry but there were no sound reasons for these expectations."[5] All Wood's biographers have noted these factoids, but never quite assembled them as sufficient circumstantial proof from which to make a case for Wood's sexual preference. Of

* Maryville Wood died March 11, 1901. Cited in Darrell Garwood, *Artist in Iowa: A Life of Grant Wood* (New York: W. W. Norton, 1944) 40, 75.

Grant Wood and his wife, Sara Sherman Maxon, at Jay Sigmund's home in Waubeek, Iowa, ca. 1939. Photographer unknown. (Photo permission the Carl and Mary Koehler History Center, Cedar Rapids, Gift of Virginia Sigmund Meyers)

course, taken together or separately, these descriptors do not constitute proof of anything. But, in popular parlance anyway, are not these among the classic, stereotypical parameters of the "timid, deeply closeted homosexual"?

I, too, had long suspected Wood was gay. Forty years ago, I point-blank asked Nan Wood Graham, Wood's sister, if it were so: came the answer no.* I personally asked Park Rinard, Wood's long-time roommate/secretary/archivist if *he* were gay; categorically no. Both Nan and Park cited their marriages—that is, Grant's and Park's—as proof against the claim, a once conventional—now laughable—cover.

Nan, who had posed for the sour-faced, spinster-like, daughter/wife wearing the calico shirtwaist gazing off wistfully to one side in *American Gothic*, spent her life defending her older brother; after his death she made a career of keeping secret whatever it was she knew about his true nature. Nan once reported to Wanda Corn that because they were "unimportant," she had long ago burned her brother's letters. Clearly, what Nan burned in her brother's correspondence was some unsuitable truth. On a claim of copyright to which, incidentally, she was not entitled, she tirelessly struck back at those who produced the ever-burgeoning parade of spoofs and lampoons on the iconic image. Relying on her legitimate

rights as his sister and sole heir, and upon her flimsy claim to copyright, she was determined to defend his—and her—honor.

She doth protest too much; what Nan invariably saw as infringement was, in fact, parody, a protected form of expression. Ultimately, Nan always settled out of court. But in this way her victims gave Nan if not an easy conscience, at least a modest living. She was by necessity litigious and proud, by nature meek and pitiable. But until her death in 1990, she always managed to keep the lid on this most pressing side issue of her brother's life. Since Nan's death, and with no champion, so to speak, left standing in the field, sexual ambiguity is gaining a foothold in modern interpretations of *American Gothic*. And, while art historians had not previously shown much appetite for making an issue of it, it seems that sexual ambiguity has also attached itself to its relatively unknown creator.

1 Wanda M. Corn, *Grant Wood: The Regionalist Vision* (New Haven: Yale University Press, 1983).

2 Sue Taylor, "Wood's American Logic," *Art in America*, January 2006 (94): 86–92.

3 Hughes, *op. cit.*, 39.

4 Garwood, *op. cit.*, 24.

5 Ibid., 73.

* In 1973, as head of American Paintings at Sotheby Parke-Bernet, I appraised the John B. Turner collection of Grant Wood's work, which Turner bequeathed to the Cedar Rapids Art Museum. Turner introduced me to Nan Wood Graham and Park Rinard.

# Homoeroticism and *American Gothic*:
# An Icon of Americana, Reconsidered

*American Gothic* may well be the most thoroughly analyzed painting in the history of American art, all of it an attempt to shake down the picture for its essential message. Art historians, social anthropologists, movie critics, political analysts, cultural historians, retired museum directors, close relatives, and even closer friends—the list goes on—have produced a torrent of theories on the seemingly simple yet ultimately puzzling significance of this picture. Many of these writers have articulated important insights; but after a while, they all merge into one inconclusive heap. Or, at any event, none has risen to the top. All we would know from reading them is that we do not yet understand what Wood had in mind in painting *American Gothic*.

But the wonder is not that the picture engages so many plain folks, critics, and scholars. It is that none of them has ever seen a phallic symbol in the *outlines* of the gothic window and the two, curiously oval heads of the figures.

Don't see it? You were never supposed to.

Some symbols, like the Star of David or the cross, don't need a key to be understood. Some tease or require a little thought to be understood and some require that you put aside what you think they mean because they are intended to distract you from understanding what they really mean.

Wood was practicing steganography, the art of concealing one message beneath the text of another such that it will appear to those who are not the intended recipients, to be something else, commonly another text, an article, a shopping list, or a picture—in this case, of a goofy Iowa farmer and his young, spinster-like daughter/wife. *American Gothic* was an immediate success and, for some reason, it drew a lot of fire. But if, as Hughes brazenly opined, Wood was a "timid, deeply closeted homosexual," he would have hid his message—and with it his temerity—very, very well. And, if he were alive today, that is just as he would want it to remain.

Symbolism's goal is the rational rearrangement of seemingly incongruent ideas. To make obvious what was intended to be deeply encoded or to provide a key alongside the formulation, once successfully completed, defeats the artist's purpose.

The literature tells us that the little house in Eldon, Iowa, where he conceived the picture, appealed to Wood because of "the Gothic window prominently placed in the gable. With his fondness for repeating geometry, Wood immediately envisioned a long-faced and lean couple . . . to complement the house and echo its predominantly vertical lines."[1] And this: "*American Gothic* combines a personal, iconography drawing upon a visual pun, portrait caricature, comic satire and rural regionalism with an eccentric unification of 'decorative elements' derived from local sources . . . the modest, Carpenter Gothic house

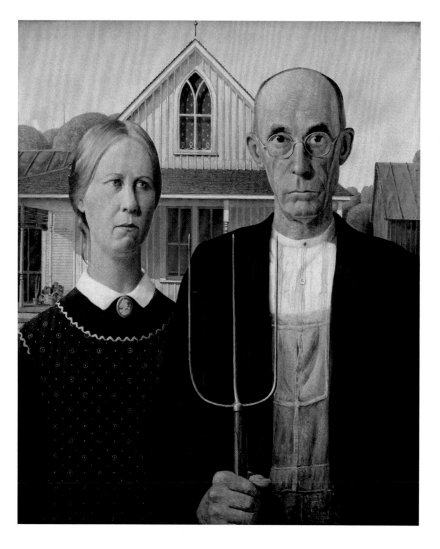

American Gothic, 1930. Oil on Beaver Board, 30³/₄ × 25³/₄ in. (The Art Institute of Chicago, Friends of American Art Collection, 1930.934.) © VAGA, NY. Photo credit: The Art Institute of Chicago/ Art Resource, NY.

I know what you are thinking. But have we not all been told Columbus discovered America and is that not a problem of perspective or semantics? When Columbus arrived in 1492, he found people who had been in America for millennia. What is more, Leif Erikson and Amerigo Vespucci both stopped here before Columbus: what is the meaning of the word "discover"?

Okay: you still don't see it. But I am going to ask you to accept for now the proposition, as yet unexplicated, that Wood's work embeds extremely well-hidden, homoerotic imagery. I am going to ask you to accept, for now, that Wood planted this queer, Midwestern American couple, with their inscrutable expressions and quaint clothing, before an equally absurd house in Eldon, fully secure in the knowledge that the sum of these curiosities would entirely upstage his primary message. Today, we find the painting inscrutable because Wood succeeded too well.

Don't expect it to jump out at you: it is an outline in parts motley. It might help if you were to tip the illustration of Bourgeois's La Fillette away from you, which would simulate Wood's view of his lover looking up from his knees. It might also help if you were to accept that Wood did not, as scholars have all supposed, imbue these everyday objects with cultural significance; instead, he stripped them of it. If you will bear with me, I will make the case that homoeroticism was Wood's message in American Gothic, this and nothing more.*

Keep in mind that we are dealing here with a "timid, deeply closeted homosexual" living in Iowa in the 1920s and '30s, a time and place not exactly friendly to gay people, let alone to those who come out. I only "saw" it in American Gothic after I "saw" it in Wood's later works, which we will get to shortly. Then, looking expressly for it—and wondering when and where it all began—I

abounding with social and cultural implications."[2] Or this: "[Wood] thought the house a form of borrowed pretentiousness, a structural absurdity, to put a Gothic-style window in such a flimsy, frame house."

I have found several instances where American, Carpenter-Gothic houses are referred to as "queer." But it was not that, or "repeating geometry" or the chance to "make a pun on the structure's flimsy absurdity" or the "long-faced and lean couple" that caught Wood's attention. It was only the diverging lines in the mullion of the window that echoed the cleft in an uncircumcised man's foreskin.* A couple, their oval heads positioned below and to either side of the mullion, one a little higher than the other, would complete the figure.

___

* The window in the Eldon house was, in reality, more square (see Dennis, op. cit., p. 80), but Wood narrowed and elongated it to better capture his message.

___

* In May 2002, Congressman Ronnie Shows of Mississippi rose in the House of Representatives to introduce the Federal Marriage Amendment, to preserve the "traditional heterosexual marriage captured by Grant Wood's American Gothic as the bedrock of American society." See Jonathan Turley, "The American Gothic Amendment: Tinkering with the Constitution for the Wrong Reason," in Chicago Tribune News, May 19, 2002. http://articles .chicagotribune.com/2002-05-19/ news/0205190435 1 same-sex -marriages-marriage-act-marriage-matters

worked my way backward from *January*, 1940, and found it in *American Gothic*, 1930, then in *Woman with Plants*, 1929, and finally in *Memorial Window*, 1927. But there is another, larger reason why you don't see it: you would rather not.

Don't we all see erotic content in Georgia O'Keeffe's floral close-ups and have we not all agreed these images are less likely to be, as she insisted they were, botanical studies than metaphors for the female genitalia? Well, genitalia come in two varieties, male and female: why do we so readily see one but balk when presented with the other?

Perhaps the refusal (unanimous among early readers of this paper) to see Wood's erotic content in *American Gothic* arises because we unconsciously apply a double standard, a cultural reluctance to envisage *male* genitalia, let alone acknowledge that anyone would be sufficiently obsessed to want to paint them.[3] And yet, it was precisely Wood's reliance on this double standard that made it possible for him to drag a big red herring across his path, a distraction we have been obligingly following for seventy-seven years.

Well, you say, if Wood intended it to be so well hidden, for whom did he paint it? And I would answer that there is no point in speculating for whom exactly Wood's message, so well encoded, was intended: this misses the point. We are unarguably seeking meaning in *American Gothic* because *something* in it speaks tenaciously to us, but in a language we struggle (or are unwilling) to comprehend. And, if we continue to insist on a conventional line of inquiry, and a conventional reading of Wood's outlandish lingua franca, we are simply going to continue to be, like those standing behind him in *Return from Bohemia*, blind to his message.

For example, Wood's posthumous biographers seem all to have accepted Jim Dennis's interpretation of the word "Gothic" in the title of Wood's iconic picture, as a reference to the glorious, cathedral architecture of the late Middle Ages, or to the sublime Flemish and Northern paintings of the twelfth to fourteenth centuries, which Wood first saw in 1928 on his trip to Germany, whence he had recently returned. Dennis links Wood's self-proclaimed, inner Iowa-country-boy soul to the outward style and refined beauty of the Renais-

sance arch, the form of it, he opines, brought forward as a "remnant of the 19th century Gothic Revival."[4] But this mind-set took Dennis—and all Wood's subsequent biographers—at their very first step along the journey, irretrievably off the track.

I suggest that instead of architecture or paintings, by assigning the title "American *Gothic*" to his picture, Wood referred—quite literally and without apology or artifice—to a mode of literature characterized by emotional sorties into the grotesque and barbarous, the loathsome, uncivilized and crude, a genre widely known as *Gothic*.

Is this reading really such a leap that no one has ever previously made it?

The style began in England with the publication, in 1764, of *The Castle of Otranto* by Horace Walpole (1717–1797), billed innocently enough as a "romantic novel." But once into it, readers found they were on an involuntary journey into the dark and macabre side of human nature. Mary Shelley

Louise Bourgeois (French American, 1911–2010), *La Fillette (Sweeter)*, 1968. Latex over plaster, 23½ × 11 × 7½ in. (59.7 × 28 × 19.1 cm). (Museum of Modern Art, NY. Gift of the artist in Memory of Alfred H. Barr.) © The Easton Foundation/Licensed by VAGA, New York, NY.

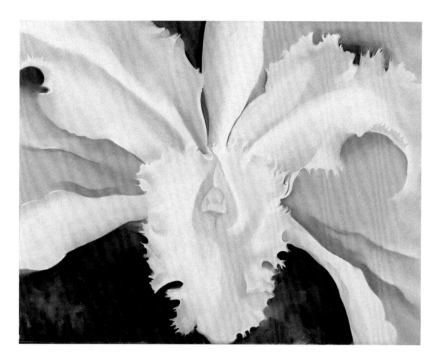

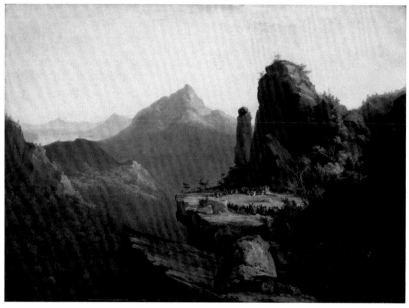

Georgia O'Keeffe (1887–1986), *Narcissa's Last Orchid*, 1941. Pastel, 21½ × 27¼ in. (Princeton University Art Museum, Gift of David H. McAlpin, Class of 1920, x1982–357.) Photo: Bruce M. White.

Thomas Cole (1801–1848), *Scene from "The Last of the Mohicans," Cora Kneeling at the Feet of Tamenund*, 1827. Oil on canvas, 25³⁄₈ × 35¹⁄₁₆ in. (64.5 × 89.1 cm). (Wadsworth Athenaeum, Hartford CT. Bequest of Alfred Smith, 1868.3.) Photo: Allken Phillips/Wadsworth Athenaeum.

(*Frankenstein*, 1818) and Bram Stoker (*Dracula*, 1897), reacting against the dehumanizing effects of the Industrial Revolution, extended the form into the Romantic and Victorian eras.

The style has its American roots in author Charles Brockden Brown (1771–1810), *Weiland*. The form's post–Romantic era revivalists include Edgar Allen Poe (1809–1849), *Fall of the House of Usher*, 1839; Herman Melville (1819–1891), *Moby Dick*, 1851; Nathaniel Hawthorne (1804–1864), *The House of the Seven Gables*, 1851, and *The Scarlet Letter*, 1850; Robert Louis Stevenson (1850–1894), *The Strange Case of Dr. Jekyll and Mr. Hyde*, 1886; Henry James (1843–1916), *The Turn of the Screw*, 1898; William Faulkner (1897–1962), *Light in August*, 1932; Truman Capote (1924–1984), *In Cold Blood*, 1965; Stephen King (1947– ), *The Shining*, 1980; and yes, Annie Proulx (1935– ), "Brokeback Mountain," 1997.

All Gothic literature relies for its impact on the setting up of some seemingly regular occasion: a visit to the old, ancestral lodge or a moonlit boating trip along the edge of a remote lake. Having once set the scene, the author then slowly, relentlessly submerges the reader in a morass of forbidden emotions, conventionally beyond the pale — incest, patricide, familial dysfunction, abject rage, and erotic desire — emotions refined readers would consider as not just out of this world but "Other."[5] But Gothic's "hook" derives its strength from the seemingly casual intraposition of the familiar with an imminent, sensational terror of inordinate violence or the prospect of — always lurking — illicit or immoral sexual arousal of delectable intensity. Upper-class gentlemen who drink dark potions or inject drugs that give license to wicked, forbidden desires; lightning storms that illuminate dark castles where aristocratic scientists, who sew together body parts stolen from graves, give life to brutal, murderous monsters. Scantily clad beauties scream for their deliverance: *delightful!*

American nineteenth-century artists practiced the genre too. While only his "closest" circle of gentlemen friends realized it, Thomas Cole's *Last of the Mohicans, Cora Kneeling at the Feet of Tamenund*, 1827, impounded a (fairly obvious!) erotic message, linking together as appositional texts a crude impulse behind a refined, literary allusion.

A century later, invoking exactly this tradition—and, with almost truculent conviction, precisely naming it—Wood's *American Gothic* linked together the quaint, Midwestern attributes of the pathetically simple farmer and his serenely apathetic wife/daughter to one of the most sinister horrors in the Gothic catalogue: *homosexuality*. Wood, like Cole before him, gambled that his audience's sanctimonious adherence to propriety would trump any temptation to appear interested in the "Other," thereby bearding a very organic passion behind a very thin gloss of politesse.

It worked: Wood was, in fact, so confident his ruse was intact that, as a response to contemporary criticism of the predominantly "vertical lines" in *American Gothic*, he actually said he might, as a follow-up, "do a couple in front of a Mission-style house with the emphasis on the horizontal."[6] Please: (*couple . . . Mission*[ary]*-style . . .* emphasis on the *horizontal . . . ?!*) Wood was fairly hitting his audience over the head with his unwholesome theme and he was supremely certain they were insistently not getting it.

Perhaps you too are still not getting it? Look carefully at the pattern of shapes below. Perhaps you see puzzle or machine parts. Try concentrating not on the "positive" shapes defined by the

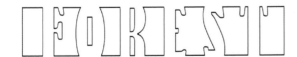

lines, but at the voids between the shapes. Have you ever heard the expression "to miss the forest for the trees"? Now read the sentence below and count the *F* letters in the sentence. Read it again to be certain you've got them all. Almost all readers see three *F* letters in the sentence instead of the six actually there.

FORENSIC WEATHER FORECASTS
ARE THE CONSEQUENCE OF YEARS
OF SCIENTIFIC OBSERVATIONS
COMBINED WITH YEARS AND YEARS
OF EXPERIENCE.

This sort of illusion was currency to Grant Wood, who knew that we do not see what we are predisposed *not* to see, even when it is right there, but hiding in plain sight. "We have met the enemy—*and he is us!*"[7]

1  Corn, *op. cit.*, 129.

2  James Dennis, *Grant Wood: A Study in American Art and Culture*, (New York: Viking Press, 1975), 79–80.

3  *See* note 46, *infra*

4  Dennis, *op. cit.*, 80.

5  William Veeder, "The Nurture of the Gothic, or How can a Text be both Popular and Subversive," *American Gothic: New Interventions in a National Narrative* Robert K. Martin and Eric Savoy, eds. (Iowa City: University of Iowa Press, 1998), 23.

6  Grant Wood, Letter to the Editor, *Des Moines Register*, December 21, 1930, cited in Corn, *op. cit.*, 129.

7  Walt Kelly, *Pogo*, in anti-pollution poster for Earth Day, 1970.

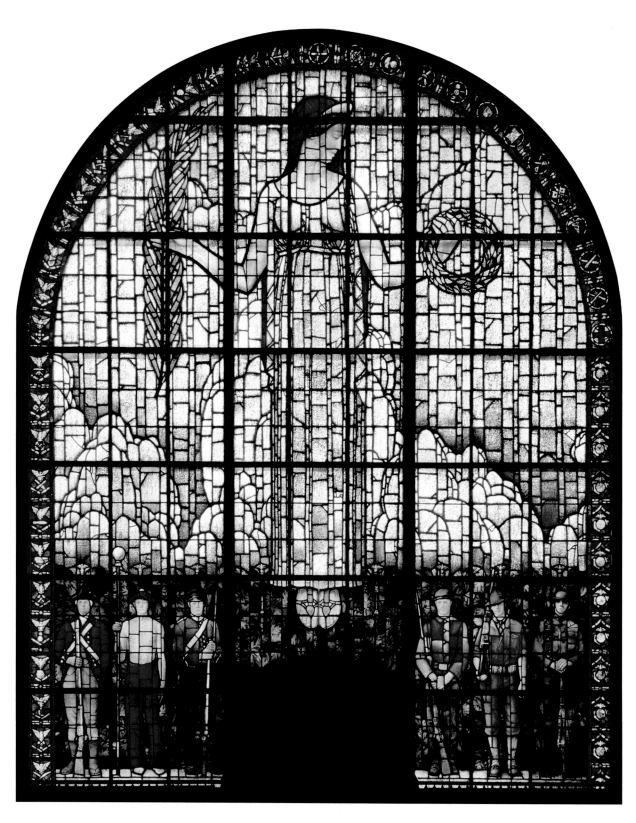

*Memorial Window*, 1927–29. Leaded stained glass, 24 × 20 ft. (Cedar Rapids Veterans Memorial Building)

# Sojourn in Munich: Wood Absorbs the Dark Humor of the Verist Branch of the Neue Sachlichkeit Painters and Brings it, Undercover, Home to Iowa

Wood made three trips to Europe between 1920 and 1926, traveling extensively to Italy and Paris, where he studied briefly at the Académie Julian. The focus of all his work up to, and during, this time was an atavistic interpretation of Impressionism, both decorative and insipid, yet popular in America. All Wood's biographers agree that, at the close of this period, he abruptly changed his style. But precisely what influences worked most significantly upon him to occasion the change is a matter of debate.

James Dennis makes a fleeting reference to the Neue Sachlichkeit or "New Objectivity" painters, who at the time of Wood's visit, were working in opposition to German Expressionism and who, like Wood, would finally reject Impressionism.[1] To make the point that their work influenced Wood, Dennis provides a comparison between one or two of Wood's commissioned portraits of the 1920s and a portrait by George Schrimpf (German, 1889–1938).

In Joni Kinsey's view, Wood was drawn to the "clarity, expressive contours, decorative details, smooth surfaces and rich coloristic effects" of the Late Gothic and Northern Renaissance. She joins in the majority opinion that it was this influence that finally "transformed Wood, from a bohemian, who experimented with a variety of styles and subject matter, to an avowed Iowa Regionalist."[2]

Corn also mentions that, while in Munich, Wood "may have chanced upon" paintings by the Neue Sachlichkeit; she compares Wood's mature style to a portrait by Christian Schad and reports that Wood liked "the apparel and accessories of the figures" from the Gothic period and that he was particularly impressed by the "crystalline realism" of the Flemish painters. Corn states that Wood was "heartened by the heightened realism [of the Neue Sachlichkeit painters, but that] he would have had no sympathy with their disgust, cynicism and social criticism."[3]

But, in my view, it was *precisely* this ugly message of disgust, cynicism, and social criticism with which Wood had empathy. He was, along with the Weimar artists of the twenties, "longing for something whole and [bursting] with an enthusiasm for things as they are, rather than as they should be."[4] This explanation of what the Neue Sachlichkeit painters were about could just as well have been written *for* Grant Wood; and the wonder is not that Wood was drawn to the art of the Weimar Republic, but that his biographers did not see why.

Wood served a short stint as a soldier during World War I, but his deployment coincided with the signing of the armistice; he was sent home almost immediately. Perhaps, for this reason, Wood's biographers have given little space to the impact that the war had on him and his art. But Sabine Rewald (referring only to German artists) calls World War I the "quintessential 20th-century catastrophe" and the "quintessential experience

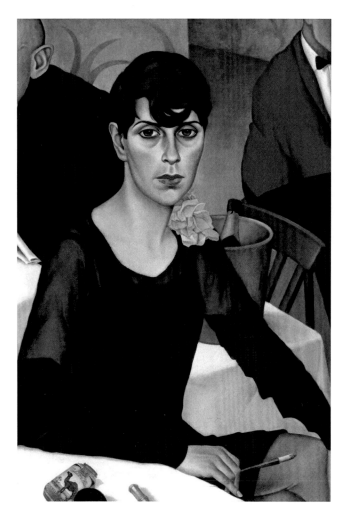

Christian Schad (German, 1894–1982), *Sonja*, 1928. Oil on canvas, 35½ × 23⅝ in. (90 × 60 cm). (Staatlich Museen zu Berlin, Nationalgalerie. Purchased 1997 by the Friends of the Nationalgalerie, Stift ung Ingeborg and Gunter Milich, Berlin.) © ChristianSchadStiftungAschaffenburg/ARS,NewYork/VGBild-Kunst,Bonn.

*Portrait of Frances Fiske Marshall*, 1929. Oil on canvas, 40 × 30 in. (Cedar Rapids Museum of Art. Gift of Frances Marshall Lash, Patricia Marshall Sheehy, Barbara Marshall Hoffman and Jeanne Marshall Byers, 81.11)

for [Otto] Dix's generation of artists."[5] But this was Wood's era too and, in fact, Wood (1891–1942) and Dix (1891–1969) were exact contemporaries.

I do not suggest that Wood and Dix were personally acquainted, or even that Wood was aware, before going to Munich, of the Neue Sachlichkeit painters. But Wood surely did know that, after World War I, the Weimar Republic (1919–1933) was the epicenter of an enormous, creative ferment in literature, music, film, theater, and art, approaching in significance in the twentieth century, what the Italian Renaissance had been in the sixteenth.

He would, in all probability, also have discovered, if he did not know it already, that the Neue Sachlichkeit painters were divided into two distinct factions, the Conservatives and the Verists.

Prior to his departure for Munich, Wood had painted a number of formulaic portraits between 1925 and 1928, all in the bland style favored by his Art Students League contemporaries in New York. This was, on the surface anyway, the same style favored by the conservative branch of the Neue Sachlichkeit, whose members painted idealized, objective, but yet not rude, likenesses.

The Verist painters, on the other hand, and like Wood also nearly all soldiers, had just returned home after the disastrous experience of the war, angry and cheated of a victory they had been assured was theirs. They were "in no mood to make pretty, representational portraits intended to inflate the egos of Germany's pompous politicians and jejune aristocrats."[6]

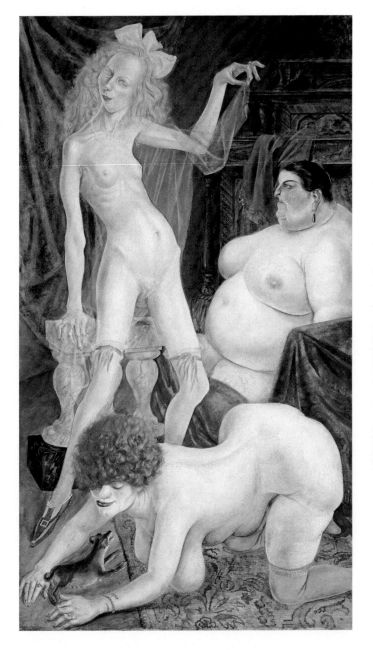

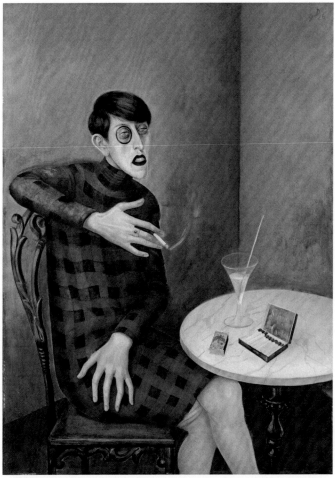

Otto Dix (1891–1969), *The Journalist Sylvia von Harden*, 1926. Oil and tempera on wood, 47¼ × 31½ in. (Musee National d'Art Moderne, Centre Pompidou, Paris.) © Artists Rights Society (ARS), New York / VG Bild–Kunst, Bonn. Photo: Jean-Claude Planchet.

Otto Dix (1891–1969), *Drei Weiber (Three Wenches)*, 1926. Oil and tempera on plywood, 71¼ × 41⅝ in. (181 × 105.5 cm). (Kunstmuseum, Stuttgart.) © Artists Rights Society (ARS), New York / VG Bild–Kunst, Bonn.

The Verists felt that the war had been a fantastic, gruesome joke played out at their expense, and they wanted to express their frustrations by trolling for character types improbably living it up, despite their wretched condition, in the demimonde of Weimar. The Verists' subjects were the "profiteers, prostitutes, now-forgotten poets, fops, cocaine addicts and transvestites—and they did not spare the republic's doctors, lawyers and businessmen."[7]

For whatever reason, masquerade and hypocrisy were near-universal, 1920s social occupations; and depending on whether one lived in the American Midwest or in Europe, one's effort at cover and dissimulation differed only by degree.

The Verists' game was to look beneath whatever sturdy façade a subject had put up to deal with the pain of a lost war and then brusquely rip it off. What attracted the Verists was the grotesque, the disquieting, the macabre; the over- and under-sexed, the too-rich and the too-poor. Into their searing caricatures, the Verists compressed as much distortion and exaggeration as they could pack into one picture. To sit, in 1926, for Otto Dix was first to submit to the creation of a *Dix* and, second, if at all, to a likeness as the sitter saw

herself or, as she desperately hoped, she was seen by others. Obviously, commissioning Mr. Dix, as did the journalist Sylvia von Harden in 1926, required some self-assurance, unless, of course, she had foolishly thought she had nothing to hide and everything to reveal.[8] Such was the "school" into which timid, deeply closeted Grant Wood of Cedar Rapids inducted himself when, in 1928, he stopped in Munich.

By 1928, Wood, age thirty-seven, was also tired of all that wholesome goodness bubbling forth hypocritically from the hardworking, churchgoing folks back home. Consequently, when he came face-to-face with the impious message emanating from the Verist painters, it was to be the Verists with whom he identified. On the surface, however, Wood's style most resembles the Conservatives; America had, after all, been the victor in the Great War, not the vanquished, and once back home in Cedar Rapids, he knew the American public was in no mood to be openly satirized.

So, had Wood, as his recent biographers all contend, altered his style in response to the German and Northern Renaissance painters; his post-Munich style in evidence in *Portrait of Nan*, 1933, would resemble the style of the Conservative branch of the Neue Sachlichkeit.

Corn, Dennis, and Jane Milosch all invite us to see a loving likeness of the artist's sister, "stylish and contemporary" and painted, he is supposed to have said, to "make up for the abuse to which he had subjected her in *American Gothic*."[9] Corn continues in this vein: "[T]o heighten the decorative effects of the picture," Wood arranged for Nan to wear a blouse he had decorated with large black polka dots and "jaunty black ribbons" at the shoulders. The scalloped waves in the green drape, held back by an "antique drapery knob," would, in Corn's view, echo her lovely, marcelled hair.[10]

Corn notes that in her hands, Nan holds two "rather odd" attributes, a baby chick and a ripe plum, both, the sitter is said to have maintained, chosen by Wood "for decorative reasons." The artist is, in Corn's words, supposed to have "liked the chicken . . . because it echoed the color of [Nan's] hair. For its part, the plum reiterated the shape of the dots in her blouse and repeated the rose color of the wall behind her." Corn assures us that while Wood "never chose attributes for his sitters on stylistic grounds alone; he undoubtedly liked the chick because, as it perched, young and vulnerable, in the cupped hand of his sister, it conveyed her tenderness—and the plum because, as an artistic convention, fruit always symbolized femininity."[11]

Corn takes umbrage at critic Emily Genauer's assessment of *Portrait of Nan*, which had in it "all the bigotry, stupidity, malice and ignorance that are rife in the provinces." Corn even projects that Wood would have been offended by such an "insensitive misreading" and wonders "how, in such a climate, he could ever get people to see what he valued in rural and small-town America."[12]

But had Corn—or Genauer—looked at *Portrait of Nan* from a Verist's point of view, she would have seen that Wood was not painting a "wholesome tribute to his favorite sister" or exploring through her "what he valued in rural, small-town America."[13] He was taking wholesome, American portraiture to a caustic, Verist extreme.

The Verists chose portraiture as a vehicle for their malicious idiom because, as forms, landscape and still life did not provide as direct a platform for the ruthless and trenchant commentary they had in mind. But unlike the Verists, we will soon see that Wood used both landscape and portraiture to make his statement.

Confident of his adoption of the new style, Wood intended his early portraits—at least to the extent a timid homosexual dared make them so—to be seen as conventional likenesses and not as Verist exposés. Even so, Wood was wary about rolling out any hint of his new content. He would have been pleased that Corn, Dennis, Milosch, and Kinsey,[14] while all noting the influence of the Neue Sachlichkeit upon his work, could see no need to plumb the school's deeper influence on him.

Unfortunately, we need to postpone our full analysis of *Portrait of Nan* until we have developed more context; for now, I readily agree that the dispassionate, glassy-eyed figures found in *American Gothic* and in the portraits of his sister Nan, and of his mother in *Woman with Plants* are, outwardly anyway, reminiscent of the Conservative, Neue Sachlichkeit style.

Grant Wood, coming of age in the "Anything Goes" era, but in Iowa, far from the decadent,

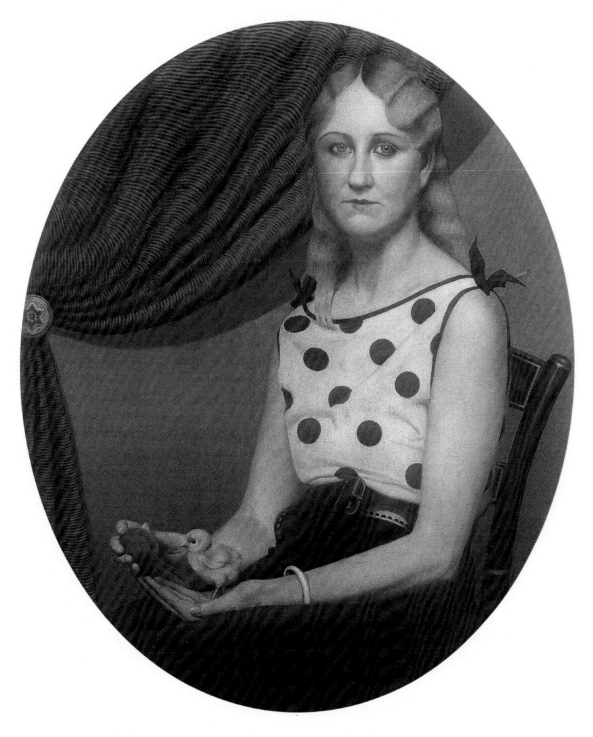

*Portrait of Nan*, 1933.
Oil on masonite, oval,
40 × 30 in. (Chazen
Museum of Art, University
of Wisconsin-Madison,
Collection of William Benton,
1.1981)

urban centers, had instinctively concealed his homosexuality. After his trip to Munich, Wood abruptly changed his style, but he intended his audience to hear only the cheery melody running gaily along the surface of his work. It is, then, exactly here that Wood's biographers come under the spell of a flawed assumption: that in Munich, Wood had recoiled from Bohemianism and started on his way to becoming an "avowed Regionalist,"

or even that Wood was, at heart, a jolly, good-natured homeboy. The misunderstanding arises because his biographers do not detect the change in tone playing in a minor—not a major—key deep below the surface of his patently new style.

When he arrived in Europe, he was undoubtedly astonished (or thrilled) to see that mainstream society appeared to tolerate a variety of outlandish—even deviant—behavior, that Bohemianism

was not conducted secretly but openly, and that he too could participate. In 1928, Wood heard the raw, gruesome melody emanating boldly from the Verists, and from that point forward, he would embrace their message and make it his own.

In 1928, the state of craftsmanship in leaded glass may well have been superior in Germany, but it was sex that drew Wood to Munich. Christopher Isherwood (English, 1904–1986), author of *The Berlin Stories*, upon which the musical *Cabaret* is based, went with W. H. Auden (English, 1907–1973) in 1929 for the same reason.

For inhibited, upper-class Englishmen and Bohemian American artists, Germany meant "working-class boys in tight leather shorts, any of whom could be had for the price of a warm meal and a mug of beer."[15] Homosexual fantasy was for sale on the cheap in Munich in 1928. With overvalued American dollars in his pocket, Wood could go out all night and play the prince and, no doubt, he bought warm meals and tankards of beer for a great many pretty, young men: he stayed for three glorious months.

Without any discussion of the insalubrious social and economic conditions that greeted Wood on his arrival in Munich, Dennis speculates that in the towering *Memorial Window*, we first see "an unplanned prelude to *American Gothic* . . . and the values underlying the outwardly changing culture of the United States."[16] Milosch agrees that in Wood's cartoons for the window, "it is possible to see the beginning of a new stylistic direction."[17]

I see this too; but chiefly, I see beneath the artist's new "style" a twenty-four-foot-high phallic symbol embedded in a memorial to Cedar Rapids' World War I veterans who, in the "quintessential catastrophe of the 20th century," had just given their lives in—of all places—Germany. Grant Wood was now in Munich having the quintessential experience of his life.

And so, to judge only from what appears in his work, I pinpoint Wood's conversion from parochial, neo-Impressionist to urbane, nascent Verist coincident with his designs for the *Corn Cob Chandelier* (frontispiece), its iconography of multiple, erect corn cobs about as impenitent as the entire object is bizarre: it was Wood's proto-phallic image. In the following year, he

began designs for his next, the *Memorial Window*, which commission he was awarded in 1927 and which he completed in 1929. This was the first appearance in his work of a complete phallic symbol in outline; and thus he initiated what would, henceforth, be the basso profundo in his work for the remainder of his life. But at this early stage of his career, Wood's erotic symbolism is so well encrypted that, but for this analysis, it may have gone forever unremarked.

The window's design centers around an erect female figure demurely holding, in one hand, a palm frond—shaped in outline like a kielbasa—and in the other, a wreath in the shape of a torus (bagel) on which her glance is fixed: it is as if she has just redirected the same querulous look from the frond to the torus, as if pondering the relationship between them. She rises on clouds, like crumpled bedclothes, in the "crotch" formed by two mountains floating over a large, dark void, which is actually a bronze tablet onto which the names of the fallen are embossed, flanked on either side by square panels enclosing two groups of three soldiers arrayed against clusters of oak leaves and a profusion of acorns—the neatest of Wood's homoerotic symbols, about which more in a moment.

Looking for something similarly erect, if not even more recondite, the very vertical snake plant makes its first appearance in *Woman with Plants*, 1929, Wood's portrait of his mother.

It is impossible, I think, to paint a picture of one's mother and not load it. Yet, according to Garwood, "Wood hadn't meant the portrait to represent his mother: in choosing the snake plant, he was thinking in terms of *design qualities* and simply needed something *up and down*." (Emphasis added.)[18] In this, only his second picture to include weighted symbols, the begonia, barn, and windmill also make their first appearances, about which more shortly.

Hattie Weaver Wood, who does not look us in the eye, is said to have raised petunias, verbenas, geraniums, begonias, and snake plants.* The snake plant, which suggests hardiness but also

---

* Taylor, *op. cit.*, p. 93, suggests that Hattie Wood refused to look at her son because there was something about him she could not acknowledge.

solitude and desolation, is alternatively called *Widow's Tongue* or *Mother-in-law's Tongue*.

Colloquially speaking, a "plant" is a stand-in for something else, a surrogate. Wood makes abundantly clear that the objects in this picture are surrogates, assigning an impersonal, generic title: [nameless] woman with [undifferentiated] plants. If these were not symbols, the reappearance of the snake plant and begonia sitting silently on the porch just over the shoulder of his sister, the other domineering woman in his life, making her first appearance in *American Gothic*, is difficult to explain; they do not ever appear again. Not mentioned much, and apparently without salutary—or disquieting—attributes, the significance of the begonia eludes me.

Potted plants—Oedipal, generational, incestual—may just be plants, living things typically cared for by women. But to children, plants are inanimate things that women appear inscrutably to nurture. As a child, Grant Wood may have been curious about, or even jealous of, the attention his mother and sister showered upon them.

Corn sees the snake plant as "an obvious reference to [his mother's] much-praised talents as a gardener . . . more importantly, the snake plant, well known on the frontier for its hardiness, signified the sitter's resilience and strength of character, qualities Wood felt were indigenous, not only to his mother, but to the Midwestern pioneer."[19] Taylor refers to *Woman with Plants* as "a loving rendition of the old woman as Mona Lisa."[20]

But patently, the "snake" plant is named for the viper, for the "woman as serpent" theme from Genesis. Hattie's snake plant stands erect, like a phallus; as held between her two hands, one on either side at its base, it is an ensemble, in outline, of the whole male genitalia. Or, more horrifying, Hattie is a Harpy who, because in Greek mythology she has snakelike lower parts, Wood purposely shows from only the waist up. Be whichever she may, mother as hardy pioneer/wife or as loathsome, voracious Harpy, Wood puts a snake plant, with appallingly plain connotations, in the hands of his mother.*

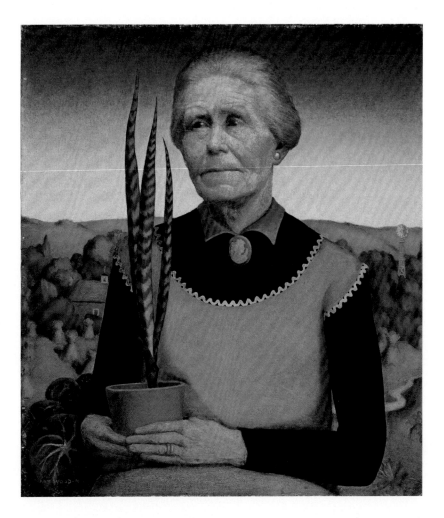

*Woman with Plants*, 1929. Oil on composition board, 20¹/₂ × 18 in. (Cedar Rapids Museum of Art, Cedar Rapids Art Association Purchase, 31.1)

* Grant Wood's friend Jay Sigmund wrote a chilling poem about the perfidious snake titled "The Serpent." Might he have had Wood's mother in mind?

Wood purchased the cameo adorning his mother in *Woman with Plants* in Italy and, upon his return home in 1924, presented it to her as a gift.[21] He put it again, one year later, on his sister Nan in *American Gothic*. By placing it *just so* at the throats of the women under whose control he had chaffed as a boy, the cameo is like a coup counted upon one's antagonists, a talisman of that time in Europe where, already age thirty-three and out of their sight for the first time, he was free to explore his sexuality.

And what are we to make of the "single strand of wayward hair," which in order to "show her humanity [and] underline her insistent tidiness" Corn says Wood allowed to "escape from Nan's bun and snake mischievously down her neck, the only unruly element in an otherwise immaculate conception"? Do we not see that hanging as it does from her ovoid head, it so closely resembles the morphology of the spermatozoon?[22]

1 Dennis. *op. cit.,* 67–77.

2 Joni L. Kinsey, *Cultivating Iowa: An Introduction to Grant Wood,* in *Grant Wood's Studio, Birthplace of American Gothic,* Jane C. Milosch, ed. (Cedar Rapids: Cedar Rapids Museum of Art, 2005), 29.

3 Corn, *op. cit.,* 28.

4 Alexandra Ritchie, *Faust's Metropolis,* cited in Francine Prose, "Berlin Stories: The Caustic Energy of Weimar Art," *Harpers,* (April 2007), 91–97.

5 Corn, *op. cit.,* 3.

6 Philippe de Montibello, "Director's Forward," in Sabine Rewald, *Glitter and Doom* (New York: Metropolitan Museum of Art, 2007), vi.

7 Ibid.

8 Ibid.

9 Jane Milosch. *Grant Wood's Studio: Birthplace of American Gothic* (New York: Prestel Publishing, 2005).

10 Corn, *op. cit.,* 102.

11 Corn, *op. cit.,* 102.

12 Ibid.

13 Ibid.

14 Joni Kinsey, "Cultivating Iowa: An Introduction to Grant Wood," in Milosch, *op. cit.,* 11–33.

15 Rewald et al., *op. cit.,* 15.

16 Dennis, *op. cit.,* 67.

17 Milosch, *op. cit.,* 102.

18 Garwood, *op. cit.,* 109.

19 Corn, *op. cit.,* 70.

20 Taylor, *op. cit.,* 93.

21 Ibid, 79.

22 Corn, *op. cit.,* 133.

# Wood Gives His New Theme Its Legs, Makes Common Cause with New Dealers, Queers, Communists, Jews, and Blacks

*C*orn Room Chandelier, 1925–26; *Memorial Window*, 1927–29; and *Woman with Plants*, 1929, were, respectively, Wood's first, second, and third sorties into homoerotic symbolism. And aside from a few classic, Freudian, Oedipal connotations, they comprise a pretty timid beginning. From the artist's perspective, *American Gothic*, 1930, his fourth effort, its symbolism also very assiduously concealed, was if anything even less daring.

But the acquisition prize and instant celebrity status accruing to *American Gothic,* not to mention its destiny to hang forever on the walls of the most prestigious art museum in the American Midwest, must have given its maker encouragement to continue in this vein.*

The community of conservative Protestants, into which Wood was born, had always been suspicious of art's propensity to deceive and entice. Yet, in spite of their vigilance, from 1932 forward, Wood began to incorporate homoerotic symbols into his work with something like impunity. We will see shortly how blatant his symbolism became as his career progressed, and, as he gathered his nerve, how broad was the space between

deception and detection a thoroughly blind community provided him.

But as far as Dennis could see, *Arbor Day, Spring Turning, Fall Plowing, Young Corn, Haying,* and *New Road* were all cheery Iowa scenes, peopled by innocent farm folk plowing rich, dark soil under clear blue skies, all of it a profusion of bucolic subjects and luxurious meadows newly planted in corn.[1]

Dennis, however, sees a problem. After describing how the introduction of machinery and the trend to larger farm size and greater yields contributed to the farm crisis that followed hard upon the prosperity of the 1920s, and how, in the years 1931 to 1935, the Iowa farmers were struggling desperately with the Depression and its harsh effects, Dennis wonders why, if Wood were intent upon glorifying the rural landscape, his paintings of agrarian scenery were so "painfully paradoxical."[2]

Dennis does not draw from this astute observation that the difficulty lay not with Wood, whom he sees as "driven by loyalty to the regionalist principle of interpreting . . . an idealistic vision of the landscape that poeticized [the] agrarian myth," but with his own misapprehension of Wood's fundamental purpose.

I suggest that Wood's idea in *Arbor Day* was to simply play a pun on his surname. Wood is, of course, what trees—arbors—are made of. And, if one's name were Wood and one were in the mood for fun, one could go prospecting for the word and

---

* Wood submitted *American Gothic* to the annual exhibition of American Paintings and Sculpture at the Art Institute of Chicago, where after some controversy among the jurists, it was admitted and awarded the Norman Waite Harris Bronze Medal and a $300 prize. (The Friends of American Art bought the painting for $300.) See Corn, *op cit.*, p. 131.

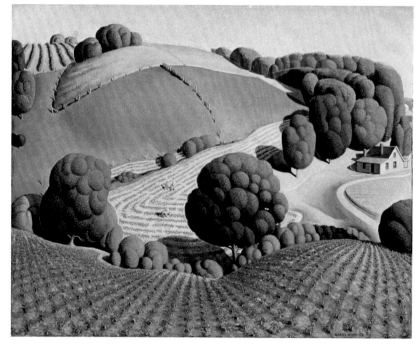

*Arbor Day*, 1932. Oil on masonite panel, 25 × 30 in. (Private Collection)

*Young Corn*, 1931. Oil on masonite panel, 24⅛ × 30 in. (Cedar Rapids Museum of Art, on loan from the Cedar Rapids Community School District Collection)

find it everywhere, in a wide variety of uses, and see a second meaning in each, according to one's peculiar bias. The phrase "Can't see the wood for the trees," meaning one who is too wrapped up in details to gain a view of the whole, comes quickly to mind.*

But for a man in the middle of his life, still conflicted about his sexuality, the choices were many and rich in double entendre:

> *"In the middle of the journey of our life, I came to myself within a dark wood where the straight way was lost."*
>
> —Dante (1265–1321),
>  *The Inferno*, canto I, l. 1

> *"Is not old wine wholesomest, old pippins toothsomest, old wood burn brightest, old linen wash whitest? Old soldiers, sweethearts, are surest and old lovers are soundest?"*
>
> —John Webster (ca. 1580– ca. 1625),
>  *Westward Hoe*

> *"Demetrius: Or, if thou follow me, do not believe but that I shall do thee mischief in the wood.*
> *Helena: Ay, in the temple, in the town, and the field you do me mischief. Fie, Demetrius! Your wrongs do set a scandal on my sex. We cannot fight for love as men do. We should be wooed and were not made to woo."*
>
> —William Shakespeare (1564–1616),
>  *A Midsummer Night's Dream*

> *"Two evils, monstrous either one apart Possessed me, and were long and loath at going: A cry of Absence, Absence, Absence, in the heart, And in the wood the furious winter blowing."*
>
> —John Crowe Ransom (1884–1974),
>  *Winter Remembered*

---

\* First appearance 1546 in John Heywood's *A Dialogue Conteynyng the Nomber in Effect of all the Prouerbes in the Englishe Tongue*: "I see, ye can not see the wood for trees." And a few years later, in 1583, Brian Melbancke, in *Philotimus: The Warre Betwixt Nature and Fortune*, wrote: "Thou canst not or wilt not see wood for trees."

*"I shall be telling this with a sigh*
*Somewhere ages and ages hence:*
*Two roads diverged in a wood, and I—*
*I took the one less traveled by,*
*And that has made all the difference."*

—Robert Frost (1874–1963),
*The Road Not Taken*

I do not suggest that Wood referred to these passages in particular, but being well read, only to usages like them, in general.

According to the *Oxford English Dictionary*, the word "wood" is also used synonymously with anything made of wood, such as the shaft of a tool. It was once also used as a verb, to grab a pitchfork by the wood.

There are in the literature numerous observations upon the pitchfork in *American Gothic*—the artist had originally envisaged the farmer holding a rake—upon its utilitarian significance and the "echo" of its three tines in the farmer's coveralls. But rake or fork, there is no mention anywhere of the fork's wooden *shaft*, which is what the farmer actually holds in his hand.*

To be "of wood" also carries the property of being dense or stupid. The word is, of course, also synonymous with faggot or with the loss of one's status in society, as to be sent to, or to take oneself to, the wood [shed]. The point is that, to this young, timid, highly intelligent man, his surname was seemingly ubiquitous and manifestly redolent of entendre.

In searching *Young Corn* for meaning, I surmise that Wood may have embedded his "message" in the wood growing in the hedgerows, not in the young corn growing in the fields: fields with hedges or pollards such as those shown were the bane of farmers, who referred to such fields as "wood-bound," a term that for Wood would have impounded sexual overtones.

Be all that concerning "wood" as it may, corn, because of the erect phallus shape of its ear and its coincident role as a crop synonymous with all things Iowa, was to be Wood's most ubiquitous homoerotic symbol, a symbol so serviceable he must have privately reveled in his freedom to deploy it. As we have seen, Wood placed eleven ears of corn standing implausibly erect as the unifying motif in the *Corn Room Chandelier*; other forms appear variously throughout Wood's career as young shoots (*Young Corn* and *Stone City*), harvested stubble (*Arbor Day*, *Spring in Town*), or in stacks of stover, which were gathered in the fall and left to dry through the winter (*Fall Plowing*, *January*).

In the same way a farmer might record the weight of the year's crop or a hunter the number of trophies bagged, references to the harvest might for Wood count sexual partners metaphorically "harvested." The corn shocks over his mother's shoulder in *Woman with Plants* would by this interpretation be references to the prior season's "crop" taken, but "behind her back," out of her notice, even while he was in her house. That *Young Corn* and *Arbor Day* illustrate students' activities reveals an interest in children, expressed perhaps pruriently through the metaphor of preparing for the year's new "crop."*

There are other, more subtle subjects underlying his interest in the harvest motif, namely that in those days some goodly portion of the grain harvest, which was a man's occupation, invariably led to the production of home-distilled whiskey. In early twentieth-century America, the political and social suppression of this habit could either be framed as a conflict between country and city people, Republicans and Democrats, or men and women. More about alcohol and Wood's interest in it as object of desire and subject for art, later on.

We have seen how Wood, post Munich, had impounded homoerotic symbols into almost all his work and how, risking discovery, he had tempted fate. All this came to a crisis in 1939.

Wood divorced Sara Sherman Maxon, his bride of three short years. In the same *annis*

* Byron McKeeby, Wood's dentist who posed for *American Gothic*, had exceptionally large hands. Wood is supposed to have remarked upon seeing them: "You know what that is? That's the hand of a man who can do things!" Cited in Thomas Hoving, *American Gothic: The Biography of Grant Wood's American Masterpiece* (New York: Penguin Books, 2005) p. 41

* Without doubt, references to schoolchildren, both *Arbor Day* and *Young Corn* were commissioned by, and today the latter still belongs to, the Cedar Rapids Community School District, where Wood first attended and later taught.

*Haying*, 1939. Oil on canvas on paperboard mounted on hardboard, 13 × 14¹³/₁₆ in. (National Gallery of Art, Gift of Mr. and Mrs. Irwin Strasburger 1982.7.1)

*New Road*, 1939. Oil on canvas on paperboard mounted on hardboard, 13 × 14¹⁵/₁₆ in. (National Gallery of Art, Gift of Mr. and Mrs. Irwin Strasburger 1982.7.2)

*horribilis*, a faculty member at the University of Iowa in Iowa City, where Wood taught, lodged a complaint against Wood, demanding his dismissal.

Corn notes that, in 1940, Wood "takes a year's leave of absence . . . to escape controversy over his position at the school," but she demurs in the nature of the "controversy." Dennis writes that Wood was "experiencing a period of domestic stress and departmental strife at the University," in response to which, in Dennis's euphemistic choice of words, Wood "allowed the winter season—cold, dark and barren—to enter his landscapes."[3]

In a footnote, Dennis cautiously elaborates: "Painter-illustrator Fletcher Martin . . . accused Wood of tracing photographs [and of] training his students to paint as he did in order to . . . utilize their work [in] his paintings. [Lester] Longman [also] disparaged Wood's ability . . . and accused Wood of over publicizing himself. Such personal attacks led to a . . . compromise solution [in which Wood would be permitted] to teach in accordance with strict, academic guidelines."[4] For sources, Dennis cites "letters, memoranda, reports and typescripts of interviews, dating from January 26, 1940 to June 28, 1941," still in University of Iowa files. I presume that Corn and Dennis, both looking for something important, very carefully read all the same documents.

But in their final distillation of these events, Corn and Dennis are overly circumspect: they both knew it is implausible that either "tracing" or Wood's "homespun, Regionalism and idiosyncratic teaching methods [that] came into conflict with a progressive vision for the program favored by the proponents of international modernism"[5] were the basis for all this controversy, let alone for his dismissal. But because neither would dare speak its name, and because the details of it all are not in the file, that is where Corn and Dennis leave the matter.

Corn and Dennis are empirical art scholars; without documentary proof, they would not conclude what was really at issue. But I will hazard a guess: the details are not in the file because in the American Midwest of 1939 to 1940, to be *charged* as a homosexual was tantamount to treason or heresy, sedition, blasphemy, larceny, profanation—and all these were as nothing compared

to being found *in* flagrante delicto for that most heinous of sins.*

In a plea for his life, and probably confronted with corroborating hearsay evidence, Wood made the conventional bargain: if the file were left silent on the charges, he would volunteer to accept a "leave of absence." His executioners were only too willing: how could they have brought such a charge (or God forbid, even *thought* of it) without the appearance of complicity? Justice would have required proof and gathering proof exposes those who would root out sexual deviancy to admit that they are luridly fascinated by what they profess to loathe. Wood left to "spend more time with his family." He did return for a spell, but he did not stay; and he was unreconstructed.

Since his death in 1942 everyone interested in Grant Wood and the details of this watershed incident has looked high and low for proof and found nothing. Even as far along in our collective cultural evolution as 1975—the date of Dennis's publication—and 1983—the date of Corn's—the charge could not be made, nor the word written, without proof. And while, in 1940, it could not be allowed even to appear in his file, and, in 1975 to 1983, it could not even be alleged, Wood had put ample evidence of his sexual orientation into his work.

In *Haying*, 1939, Wood presents a pretty little farm scene, its hills and valleys patterned with windrows of freshly cut hay. A barn, a hay rake, and a windmill stand atop the meadow in the distance; a little stoppered jug sits inconspicuously, but in the foreground.

The English word "libation," derived from *libare*, to taste, shares a root with the Latin *liber*, the word for "free." That Wood, given his travails in 1939, longed to taste freedom is without question this picture's theme: then, as in Roman times, the urge to take a drink, and the desire to be free of one's troubles, both arise from the same basic impulse.

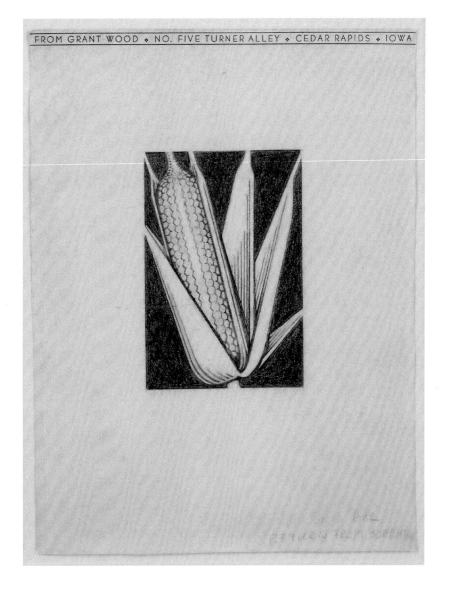

FROM GRANT WOOD ◆ NO. FIVE TURNER ALLEY ◆ CEDAR RAPIDS ◆ IOWA

*Corn*, ca. 1939. Pencil on paper (Grant Wood's personal stationary), 9¹/₂ × 7¹/₂ in. (Estate of Thomas Seth Holman, Courtesy of Childs Gallery, Boston)

In *New Road*, 1939, Wood presents another seemingly pleasant landscape, an intersection of country roads passing through Iowa farmland. A barn with a windmill stands at the crossroads; a sign in the foreground reads: "SOLON 5 MI . . ."

The first picture conveys a clear sense of "making hay while the sun shines," while the title of the second has a plausible antecedent in Robert Frost's "The Road Not Taken," 1916. There is a strong implication from the two paintings taken as a pair that we are to infer Wood is "at a crossroads" and will soon look for new opportunities. As such, *Haying* and *New Road* appear as statements from an unreconstructed sinner.

Even though Solon is ten miles from Cedar Rapids, a sign in *New Road* reads: "SOLON 5 MI . . . ," leading me to wonder if he attached

* In seeking in 1939 to dismiss Grant Wood for homosexuality, the faculty at the University of Iowa was not unique. Harvard University recently discovered a secret disciplinary file of over 500 pages from 1920 dealing with the expulsion of one teacher and eight students under suspicion for being gay or associating with gays. See "In Harvard Papers, a Dark Corner of the College's Past," *New York Times*, November 30, 2002, p. A13.

some significance to the cardinal number five, and I suggest that he did.

In 1924 Wood converted the carriage house behind the Turner Mortuary, which had no proper address, into a one-room apartment that he referred to as "5 Turner Alley." In *Return from Bohemia* Wood includes, in addition to himself, five figures. In *Trees and Hills, Autumn Oaks*, 1933, he presents a grouping of five oak trees. In *Village Slums*, footprints in the snow leading to the pump at the center of the square form a pattern like the five radiating fingers of a hand. And in a little drawing of a partially shucked ear of corn the leaves have been pulled off to resemble the five "fingers." Wood's fascination with the cardinal number 5 was a sly metaphor for the hand. Or, as in the little drawing of a single ear of corn, in 1939, at the lowest point in his professional and personal life, out of a job and run out of town in disgrace, he employs the hand and five fingers as a metaphor for masturbation, *i.e.*, self-sufficiency.

*Fall Plowing*, 1931 (The John Deere Collection, Moline, Illinois) conveys a sense of cutting open the earth for the new crop. Cutting, as with the ax in *Parson Weems' Fable*, 1939, has, since Roman times, symbolized intrusive entry—the Latin *caesus*, from which derives "Caesarian section."* Little George Washington, felling his father's cherry, has made a surprisingly fresh wound with his extravagantly sized, red-painted hatchet, all ideas—felling, cherry, red, and cutting—vulgarly associated with the metaphorical taking of virginity.

The figure of George brandishing his ax has been called "castrating." But, in the Freudian sense, it isn't only women who commit this outrage upon their sons. Young men aspire to their fathers' power and authority, the basis for which is the phallus.[6] Fathers, who, in one way or another, withhold from their sons the succession of power, are also said to be castrating.

George confronts his father, and never was a more virile father figure painted in American

* *Plowing on Sunday*, 1938, in which a farmer in overalls swigs from a jug, was also drawn during Wood's tempestuous marriage.

art, with his red coat, his legs spread akimbo, his feet planted with confidence, his gestures assured and authoritative, his maleness jutting proudly from his tight breeches: he fairly brims with it. Wood is retailing the early loss of his own father, a man he barely knew but clearly one to whom he would impute great force and power. The father asks here not for the son's contrition but to oblige him to yield back the instrument with which he did the cutting.

The father and his son, the penultimate protagonists after Weems, who stands in the proscenium, occupy the picture's center, indicating their centrality to the artist's message. The house and landscape comprise a zigzag pattern, over which darkened clouds hover ominously; more about the zigzag later on. Two black slaves, neatly dressed

and picking cherries off a tree just like the one George just cut down, make their only appearance in Wood's work, and therefore, deserve our close scrutiny.

George and his father, and the Parson's famous fable after which the picture is titled, are plants, standing in for Wood's main message, which is the slaves in the background, or more particularly an arrangement about their status as fully enfranchised citizens underpinning Franklin D. Roosevelt's New Deal.

The thirteenth, fourteenth and fifteenth Amendments to the Constitution, adopted between 1865–70 during Reconstruction, the so-called Reconstruction Amendments, outlawed slavery in the US, granting due process and equal protection to all persons born or

*Parson Weems' Fable*, 1939. Oil on masonite panel, 38³/₈ × 50¹/₈ in. (Amon Carter Museum of American Art, Fort Worth, TX, 1970.43)

*Village Slums*, 1936–37. Charcoal, pencil, and chalk on paper, 20 1/2 × 18 in. (Smithsonian American Art Museum, Washington DC, Gift of Mr. and Mrs. Park Rinard, Falls Church, VA)

*Self–Portrait*, 1932–41. Oil on Masonite, 14 1/2 × 12 in. (Figge Art Museum, Davenport, IA. Museum Purchase with funds provided by the Friends of Art Acquisition Fund, 1965.1. Image Figge Art Museum, successors to the Estate of Nan Wood Graham/Licensed by VAGA, New York, NY)

naturalized in the United States, including former slaves. The amendments guaranteed that African American males could not be denied the right to vote. But the repertoire of new ideas concerning equality that were adopted during the so-called 'era of experimentation' would not have been possible had it not been for the willingness of southern Democrats to vote for these laws, which they did with the understanding that the federal government would not intrude upon state laws put in place expressly to deny blacks these very rights. Consequently, black men, and much later women, the ostensible beneficiaries of these amendments, were obliged to wait two and even four generations before realizing even the shadow of any benefit from them.

Southern legislators, realizing that their agrarian and racial interests were intertwined, saw in FDR's New Deal an unparalleled opportunity to bring federal money to the south, which they would spend to maintain racial inequality on southern farms. The *quid pro quo* gave each side what it wanted: northern legislators got the appearance of change written into the constitution and southern legislators, with no grounds to believe that anything would ever be done, in fact, to threaten segregation and white political domination, got a federal commitment to maintain the *status quo*.[7]

In 1933, the year Franklin D. Roosevelt was inaugurated, racial segregation seemed secure; the country's political class had come to terms with a system of differentiated citizenship based upon a system in which southern employers could continue to draw without interference upon the still-enormous supply of inexpensive and vulnerable black labor.[8] Grant Wood was horrified by this iniquitous situation and by the Democrats'

*January*, 1940. Oil on masonite
panel, 26³/₈ × 32⁷/₁₆ in.
(Cleveland Museum of Art,
J. H. Wade Fund, 2002.2)

despicable political solution for it. *Parson Weems'
Fable* is his testimonial.

The windmill is Wood's most personal symbol.
His frequent use of it, no matter how appropriate
to rural Iowa, elevates the windmill to the level
of a signature, musical phrase, or trademark, well
above its utility as a mere prop.

The windmill has a number of attributes —
pumping, blowing, sucking, turning, as in, to
rotate to reorient position — that would qualify it
for a range of homoerotic analogies. Windmills,
in consequence, often appear more than once
in a single composition. They are never in the
foreground but usually on the distant horizon or
partly concealed, as if hiding or coyly peeking
out from behind trees. If, in his pictures, Wood
deploys the windmill as a presence synonymous
with himself, then he indicates that he is some-
times a distant presence, a passive agent in the
main action, or even a voyeur. In *Self-Portrait*,
1932–41, Wood gives to the windmill billing nearly
equal to his own visage.* The significance of his
outfit, a plain blue shirt but without overalls, we
will get to shortly.†

The hand pump, with four appearances, is
cousin to the windmill and shares its attributes,

* Nan Wood Graham noted that "windmills were so much a part of
Grant's life that he decided to use one as his trademark," quoting
him as having often said: "The Old Masters all had their trade-
marks, and mine will be the windmill. Wherever it is feasible to use
it, I will." *See* Wanda Corn, introduction to *My Brother, Grant Wood*,
by Nan Wood Graham with John Zug and Julie Jensen McDonald
(Iowa City: State Historical Society of Iowa, 1993).

† In the preliminary *Sketch for Self-Portrait*, 1932, Wood presents
himself wearing overalls, implying that at this stage of the work
he is still in character.

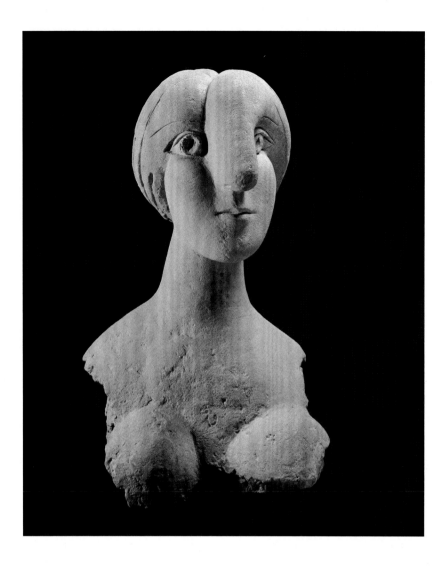

at first, appear to make an important statement in the composition.

But rabbit tracks make a very important statement in *Village Slums* and in *January*, 1940, where they do not ramble listlessly across the composition but according to some unknown design, aligning the rabbit's route with the grid-like layout of the corn shocks lined up in rows like tents in a bivouac. The tracks come from the upper right corner of the field, zigging 90 degrees this way and zagging 90 degrees that, and finally disappear into the dark, inverted V-shaped door of the tent closest to the viewer.

Art historians never fail to mention the rabbit tracks in *January*, but always as subordinate to the grid made by the stacks, or to the verisimilitude of the rural winter scene, or like Hokusai's cresting wave, to the decorative quality of the snow blown horizontal in the wind. They are, critics maintain, just a "light-hearted note from an artist beloved for his wholesome, down-home sense of humor." If that were so, the rabbit tracks are a blatantly gratuitous feature of the composition.

In a letter to King Vidor, who had just bought *January*, Wood speaks of the harsh Iowa winter depicted in the scene. But he closes by saying that the rabbit tracks are "a piece of symbolism with which I had some fun."

Symbolism? If, at the end of his career, Wood was, by his own admission, using symbolism in his work, it was *January* that convinced me to look more closely at his entire oeuvre.

In *January*, the rabbit tracks form the outline of an unmistakable phallic symbol known to every subway graffiti artist. Tracks, as any reader of detective stories knows, are evidence of criminal activity; phallic tracks in the snow that lead into a hole in the corn stack—the "corn hole"— betray evidence, in Iowa, of homosexual activity conducted, because it was literally criminal, in secret, at night.

Taking the reading one step further, the snow in *January*, the month that takes its name from Janus, the Roman god of beginnings and endings, serves as a metaphor for renewal, as from his troubles, in 1939 to 1940, with his peers at the university. If then, the subject of *January* is purely symbolic and not a "formal superimposition of order and repetition onto the untidy agrarian

listed above; it also supplies sustenance for life and is, as such, applied daily. In *Dinner for Threshers*, there is one in the kitchen standing passively off to one side, another stands in the yard outside the schoolhouse in *Arbor Day*, and one more in the dooryard of *The Birthplace of Herbert Hoover*.

In *Village Slums*, 1936–37, however, a hand pump occupies the center of the village square at the center of the composition, an indication of its centrality to Wood's subject. Because it is winter, we see in the snow the footprints of those who have used the pump and the outhouse—which is to say everybody's—neatly etched into the snow in the shape of an outstretched arm and hand with five fingers, a reference to masturbation. There are also rabbit tracks leading not to the pump, for which the rabbit has no use, but, seemingly at random, from one house, at the left edge of the picture, to another, across the way. They do not,

landscape of rural Iowa" or Wood's interpretation "of the orderly arrangement of corn shocks dotting the Iowa winter landscape,"[9] its message becomes something quite different from the canonical interpretation. It is that, in January, no matter what else is going on in the dead of night in Depression-era Iowa, the phallus makes its customary rounds.*

Phallic symbols are nothing new in art. Charles Demuth shamelessly deployed them as did Marcel Duchamp, Joseph Stella, and Marsden Hartley, to name only a few. Pablo Picasso draped one over a portrait of his young lover Marie-Thérèse Walter. In spite of his biographers' refusal to acknowledge this well-established tradition, Wood was in good company in his early use of them.

Still, there is, in the extant Grant Wood literature, no reference to the similarity of rabbit tracks to the phallus or, for that matter, of his aunt's extravagantly long neck and anatomically intriguing throat in *Victorian Survival*, 1931, her tightly coifed hair parted like the cleft of the glans penis. I am certain Barbara Haskell and Richard Meyer, who both now state that Wood was gay with no more justification than Robert Hughes had for doing so, can see that Picasso used phallic symbols. But when faced with the same symbol in the work of Grant Wood, they follow in the tradition of all Wood's biographers and they too demur. Meyer, who admits he only learned that Wood was a homosexual in 2011 and that before then he had never thought much about Wood's sexuality at all, and who until now had accepted Wood's "anti-modernist commitment to realism," and who now denies that Wood put signs of his sexuality into his art, writes: "Wood's sexuality — and the complex way in which it was concealed and revealed — cannot be taken as a transparent mirror or bedrock explanation of his art."[10] He goes further: he states that "it is not Wood who has 'gone gay' but we who made him do so!" How could he possibly have missed seeing the resemblance — which, once seen, cannot ever again be ignored — to the phallic shape (again, in outline) of the dreadfully long, glabrous neck

*Adolescence*, 1940. Oil on masonite panel, 20³/₈ × 11³/₄ in. (Anonymous Collection)

* Never noted in the literature, corn stubble, after the fall harvest, comprises one stalk every six inches or so in a row, not groups of three cut stalks resembling a *W*, as Wood depicts it here.

Victorian Survival, 1931.
Oil on composition board,
32¹/₂ × 29¹/₄ in. (Reproduced
with permission from the
Carnegie-Stout Public
Library, Dubuque, Iowa;
acquired through the
Library's Lull Art Fund)

Corn comes perilously close to seeing a phallus in *Victorian Survival*: "Around her exceedingly long neck, a black ribbon, tight and taut, throttles her pronounced muscles . . . one bare hand clasps the other in a pose that signifies feminine politeness but also hides the lower body . . . Overall, the torso proclaims 'Do not Touch.' On [the] table sits an open-mouthed telephone, stretching like a daffodil to the sun inviting the woman to pick it up, hold it, and talk into its mouthpiece . . . it is everything the woman is not . . . outgoing and alive while she is reserved and repressed . . . it begs for her attention. The anthropomorphic shape and the anatomy of the black-clad matron mimic one another . . . Both have heads, long necks and black torsos. . . This correspondence suggests intercourse between the two of them, but one that will never be consummated."[12]

Corn was on track to take Wood's message *exactly*, but she veers off this course, seeing in *Victorian Survival* not a phallus or carefully qualified gender ambiguity but an "amusing confrontation" between a spinster and modern technology. In *Adolescence* she describes another amusing confrontation between two, older, wiser "chickens" and an adolescent.

Telephones do have long necks, black torsos and anthropomorphic mouthpieces. But Iowa chickens, whether young or old, male or female, do not, when alive, ever stand thus erect, day or night, completely featherless on rooftops; and perhaps we have not paid sufficient attention to these birds' feet and menacingly sharp toenails, or to the way the one in the center holds his/her wing folded up in a double zigzag, about which more in a moment. All in all, Wood's title *Adolescence* would seem to refer to some other properties of the bird, as he is so improbably presented, besides his tender age.

Since time out of mind, a "chicken" is a timid or cowardly person, a recruit, or any young man who appears to his seniors to have potential as a homosexual partner.[13] But it was Horst W. Janson who pinpointed this particular chicken's origins.

While pursuing his graduate degree in art history, 1938 to 1941, Janson taught at the University of Iowa, where Grant Wood was chairman of the art department. According to local lore, Janson, a progressive, is rumored to have taken his art students to Chicago to a Picasso show,

of the startled young cock who stands featherless and erect between two orb-like sentries, one to either side, in *Adolescence*, 1940?*

Writing in 2005, Corn gingerly proposes that one of Wood's most carefully encrypted compositions, *Daughters of Revolution*, 1932, might include a phallus or two. She writes: "The heads and necks are like asparagus spears or more wickedly, like fleshy phalluses. The sexual metaphor is not far fetched given the way Wood shaped the three noses, particularly the two on the left side that look decidedly like the male member."[11]

* Dennis sees in Adolescence ". . . a fledgling rooster, pecked down to his pin feathers . . .[rising between two hens], stretching an extra-long, perfectly erect neck straight into the dark sky." But he leaves it there. Dennis, *op. cit.*, p. 120

thus drawing the ire of the chairman, a traditionalist. Notwithstanding this apocryphal incident, in 1955, long after Wood's death, Janson wrote a fair deconstruction of *Adolescence* titled "The Case of the Naked Chicken."

The author cites as the source for the picture's singular iconography a chiaroscuro woodcut of *Diogenes* by Ugo da Carpi (ca. 1480–1520), itself after a painting by his Florentine contemporary Parmigianino (1503–1540). In the woodcut, a rooster, standing on his feet, plucked of all his feathers, is unmistakably similar to the one in *Adolescence* except that Wood, four hundred years later, has elongated and stiffened the rooster's already improbably, elongated neck.[14]

It is unlikely that Grant Wood would have independently conceived this queer bird and then gone into the literature, looking for an antecedent. But had he, a seasoned art historian, been interested in Diogenes, in his research of the philosopher he may well have serendipitously found Parmigianino's (or da Carpi's) naked cock and adopted it for his own use. But why would Wood have been interested in Diogenes?

Diogenes of Sinope (ca. 412–323 BC), also known as Diogenes the Cynic (the Greek word *kynikos*, or dog-like, from which we derive the English word "cynic") was a celibate Greek philosopher and a beggar who made a virtue out of extreme poverty. He taught contempt for human achievements, social values, and institutions and, in keeping with his teachings, made his home on the streets of Athens. Diogenes believed that human beings, who he said live hypocritically, would do well to study the dog, which, besides performing its natural, bodily functions in public, will eat anything and make no fuss about where to sleep. Dogs, he mused, have no use for the pretensions of abstract philosophy and know instinctively who is friend and who is foe. They make a cult of indifference and, like dogs, eat and make love in public, go barefoot, and sleep in tubs and at crossroads.[15]

Diogenes was supposedly exiled (from what is now Turkey) for "adulterating the coinage." Diogenes's mission in Athens, his new home, became the metaphorical adulterating/debasing of the "coinage of custom," which, he alleged, was the false coin of human morality. Instead

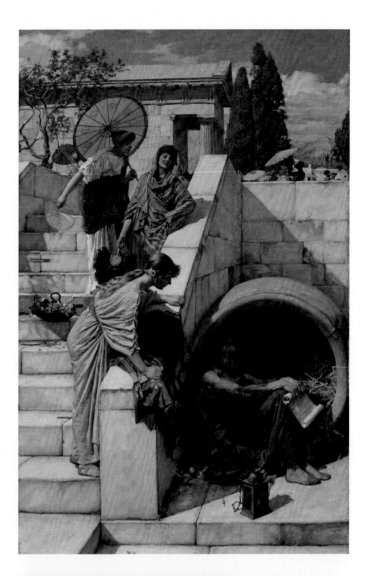

John William Waterhouse (English, 1849–1917), *Diogenes*, 1882. Oil on canvas, 208.3 × 134.6 cm. (Art Gallery of New South Wales, Sydney, Purchased 1886)

Jean-Leon Gerome (French 1824–1904), *Diogenes*, 1860. Oil on canvas, 29⁵/₁₆ × 39³/₄ in. (Walters Art Museum, Baltimore, by Bequest from Henry Walters, 37.131)

*Midnight Alarm*, 1938.
Lithograph, 21 × 17 in. (Cedar
Rapids Museum of Art,
72.12.42)

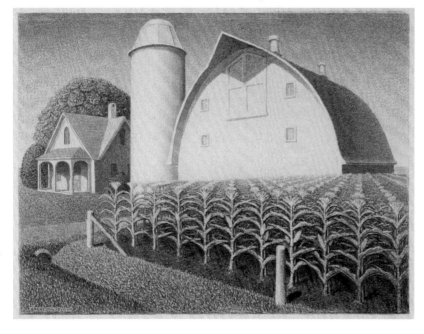

*Fertility*, 1939. Charcoal on
board, 18 × 24 in. (45.7 ×
61 cm). (Courtesy Crystal
Bridges Museum of
American Art, Bentonville,
Arkansas. Photography by
Dwight Primiano)

Quoting Plato, who gave Socrates's definition of man as a "featherless biped," Diogenes famously plucked a cock and flung it into Plato's Academy, saying, "This is Plato's man," after which the words "with broad flat nails" were added to Plato's definition.

Diogenes's interest in Plato, for whose abstract philosophy he had contempt, was obviously complex, but for my purposes here, it comprised the concept of Platonic love, which focused partly on the beauty of a person's character and intelligence. More to the point, Plato belonged to the community of men who desired young boys, with whom they engaged in erotic, pedagogic "friendships." The concept of Platonic love thus contrasted mundane, sexually expressed pederasty with a philosophic—or chaste—pederasty. (The hypocrisy of the Miss America pageant comes to mind.) Pederasty, or sex between men and boys, was considered at the time to be just another form of human sexuality, not a moral or civil crime.[17]

All in, it is not difficult to understand what about Diogenes and Plato and pederasty appealed to Grant Wood, and he invested the naked cock in *Adolescence* with the lot of it.

In 1955, Janson, himself a seasoned art historian, recognized the source for Wood's *Adolescence* as an updated, satirical illustration of Plato's bipedal man. But in view of Janson's presence at the University of Iowa and, shall we assume, his knowledge of the grounds for the "controversy" surrounding the famed Regionalist, not to mention his legendary enmity for Grant Wood, who, fifty-five years after its first publication in 1962, goes conspicuously *unmentioned* in seven editions of Janson's ubiquitous "History of Art," he just as astonishingly missed—or chose not to write about—the implications inherent in Wood's adaptation to a homoerotic theme of "the featherless cock with broad flat nails." For that, we must explore Janson's own source for the discovery, in which we find two more clues about Wood's carefully encrypted symbols: the cameo and the horse-drawn chariot.

Janson probably drew from an article by Rudolph Wittkower, who, with Edgar Wind, wrote a critical analysis about a certain bust by Donatello (born Donato di Niccolò di Betto Bardi, ca. 1386–1466) of a *Youth in the Bargello*

of being troubled by what is really evil, people make a big fuss over whatever is in fashion as conventionally evil. When asked how one should avoid the temptation to lust of the flesh, Diogenes began masturbating. Rebuked, he replied, "If only I could soothe my hunger by rubbing my belly." It is said that he used to stroll through the Agora at full daylight with a torch (or, as legend sometimes has it, a lantern), "looking for an honest man."[16]

*with an Emblem of Platonic Love.** The youth wears a cameo emblazoned not with precious stones, in accordance with the classic tradition, but with a naked putto holding a whip and driving a winged chariot drawn by two horses, an image more in sync with the growing tastes of the Renaissance and its new conception of Antiquity. According to Wittkower, young men never wore such ornaments. But by increasing its size and putting the cameo on the boy's throat, Donatello emphasizes the symbolic meaning of the scene.

Wittkower notes that the bust—*ca.* 1440— originally belonged to Cosimo de' Medici, who, with his friends, were filled with enthusiasm for a revival of Platonic (i.e., pederastic) love, lending support to the interpretation of the bust as an invocation of the passage in Plato's *Phaedrus*, where winged genii on chariots driving horses with whips are symbols of the madness of love for beautiful boys.[18]

It is completely implausible that an avowed Midwestern Regionalist "driven by loyalty to the regionalist principle" would have found it necessary, let alone appealing, to rely in his work on such obscure, classical antecedents in order to present "an idealistic vision of [the] agrarian myth."[19] Surely, Wood reaches for something purposely arcane, but still, where would he have found these subjects?

Rudolph Wittkower and Edgar Wind were interdisciplinary art historians specializing in iconology of the Renaissance era. They were both members of the Warburg School of art historians, as was H. W. Janson, and all lectured frequently in Grant Wood's backyard: at the University of Chicago. Wind is best known for his research in allegory and symbolism, especially the use of pagan mythology during the fifteenth and sixteenth centuries, and for his book on the subject, *Pagan Mysteries of the Renaissance.*

Wittkower's publication of "A Symbol of Platonic Love in a Portrait Bust by Donatello" appeared in the *Journal of the Warburg Institute* in 1938, two years before Wood's painting of *Adolescence* 1940, an enticing lead. But Wood's art education was not entirely derived from Wittkower's article.

John William Waterhouse (English, 1849– 1917) was a member of the Pre-Raphaelite Brother-

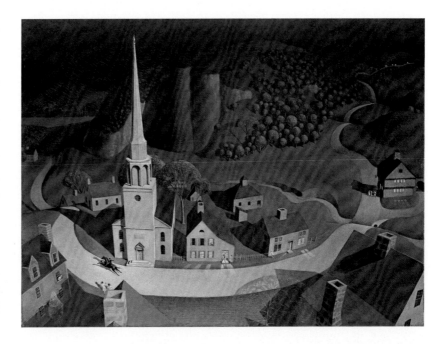

hood, most famous for his paintings of characters from classical literature. Waterhouse also painted a picture of Diogenes, with his lantern and his diet of onions, living in an overturned cask on the streets of Athens. The cask may have some other significance to Waterhouse, but whatever else it is, it forms a large, black hole near the center of the composition, where Diogenes, a "confirmed bachelor," sits oblivious to the three pretty young women petitioning him.

A Diogenes-like figure makes an appearance in Wood's lithograph *Midnight Alarm*, 1940, in which a man dressed in his pajamas and holding a lantern descends a stair, in search, perhaps, of an honest man. But the prominent "black hole," in which Waterhouse and Gerome both present Diogenes, makes many other appearances in Wood's work.

We are beginning to see that Wood grew bolder in his deployment of the phallic symbol toward the end of his life. And his most daring iteration came in the form of a silo standing innocuously and erect between a house and barn in *Fertility*, 1939.*

*Midnight Ride of Paul Revere,* 1931. Oil on masonite, 30 × 40 in. (Metropolitan Museum of Art, Arthur Hoppock Heran Fund, 1950)

---

* Dennis also cites this article but draws different conclusions from it.

* Milosch, *op. cit.*, p. 107, sees theatrical, female, religious, and agrarian forms in *Fertility*, a "tribute to shape, textures and motifs that Wood embraced, the proscenium arch, formed by the silhouette of the pregnant barn, the rocket-shaped silo which performs like a bell tower, the barn as an agrarian cathedral . . ."

finally, as if the title alone would not serve, the inclusion of a field of corn, its ears in tassel—the peak of male sexual potency—resembling a bed with an Amish coverlet thrown over it, brings the symbolism to completion.

The presence in *Fertility* of a culvert beneath the driveway to the house could be just a normal feature of this little farm that Wood simply included because it was there. But when such a feature appears over and over again in an artist's work, one begins to suspect that it signifies something other than a device for channeling water. In fact, the "black hole," taking the form of either a culvert or sewer, or an open cask, or a dug hole, a chimney opening, a door or window, a cleft made by a plow or ax, appears fourteen times in Wood's post-Munich work, beginning with *Memorial Window*, 1927–29; *Midnight Ride of Paul Revere*, 1931; *Fall Plowing*, 1931; *Arbor Day*, 1932; *O, Chautauqua*, 1935; *Spring Turning*, 1936; *Village Slums*, 1936–37; *Breaking the Prairie*, 1937; *Honorary Degree*, 1937; *Fertility*, 1939; *In the Spring*, 1939; *Parson Weems' Fable*, 1939; *January*, 1940; and *March*, 1941.

The "black hole" was Wood's addendum, a fillip if you will, to what had become his standard phallic symbol. I suggest, because of his interest in Platonic love and Diogenes, Wood borrowed Waterhouse's (or Gerome's) large-black-hole symbol and incorporated it into *Fertility*. I also suggest that Wood began his inquiry into the ancient iconography of Platonic love as early as 1929 and placed his cameo at the throats of his mother and sister in *American Gothic* and *Woman with Plants* just where Donatello placed it on his *Youth with Symbol of Platonic Love*. I further suggest that the image of the boy driving a horse-drawn wagon in *Arbor Day*, 1932, found its origins in ancient iconologies of boys with whips driving horses and chariots.

The narratives in *January*, *Victorian Survival*, *Fertility*, and *Adolescence* are plain and really need little explication. But most observers, believing Wood's intentions were a little catty but still in good taste, have misconstrued his intent, which is decidedly prurient, and his tone, which is emphatically dark. This is Wood not as fun-loving satirist but as ardent homoeroticist.

*Honorary Degree*, 1937. Lithograph, 16 × 20 in. (Cedar Rapids Art Museum, Gift of Harriet Y. and John B Turner II 72.12.27)

To compose the symbol, Wood makes use of a globe-like house/tree shape on the left and a round-top barn on the right, between which stands an erect silo, with its familiar roof cap at the top of the shaft as the glans. In a nod to Gerome and/or Waterhouse, he adds a culvert under the driveway, a little dark hole just where the anus in the symbolic male's anatomy would be. And

The telephone, which his aunt would grasp by its erect shaft and hold up to her tightly pursed mouth, is, like her own elongated neck and neatly cleft hair, precisely that to which Aunt Tillie would least want of anything in the world to be compared: the termagant as phallus.

At this late stage in his career, Wood experiments, and gets away with, conflating female and male gender characteristics because he directed his anger at both: first, chickens come in two genders and people automatically think of the one associated with eggs; and second, spinsters, irrespective of their sexual personae, *are* (or at birth were) women.

But the chicken in *Adolescence* is no hen, no "nubile Venus." The form, as every schoolboy knows, is the outline of the erect phallus and testis, which, like the rabbit tracks in *January* and *Village Slums*, emerge at night to make their depredations. Wood, once inhibited and coy, boldly lifts this motif from *Memorial Window*, *American Gothic*, and *Arbor Day*, and with confidence bordering on impunity, deploys it anew.

In *Honorary Degree*, Wood again borrows the form of a tall, Gothic window, first seen in *American Gothic*, rising in a "shaft" of light between the orbital heads of two attendant professors, one on either side. Wood goes further: he positions the three figures in a ménage a trois; one holds the "hood" also shaped like the Gothic window/phallus; the other holds the "degree" in the shape of a tube rising suggestively at an angle from Wood's groin. In a riot of self-deprecation, Wood positions his own face where the anus in the phallic symbol would be, as if to say: "Look at the asshole to whom they are giving this award!"

1 Dennis, *op. cit*, 201–206.

2 Ibid., 201–206.

3 Dennis, *op. cit.*, 201.

4 Ibid., 246.

5 Taylor, *op. cit.*, 92.

6 Taylor, *op. cit.*, 90.

7 Ira Katznelson, *Fear Itself: The New Deal and the Origins of Our Time*, (New York: Liveright Publishing Corporation, 2013), 156–168.

8 Ibid.

9 Dennis, *op. cit.*, 202.

10 Haskell et al, *op. cit.* 84–87.

11 Wanda Corn, *Grant Wood's Studio: Birthplace of American Gothic*, *op. cit.*, 126.

12 Ibid., 112.

13 *See* Webster's New World College Dictionary, 4th Edition, or Random House Dictionary of American Slang, 1994.

14 Horst W. Janson, "The Case of the Naked Chicken," *College Art Journal*, vol. xv, no. 2 (Winter 1955) 124–27, illus. 125.

15 http://en.wikipedia.org/wiki/Diogenes of Sinope

16 Ibid.

17 Ibid.

18 Rudolph Wittkower, "A Symbol of Platonic Love in a Portrait Bust by Donatello," *Journal of the Warburg Institute*, vol. 1, no. 3, 1938, 261.

19 Dennis, *op. cit.*, 201–206.

# Xenophobia in Twentieth Century America: Prohibition, the Pansy Craze, the Great Depression, and the Run-Up to World War II

I will explicate a few more homoerotic symbols and then expand my inquiry into the socio-political significance of the various objects Wood employed as symbols, his use of which came toward the end of his career. Some symbols I must treat briefly, but I am setting the stage for a more thorough analysis of the four or five most important.

Earlier, I noted that acorns appear behind the six soldiers in *Memorial Window* (1927–29). They appear again, most improbably but conspicuously, on the tree in the immediate foreground of *The Birthplace of Herbert Hoover*, 1931; quite naturally in *Trees and Hills, Autumn Oaks*, 1933; and dangling inexplicably like fruit ripe for picking in *The American Golfer: Portrait of Charles Campbell*, 1940. If, indeed, the acorn is an important symbol, its meaning is pretty obscure. And while he deployed it as early as 1925 to 1926 and as late as 1940, he used it only sparingly.

Wood's only post-Munich, pure landscape, *Trees and Hills, Autumn Oaks*, 1933, is impossible to fit into the conventional analysis of his mature oeuvre. But we can account for it if we make allowances for his penchant for punning on his surname, which leads him to his obsession with oak trees and acorns.

Clearly, in *Trees and Hills, Autumn Oaks*, this is a "wood" in the old sense of the word: "Where the trees do grow scattering, here and there one, so that these trees do not one of them touch an other;

such places are called woods, but they are not properly to be called couerts."[1] Or, if you like, had he wished to make a straightforward statement about oak trees, he would have observed that oaks are self-reliant, assertive of their individuality, and do not bend away submissively to accommodate others in the grove their fair share of the light.* If his intention had been either of these, there would be an elegiac quality to the subject and it would stop there. But there isn't and it doesn't.

More likely than either of these motivations, Wood enlists this grove of oak trees to invoke the cardinal number 5, as on the fingers of a hand, which we first saw printed in the snow in *Village Slums*, and the theme of masturbation. But what was there for Wood about the oak, in particular, and/or the acorn? Our inquiry takes us back again to Munich.

As a durable symbol of the strength and resilience of classical, humanistic German culture, Goethe's Oak Tree stood in his hometown of Weimar. In 1919, the Weimar Republic appropriated the oak tree—redolent of the poet's, and by association, the postwar society's will to protect basic liberties like freedom of speech and the press, equality for women, and voting rights for

*Cannoneer, War of 1812.* Drawing for *Memorial Window*, 1927–29. Charcoal, ink, and pencil on paper, 79³/₄ × 22³/₄ in. (Figge Museum of Art, Davenport, IA)

---

\* Wood is expressing a sentiment later noted in Robert Frost's 1946 poem "A Young Birch": "The only native tree that dares to lean, relying on its beauty, to the air. (Less brave perhaps than trusting are the fair.)"

*Trees and Hills, Autumn Oaks*, 1932. Oil on composition board, 31³/₈ × 37³/₈ in. (Cedar Rapids Community School District)

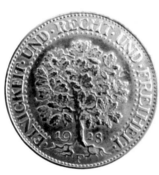

Germany, Weimar Republic, silver 1928 F-5 Reichs Mark coin. *Goethe's Oak* illustrated verso. (Collection the author; photo by the author)

all citizens—and illustrated it, verso on the new, five mark coin. When, in 1928, almost a century after the poet's death in 1832, Wood stopped in Germany to work on his war memorial window, he would naturally have seen Goethe's oak on the five mark coin, and being obsessed with the number five and being himself of the same liberal mind as the poet, he would have taken empathy with all its symbolic meanings.

But for Wood it was not just the tree, as the symbol for humanistic dogma, that caught his attention. The tip of the penis, called the glans, derives its anatomical name from the Latin word for acorn, so called because of the similarity of the way in which they emerge from their respective sheaths. If that is not enough, the German word for acorn, *Der Eichel*, is also the word for the glans.

One could surmise, given this enticing convergence, that Wood had something beside what was evident to say about generic (presumably anonymous) young American soldiers; about Campbell—to judge only from his appearance, a conservative man—and about Herbert Hoover, who was just then the conservative, Republican Party president of the United States. To see how he made this symbol work, we need to develop more context.

The years 1932 to 1933 were characterized by dramatic and exciting social change due to the combined influences of the deepening of the Great Depression and the election of Franklin Delano Roosevelt. The rise of unions in Hollywood coincided with the introduction of FDR's New Deal, which conferred upon American workers rights they had never dreamed of—and upon American capitalists pains they had ever dreaded. Like financial and business elites everywhere, studio producers wanted desperately to slow the growing strength of unions, and they blamed the communists for stirring up their labor troubles.

The Motion Picture Alliance for the Preservation of American Ideals, as militantly anti-communist/unionist as it was pro-capitalist, wanted to preserve the patrician system that unionizing had begun to displace. MPA members included elite actors, directors, and even some writers, among them union-hater Walt Disney and ultra-nationalist director King Vidor, who

owned Grant Wood's *Arbor Day* and *January*, both pictures that unbeknownst to Vidor contained gay, "un-American" themes.*

In 1947, the MPA invited the House Un-American Activities Committee (HUAC) to Hollywood, blacklisting, among others, Edward G. Robinson, the owner of *Daughters of Revolution*. The same year, a conservative-controlled Congress passed the Taft-Hartley Act, intended by its authors to deprive labor of its recent gains.

The next two decades provided Republicans with little if any comfort. By the early 1950s, they had been out of the White House for so long that they were grasping at anything that would help them demonize the New Deal. To this end, Joseph McCarthy (1908–1957) made his infamous charges that communists had infiltrated the federal government. In their fervor to politically cripple the New Dealers, Republicans added homosexual civil servants—whom they feared no less than communists—to the list of scapegoats, who were, in their eyes, the cause of Washington's "moral weakness." As one of them put it, "I can tell you exactly when the moral degeneration of America began: it began with the election of Franklin Delano Roosevelt!"[2] The speaker imputes America's "moral degeneracy" to FDR. But what, in fact, he was lamenting was the end of his own era, not the start of Roosevelt's.[†]

The Volstead Act of 1919, decades in the making, was a bill written by Republicans, whose aim it had always been to curb lewd and immoral public behavior attributable, according to its zealous sponsors, to alcohol. Prohibition was the culmination of the effort, taking effect during

Charles Demuth (1883–1935), *The Cabaret, Barron Wilkins's Savoy*, 1919. Watercolor, 8 × 10¹/₄ in. (Private Collection, photograph Courtesy of Sotheby's, Inc. © 1988)

Otto Dix (German, 1891–1969), *To Beauty (An die Shönheit)*, 1922. Oil and collage on canvas, 55¹/₈ × 48¹/₈ in. (140 × 122.2 cm). (Von der Heydt–Museum, Wuppertal, Germany.) © Artists Rights Society (ARS), New York / VG Bild-Kunst, Bonn.

* It is tempting to wonder if *Young Corn*, 1931, might not be a painting named for a lover with the surname Young. In 1935, King Vidor made a movie of the popular novel *So Red the Rose*, written in 1934 by Stark Young, and published by Charles Scribner's Sons, which, in 1935, also published *Farm on the Hill* by Madeleine Horn illustrated by Grant Wood. Young, from Mississippi and with no connection to Iowa, was a contemporary of Wood's, a writer and theater critic who "died a bachelor." Given that books and films often take years to write, a convergence of Vidor, Young, and Wood in 1931 is not an altogether unreasonable surmise.

† Wood's *Portrait of Henry Wallace* of Iowa, Franklin D. Roosevelt's Secretary of Agriculture who largely formulated the New Deal appeared on the cover of the September 23, 1940, issue of *Time* magazine. Wood's interest in Wallace probably grew more out of his subject's leftward political leanings than that he was a fellow Iowan.

the administration of Woodrow Wilson. Wilson, a Democrat who liked a glass of wine with his dinner, expediently advocated moderation. Nevertheless, with a legislature dominated by the opposition, he reluctantly signed the bill, and, in 1920, the 18th Amendment became law.*

Like the permissive environment of the Weimar Republic, in *The Cabaret, Barron Wilkins's Savoy*, 1919, Charles Demuth documents the vibrant gay subculture that flourished in the "Anything Goes" era in New York. Demuth gives us a window on the novelty of so-called "Negro entertainment" then sweeping the speakeasies and nightclubs. The predominantly white, gay subculture of Greenwich Village, accustomed to partying openly and undisturbed, gradually moved uptown to Harlem. There, relying on an Irish police force disinclined to raid nightclubs in black neighborhoods, all the so-called degenerates could again party with impunity. Artists, entertainers, and intellectuals of all stripes, including drag performers and "Hot Mamas"—lesbian and bisexual singers and dancers—in what became known as the Pansy Craze, came to perform for a prosperous, upper-class white clientele well supplied with cash and just as well lubricated with gin. The success of female impersonator/drag performer Bert Savoy, also memorialized by Demuth, characterized the era.[3]

The Roaring Twenties, continuing unabated following the election in 1924 of Republican president Calvin Coolidge, was now in full swing. By 1928, the unofficial failure of Prohibition, which to the discomfiture of its Republican sponsors had only encouraged the insatiable appetite for booze and debauchery, was an open secret. The stock market crash of 1929 (under Republican president Herbert Hoover) and the onset of the Great Depression only put more fuel on the fire.

But by the early 1930s, the effects of the Great Depression were taking hold and the party was getting expensive: gradually, going to speakeasies lost its naughty appeal and the craze subsided. The adoption, on December 5, 1933, of the 21st Amendment finally put paid to Prohibition,

which everyone now realized had given the movement its legs. The Pansy Craze was over and the nightclubs, cross-dressing performers, and fancy patrons were all out of business. Ironically, the ascendancy of FDR—and, in the same year, of Hitler in Germany—marked the end of the good times, not the beginning.

The Republican Congress, forever seeking a fix for "moral lassitude," again agitated for the enactment of a series of laws to root out gays, making even visibility and gay sensibility into crimes. Even "latent, homosexual tendencies" were grounds for persecution, for losing one's job, or for dishonorable discharge from the military.

Grant Wood, living in Iowa, not in New York or Chicago, may not have felt himself to be a direct target of the purge. But he could not have been ignorant of these horrifying political and social developments nor of his vulnerability to them. And while he did not live to witness Hollywood blacklisting or the Lavender Scare of the 1950s, congressional enthusiasm throughout the 1920s and '30s for rooting gays out of society was a constant threat coincident with the prime of Wood's life and career. Consequently, it becomes essential to see his art through this lens.

Perhaps Wood admired certain aspects of Herbert Hoover's Quaker upbringing, how he was raised in West Branch, Iowa, and rose from nothing to become president of the United States. Painter and president shared plain beginnings in Iowa; but adulate him? I don't think so.

It is far more likely that Wood despised governmental efforts to legislate and police sexual behavior and recognized Herbert Hoover as his mortal enemy. Hoover, who was in office when the stock market crashed in 1929 and largely for that reason lost to Franklin D. Roosevelt in 1932, made an unsuccessful bid to return to power in the early 1930s by railing against fascism, a term that for us today conjures up the Nazis. But in those days, Republicans invoked the term when decrying the concentration of political power that they regarded as the hallmark of the New Deal.

At the same moment ultranationalists in Germany wanted to return to the "glorious days of Imperial Rome" by concentrating power in Adolf Hitler, affording him the "Roman Salute," or what in 1928 Rudolf Hess called the "Fascist Greeting,"

* In defiance of the law, Warren Harding, Wilson's Republican successor, is said to have kept the White House well stocked with bootlegged liquor.

performed by extending the right arm and hand straight from the shoulder, much as the figure in Wood's *Birthplace of Herbert Hoover* is doing in the future president's yard.

In 1924, Calvin Coolidge appointed J. Edgar Hoover (1895–1972) to head the increasingly oppressive Bureau of Investigation, which in 1934 became the Federal Bureau of Investigation. As a shield of protection from being himself exposed as a homosexual, which he managed to keep a secret until his death, J. Edgar Hoover kept files on everyone, including six presidents of the United States. Although president and director were not relatives, Wood would have conflated one Hoover with the other since, throughout Wood's adult life, the FBI was actively pursuing federal policies, importuning ordinary citizens, arresting them,

pushing them out of their jobs, and prosecuting them for being gay.

Everyday life for the homosexual in 1930s America was a holy nightmare. If you lived in New York City, the Roaring Twenties had been great fun, but now it began to look as if all that was over and done. Everyone, it seemed, needed a cover: as the nation's top cop, J. Edgar Hoover had a really good one.

Wood had one too; he tirelessly promoted himself as a cornball, an unapologetic enemy of feminist modernism, and a squeaky-clean Midwesterner, with all the provincial connotations he could apply to the gig, even affecting the country bumpkin by exchanging his Parisian beret for overalls, or, as they were alternatively known, coveralls.

*Cover*—alls?

*The Birthplace of Herbert Hoover*, 1931. Oil on composition board, 29⅝ × 39¾ in. (Purchased jointly by the Minneapolis Institute of Art and the Des Moines Art Center; with funds from the John R. Van Derlip Fund, Mrs. Howard H. Frank, and the Edmundson Art Foundation, Inc., 81.105)

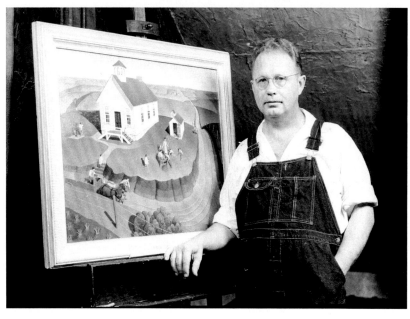

*Grant Wood and John Steuart Curry at Stone City*, 1933. (Photo by John W. Barry, used by permission of Cedar Rapids Museum of Art 89.2.9)

Grant Wood in Overalls Standing Next to *Arbor Day* at 5 Turner Alley, 1932. (Photo: Cedar Rapids Museum of Art)

Garwood writes that Wood "wore ordinary farmers' overalls to work and paint in and *he would wear nothing else* [emphasis added]; the lines and seams of a pair of overalls *had a fascination for him . . .* He knew more about a pair of farmer's overalls than any painter who ever lived."[4]

There are numerous photographs in the literature of Wood wearing overalls while painting, but in *Self-Portrait*, 1932–40, and *Return from Bohemia*, 1935, Wood presented himself uncharacteristically wearing a plain shirt. If, as Garwood claims, Wood were so sold on overalls, why, when he took the opportunity to model himself in them, would he paint himself in just a shirt?*

I aver that Wood's fascination with farmers' overalls, which Garwood tells us were "just clothes," was in fact a fascination with *covers*. For some, a *Self-Portrait* could be an opportunity to posture or promote, but for Wood it was an exposé of himself, an *uncovering*.

The standard, college dictionary provides a host of definitions for the word *cover*, among them: to copulate, especially horses; to compensate or make up for; to screen from view as a pretext; to conceal as a fact or crime; to save from censure or punishment; to beard, as with a hat or disguise. As we shall see, all these uses are relevant to Wood's interest in the word.

In subsequent years Wood created covers (book covers) for a variety of writers, among them Kenneth Roberts, the ultra-conservative writer of revisionist, historical novels sympathetic to the Tory cause in the War of Independence. Perhaps Wood suspected, or knew, that Roberts, like FBI director Hoover, was in reality a man, just like himself, in need of a "cover."

When he painted his supposed homage to Herbert Hoover, Wood placed a little figure at

* In 1932, Wood made a sketch presumably leading to the final version of *Self-Portrait*, 1932–41 (Figge Art Museum), in which he presents himself in overalls. Perhaps Wood had heard Coco Chanel's advice: "Before leaving the house, look in the mirror and take at least one thing off." Interesting for our purposes, Chanel was born in 1883 in a hospice for the poor in the Loire Valley, to unwed parents of peasant stock. To distance herself from these origins, she adopted a vociferous homophobic and anti-Semitic outlook, and became a "horizontal collaborator," i.e., the mistress of a high-ranking Nazi. http://www.nytimes. com/2011/09/04 /books/review/sleeping-with-the-enemy-coco-chanels-secret-war -by-hal-vaughan-book-review.html

Daughters of Revolution, 1932. Oil on masonite panel, 20 × 39 ⁵/₁₆ in. (50.8 × 101.4 cm). (Cincinnati Art Museum, The Edwin and Virginia Irwin Memorial, 1959.46)

the center who raises his arm and extends his open hand in a gesture that might either be a fascist greeting or a gesture to indicate "Here is the famous birthplace of Herbert Hoover, Favorite Son of Iowa!" Either way, the picture of an unadorned, undistinguished farmhouse, its occupants' laundry flapping on the line, their chickens pecking in the lawn, says "baloney." Not only that, by the prominent placement in the foreground of the large red oak blooming with little acorns—an unusual feature of the composition otherwise *very* difficult to explain, a feature that Corn mentions only in passing and that Dennis does not mention at all—Wood seems to deflect our attention away from what Hoover would have liked us to see and to depict him instead as something rude.*

* Nan reported that Wood had never intended for *The Birthplace of Herbert Hoover* to be interpreted as a personal tribute to Hoover. Be that as it may, the painting caught the attention of a group of Iowa businessmen whose intention it was to purchase it and present it as a gift to Hoover. The president, however, did not approve the picture because it obscured the cabin in which he had actually been born, giving undue prominence to the later addition of a larger, more stately house, in front, and disrupting the carefully contrived myth surrounding his humble birth. (*Ibid*, p. 240) If there is truth in this apocryphal story, Hoover's objection coincided nicely with my assessment of the artist's intentions.

The hand gesture is, of course, blooming with encoded meaning. Hands, while usually found in service to other themes, make numerous appearances in their own right in Wood's important works. Because he was largely a figure painter, hands naturally appear with frequency (27) in Wood's work; but we are concerned here only with the independent hand *gesture*, and predominantly with the stiff, highly mannered hands of women (7).

Hands are the conscripted partners of the will. Hands, which are undeniably capable of expression, can convey something akin to the power of language. But they cannot take responsibility for their own actions; they are directed as unwitting agents. Yet, they are capable of deceit. Hands, Wood seems to suggest, can act as covers, often saying one thing when they mean another: they can appear, at once, to provide comfort, yet inflict pain.

The mannered hand, most often a woman's, with straight, tightly aligned fingers, first appears, and prominently, in the lower center of *Woman with Plants*. The same hand, in the same central location, appears again, this time on a squinty-eyed, implacable Midwestern lady—perhaps a surrogate for his mother—holding a teacup

*The Booster*: Illustration for Sinclair Lewis's *Main Street*, 1936. Charcoal, pencil, and chalk on brown wove paper, 20¹/₂ × 16 in. (Figge Art Museum, Davenport, IA. Museum purchase with funds provided by the Friends of Art Acquisition Fund and funds provided by Mr. and Mrs. Morris Geifman, 1993.3.) Image © Figge Art Museum, successors to the Estate of Nan Wood Graham/ Licensed by VAGA, New York, NY.

*The Perfectionist*: Illustration for Sinclair Lewis's *Main Street*, 1936. Black and white crayon, graphite, black ink, and white opaque watercolor on brown wove paper, 20¹/₂ × 16 in. (The Fine Arts Museums of San Francisco, gift of Mr. and Mrs. John D. Rockefeller 3rd, 1979.7.106)

in *Daughters of Revolution*, 1932. This picture is invariably said to satirize the prim, "revolutionary" members of the DAR, standing before Leutze's famous Washington from whom they claim descent.* That interpretation was not lost on the ladies of the Cedar Rapids chapter of the DAR, who raised a great fuss at being thus lampooned.

But these smiling ladies, who are in reality anything but "revolutionary," are "lying with their eyes while their hands are busy working overtime."[5]

The woman's hand in the center of the picture holds a teacup, a symbol of temperance. Teetotaling refers to the powerful movement of the early twentieth century that found most of its support among women opposed to the domestic violence alcohol frequently caused, not to mention the large share of household income it caused drinking men to swallow. The *t* in teetotaling referred to those adherents who had taken the *total* abstinence pledge. Most interesting for me, it was Parson Weems, a fervent proponent, who in 1807 coined the term.* Wood's teacup in

* According to the DAR's website, "Any woman 18 years or older—regardless of race, religion, or ethnic background who can prove lineal descent from a patriot of the American Revolution, is eligible for membership."

* Mason Locke "Parson" Weems, trying to gin up interest in his biography of George Washington, created the cherry tree myth to paint Washington, an exemplary but bland leader, as a man of moral rectitude.

*Daughters of Revolution* could, therefore, be read as a plant for the insidious methods deployed by women (synonymous in Wood's argot to city folk or Republicans) when exercising power over men (country folk or Democrats).

Another, gently cupping hand, also with long, attenuated fingers but enigmatically holding a baby chick and a plum, appears near centrally in *Portrait of Nan*, more about which anon. With the exception of the *Practical Idealist*, whose unseen hands we *know* are folded neatly in her lap, hands in various emotive postures are the unifying feature of the *Main Street* suite of drawings.

Hands—but male hands—are also enlisted to tell the story in *Parson Weems' Fable*, the central theme of which is a veritable catalog of encoded hand gestures from the father and from the son: stern authority, relentless inquisition, accusation, conciliation, defiance, depravity, contrition, pride, and deceit.

Observe, if you please, this important difference between the hands of men appearing in Wood's work and those of women.

Men's hands, forcefully grasping pitchforks (*American Gothic*) and tools (*The Radical*) or tending to the sick (*General Practitioner*) or commanding awe and respect (*Parson Weems' Fable*) seem to go right about their business and to speak with one voice: what you see is what you get.

Women's hands, whether poised placidly in laps, hidden in muffs, or pulling on gloves (*The Good Influence*), holding teacups or expressing exemplary deportment (*The Perfectionist*) seem with one voice to say gentility, kindness, and decorum (what you see), but with another to say something controlling, frightening, unexpected, cruel, or even painful (what you get).

Remarkably, Wood gives to himself the same long-fingered, effeminate hand in *Return from Bohemia*, which he places in the foreground with prominence on a par with his own facial features. Wood implies, through this metaphor, that his true nature is more aligned with the female's, with one who is—if you will—inclined to be indirect, deceptive, or deceitful; someone who presents himself as one thing when, in fact, he is something quite different.

The two women in *Clothes*, now titled *Appraisal*, 1931, the one holding the Barred

Plymouth Rock whose hands are prominently revealed while the other's are completely hidden, are another case in point.

*Clothes* provides a rare opportunity to study the depth of Wood's misogyny. In the literature, the default interpretation of this picture is of a mildly confrontational exchange between two women from different social strata, one from the country, the other from town, comparing their life situations through their starkly different modes of dress.

Wood is said to have himself cut off the bottom third of the composition to, according to Corn, "emphasize the country-city contrast" [?] or because, inscrutably, the picture "did not work in a vertical format."[6] But city or country, vertical or horizontal, what, in fact, Wood cut away were his subjects' loins.

Wood had originally fenced off this section of their anatomy, the, if you will, "business end" of the women, with chicken wire, which, while a barrier, did not obscure the women's loins from view. We would rightly conclude that, to Wood, both concepts, cut off but in view, are—or were—important. We will return shortly to the metaphoric importance to Wood of the fence, without which we would have been at a loss to plumb the meaning of *Clothes* (*Appraisal*). For now, we don't know why, sometime after he painted *Clothes*, he wanted this important third of the picture gone.

Detail: *Return from Bohemia*, 1935. Pastel, gouache, and pencil on paper, 23½ × 20 in. (59.7 × 50.8 cm). (Courtesy Crystal Bridges Museum of American Art, Bentonville, Arkansas. Photo courtesy of Alexandre Gallery, New York.)

*Clothes, (Appraisal)*, 1931. Oil on composition board, 29 $\frac{1}{2}$ × 35 $\frac{1}{4}$ in. (Reproduced with permission from the Carnegie-Stout Public Library, Dubuque, Iowa; acquired through the Library's Lull Art Fund)

Robert Mapplethorpe (1946–1989), *Louise Bourgeois*, 1982. Printed 1991, gelatin silver print, 375 × 374 mm. Used with permission, The Mapplethorpe Foundation.

But we do know Wood intended that Barred Plymouth Rock, with its large, red coxcomb and full wattles, to be a cock.

Taylor, brandishing a Feminist-era sensibility, refers to the countrywoman in *Clothes* as a "farmer" and to the bird in her arms as a "gorgeous hen."[7] Grant Wood, in his era, would have done neither.

That the countrywoman, while beaming like the Giaconda, cradles in her arms a readily accessible symbol for the male sex organ has never entered the dialogue that searches this enigmatic picture for meaning. The juxtaposition of the cock-in-hand (just as the farmer in *American Gothic* holds the *shaft* of the pitchfork), the two oval heads, and the little dark window in the peak of the barn, follows the same formula for assaying the male genitalia deployed with similar impudence just one year later.

Yes: *Clothes*, ostensibly a picture of two women, is also wound around a phallic symbol, but the main message in *Clothes* is not about men. It is in Wood's anxiety-laden, conflict-ridden dialogue with women, one part of which emanates from above their waistlines, the other from below; recall that Wood's portrait of his mother, *Woman with [Snake] Plants*, 1929, presents her from only the waist up because the Harpy has snake-like lower parts.

*Clothes* might also be read as Wood's rendition of the virgin/whore paradox.

On the left, he presents the slightly androgynous countrywoman, whose exposed hand, its fingers spread expressively wide, and beguiling smile all convey—as in Robert Mapplethorpe's famous photograph of Louise Bourgeois (wearing showy furs) holding *La Fillette*—a familiarity with, if not enthusiasm for, holding the cock. On the right, we have the city woman, who with her hat pulled down over her eyes, her hands hidden safely out of sight, and her overfed body completely upholstered in expensive, showy furs, brandishes her menacing geniality like a weapon.

Wood tells us that women's faces, occupying the top third of the picture, send an assortment of coded signals; in the middle third, their hands, modes of behavior, and *clothes* transmit a different range of signals all purposefully misleading; but below the waist, their well-guarded loins clearly

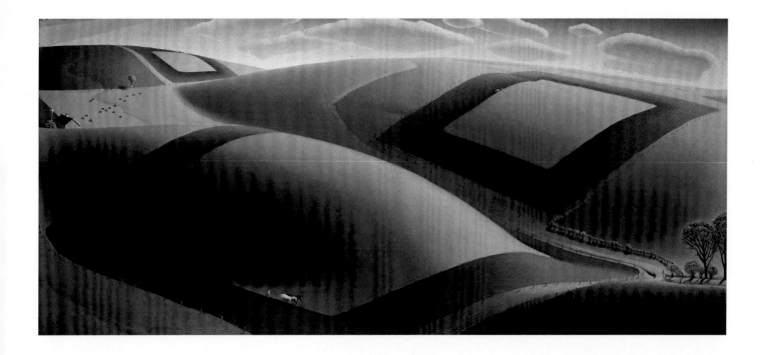

*Spring Turning*, 1936. Oil on masonite panel, 18¹/₄ × 40¹/₈ in (46.4 × 101.9 cm). (Reynolda House Museum of American Art, Winston Salem, NC, Gift of Barbara Millhouse 1991.2.2).

send only one. That third, guarded by a chicken-wire fence, now gone, once served as a warning to the unwary: *No matter how they appear from the waist up, Danger, Do Not Enter*. As originally conceived, Wood had painted a horrifying picture of female treachery and of his own sexual bewilderment and disorientation: without its bottom third *Appraisal (Clothes)* means — what?

Wood gives prominence to another pair of mannered, long-fingered hands, "inanimate objects, ceramic in finish" and cruel in their passivity, belonging to the cadaverous old woman in *Victorian Survival*.[8] It is hardly insignificant that Wood presents his once-married but now spinster-like, widowed aunt still wearing a wedding band, when he clearly meant for us to see her as chilly, forbidding, unloving, perhaps uncultivated, barren, and even cruel. Wood implies through the ring — a seemingly conventional feature also appearing on his mother's hand in *Woman with Plants* — that marriage has not made either of these harpies maternal or in any way benevolent.

That Wood delights in exposing Parson Weems's fable as a popular, improbable lie escapes none but his most ardent, family-values-oriented, flag-waving boosters. That he similarly exposes the hypocrisy of Midwestern stereotypes like the prim ladies appearing in *Daughters of Revolution*

and recoils from the prudish spinsters in *American Gothic* and *Victorian Survival* is also widely recognized. But few apparently see that these images provide Wood an opportunity to express fascination with the trauma and allure of childhood crime and repentance, or, to flout a virulent antipathy or deep-seated disgust for women.

*Woman with Plants* and *Clothes* serve principally to put Wood's deeply seated misogyny unapologetically on display. His subjects' appallingly unambiguous characterizations as vixens begs the question of how so virulent a sentiment as he harbored could, in his treatment of stereotypes like those also appearing in *Appraisal*, *Victorian Survival*, *Daughters of Revolution*, and *American Gothic*, have ever been mistaken for mildly sardonic or good, clean, fun-loving satire.

Art historians, coming of age in the 1970s, are quite naturally informed by Feminism. But they must be careful not to overlay an inquiry into the meaning of Wood's work with lessons peculiar to the movement. The canonical description of *Spring Turning*, 1936, consistently celebrated as Wood's paean to womanhood, is a case in point.

While invoking such terms as "sensuous" and "passionate," which it undeniably is, Corn sees in this marvelous picture a "relationship between the farmer and the mother earth . . . loving and

but the figure breathing with sexual fullness anthropomorphized beneath the undulating green hills* is not that of a voluptuous woman lying bosoms-up, but of a man, lying facedown.† The squares, formed by the farmers plowing the "well-rounded Iowa hilltops," are the back pockets on his coveralls. The little dark hole, in the valley between the rounded hills in the right foreground, neatly tufted round by bushes and trees is, like the dark chimney opening in *Midnight Ride of Paul Revere* and the culvert in *Fertility*, the overturned man's anus. *Spring Turning* with its suggestive title—a turn is a surprise—is undoubtedly Wood's chef d'oeuvre. Ironically, he would have approved Dennis's description of the artist at work on it "moved by the land . . . gliding over the smooth hills or penetrating the shadowy folds of deep space."[10]

Wood's investiture of the landscape with human forms—men's human forms—was not his invention. Writing of Pavel Tchelitchew (Russian, 1898–1957), a notorious pederast, Rosamond Frost reports: "About 1932, Tchelitchew began to see people as landscapes, the idea first suggested to him by the mountainous limbs of a Polynesian model. In this connection, Tchelitchew explains he is short-sighted and won't wear glasses, so that his apprehension of a figure is quite unlike that of a man with normal vision."[11]

In Wood's case, short-sightedness was unlikely to have been the inspiration for the human form

Grant Wood in WWI uniform. (Unidentified photographer, Courtesy Figge Art Museum, Grant Wood Archive, Davenport)

benevolent. In Wood's idyllic farmscapes, man lives in complete harmony with nature; he is the earth's caretaker, coaxing her into abundance, bringing coherence and beauty to her surfaces . . . Wood's way of describing the earth's goodness and fertility is . . . to turn the landscape into a gigantic, reclining goddess, anthropomorphizing the contours of the fields and hills so that they look like rounded thighs, bulging breasts and pregnant bellies, all of them breathing with sexual fullness."[9]

Corn has correctly detected the intoxicating aura of romance emanating from *Spring Turning*,

---

\* *Spring Turning* was probably painted for Alexander Woollcott, the sharp-tongued theater critic, confirmed "bachelor," and founding member, with Dorothy Parker, Edna Ferber, and Harpo Marx, of the Algonquin Round Table. Havelock Ellis (*see* note, following) opines: "The love of green (which is normally a preferred color chiefly by children and especially girls) is frequently observed. A certain degree of dramatic aptitude is not uncommon, as well as some tendency to vanity and personal adornment . . ." While it may just be a coincidence, the extravagantly green color of the hills in *Spring Turning* is the shade of Woollcott's bright, spring-green sport coat, his signature apparel. Woollcott bought the picture from Wood's New York dealer, Ferargil Galleries, in 1936.

† Havelock Ellis (1859–1939) coauthored *Sexual Inversion* with John Addington Symonds, originally published in German in 1896 and later translated into English. It was to be the first English medical textbook on homosexuality, and the first objective study of homosexuality, which he did not characterize as a disease, immoral, or a crime. Ellis also wrote *Psychology of Sex* (New York: Mentor Books, 1933), listing characteristics common to "sexually introverted," i.e., homosexual men.

as landscape, and his eye glasses, appearing on his nose in his two self-portraits, many photographs, and a small plaster relief, were not only a prosthesis for correcting his vision, he converted them into a symbol.

Eyeglasses are such a common, modern accessory that we are unaffected by their presence, especially on old people, like on the ladies in *Daughters of Revolution*, or the farmer in *American Gothic*. Wood may have been fitted with glasses as a young boy, but if he had them, he did not wear them for a photograph taken when he was nineteen, in 1910. He had them by 1918 for his photograph in army uniform. But whenever he first put them on, he would not have been the first of his generation to suffer the taunts of tormenters.

Glasses have always been a symbol with a connotation: "four-eyes" is not only a derogatory insult directed at weak, effeminate, shortsighted, i.e., clueless people, it is also prison slang for a child sex molester.*

Wood presents himself, naturally enough, wearing glasses in *Self-Portrait*, 1932–41, and in *Return from Bohemia*, which he once intended to be the cover for his autobiography. After all, he wore them and they were a part of his public identity. But glasses have conflicting, metaphysical properties: Wood knew that while they helped *him* to see, glasses could not help his audience, like those standing behind him in *Return from Bohemia*, to see *him*.

Perhaps *Spring Turning*, which once belonged to Algonquin Club writer, bon vivant, and "lifelong bachelor," i.e., homosexual Alexander Woollcott, is better understood as an expression of delight that Wood could, if he were careful, go out into the countryside with a "contact" and enjoy an afternoon of sex al fresco. Indeed, if *Brokeback Mountain* was shocking to movie audiences who were urged in 2005 to remember that, in 1965, the film's subject was largely unthinkable, is it any wonder that, in

1935, Grant Wood's audience, standing behind him in *Return from Bohemia*, was blind to the very same message?

Wood completed no easel paintings between 1935 and 1939, and only five more before his death in 1942. But we have now arrived at a point in our reevaluation of Wood's oeuvre where we might profit from a closer look at *Dinner for Threshers*, 1934, which, like a summing up, comprises almost the entire catalog of Wood's symbols appearing to date: a harvest theme (threshers), a hand pump, a windmill, chickens, hands, horses, men in coveralls, tessellated patterns—but no overtly homo-erotic or misogynistic symbolism.

Wood gives us a cutaway view—a virtual look inside—of a long room in a prosperous American farmhouse, wherein fourteen farmhands, all wearing coveralls, are sharing the noon meal, referred to in rural communities as "dinner." Two more men and a boy—for whom there is no room either in the cramped room or at the table—are on the porch washing up. Two women, dressed in calico and white aprons, prepare the meal in the adjoining kitchen; two others, similarly dressed, serve the meal. There is a total of twenty-one figures plus a cat, sitting near the stove in the kitchen.

At 20 x 80 inches, it is clearly an important entry, but in an oblong format and the largest of Wood's easel paintings. Aside from its scale, the picture is unusual in that Wood depicts women without satirizing or belittling them, on a near-equal footing together with men in the same composition, which he has not allowed since their appearance together in *American Gothic* in 1930. It is a bright, sunny, summer day; three white chickens are pecking about in the dooryard and two horses, one black the other gray, stand outside eating their dinner.

On the far wall inside, where the threshers are eating, hangs a picture of two more horses, a white and a black stallion fighting; or are they mating? The faces of the men, where during the day they are exposed to the sun, are tanned, but beneath their covers, their baldpates are actually white, their true color. There is a near symmetry to the composition, unmistakably reminiscent of Leonardo's *Last Supper*, except, of course, there were thirteen men around that table and no women.

* Stephen King, writing many years after Wood's time in *Salem's Lot*, suggests that urbanity is akin to femininity, and homosexuality even a cause, and that Mark Petrie is a "four-eyed queer-boy." *See* also Chris Roberts, *Heavy Words, Lightly Thrown: The Reason Behind the Rhyme* (New York: Gotham Books, 2004) 65, 193.

*Dinner for Threshers*, 1934. Oil on masonite 20 × 80 in. (50.8 × 203.2 cm). (The Fine Arts Museums of San Francisco, Gift of Mr. and Mrs. John D. Rockefeller III, 1979.7.105)

Beyond the picture's family-values subject, apparent to us all, one unconsciously remarks a curiously rich array of tessellated patterns and overall, a notably amber hue. For Dennis, Wood's interest in patterns derived from his attraction to "conventions of the decorative."[12]

But for Grant Wood, patterns served to call attention not to themselves, but to what it was, in their quotidian functions, they so gaily covered: wallpaper, hooked rugs, shelf liners, curtains, dresses, barn siding, cupboard doors, and table-cloths, even hats and aprons, were all applied for the purpose of putting a bright face over a plain, or even an ugly, truth. Anyone making a home in new surroundings is familiar with the process: scrub it up as best you can, and then, because some spots and stains persist, paint (or paper) it all over.

*Dinner for Threshers* casts a jaundiced light[13] over Wood's own resident status in the confines of 5 Turner Alley, an old, one-room garage loft where, for eleven, long years, between 1924 to 1935, he cohabited with his mother and sister, all drawn together, I aver, not by love, as is always asserted, but by economy, a situation that without

such a constraint, I doubt they would have long endured.* *Dinner for Threshers* was indeed painted within the constricted perspective afforded him by 5 Turner Alley, but it is informed by a much broader worldview from which Wood habitually draws his inspiration.[†]

To get beyond the family-values theme presented on the picture's surface, we shall have again to expand our own view.

The 1920s were a time of great social unrest, especially in Russia, where Vladimir Lenin was agitating for the workers of the world to rise up and resist the yoke thrown over them by the oppressive ruling classes. American, French, and English intellectuals, artists, and writers were sympathetic to the idea and they flocked to support the Bolsheviks and to join the Communist Party under the banner emblazoned with the hammer and

---

* Corn writes that Wood "had been very happy to live with his mother, for whom he had an intense affection, and he was devoted to his sister." *See* Corn, *op. cit.*, p. 47

† *See* Appendix I for an "Olde English" rhyme that includes these lines and Appendix II for "Hooked Rug," a poem by Jay Sigmund that also appears to refer to 5 Turner Alley.

sickle. As a US Army soldier during World War I, to say nothing of his four subsequent trips, in the 1920s, to France, Germany, and Italy, Wood could not possibly have been oblivious to these important social trends.

The prospect of a workers' revolution threatened the elite class of capitalists in America, and, as they tightened their grip, the workers grew more restive. Diego Rivera, an artist particularly sympathetic to the plight of workers, was commissioned in 1932 to paint a sixty-three-foot-long mural for the lobby of the new Rockefeller Center Building into which he audaciously inserted an unapproved portrait of Lenin. When Nelson Rockefeller, a very prominent member of the aforementioned class of capitalists, came to inspect the work, nearly completed, he ordered Rivera to remove the offending image. Rivera refused; and so, on February 10, 1934, Rockefeller paid Rivera in full for the unfinished work and ordered it destroyed. There is, perhaps understandably, no mention in the Grant Wood literature of this important contemporary event. But there seems little doubt that, had they dared, left-leaning artists all over the world—even

in Iowa—would have stood in solidarity with Rivera.*

Meanwhile, rumors of a link between the Jews and the Russians gathered steam and it further troubled the members of America's ruling classes, who had no fondness for either. Henry Ford, who in 1922 had written a paper linking the Jews to labor unrest in America and to all the world's troubles in general, believed that the Jews, acting under the mysterious *Protocols of the Elders of Zion*, had been the driving force behind the Bolshevik Revolution: Wasn't Lenin, for one, a Jew? Then, in 1928 there appeared a little book titled *We*, a classic of dystopian fiction written in 1921 by the revolutionary Yevgeny Zamyatin (Russian, 1884–1937). The author told a story of pervasive government control in the twenty-sixth century when, according to his script, the ruling class in "OneState" will have perfected its domination of everyone's life and work, including all artistic and sexual expression.

* So apprehensive was she to admit that Wood was a liberal, let alone that he might have stood even further to the left, Nan Wood Graham reported to Jim Dennis that her brother was a "political independent." *See* Dennis, *op. cit.*, p. 240

In 1931, the book came to the attention of Aldous Huxley who, in 1932, "borrowed" Zamyatin's theme for *Brave New World*, another dystopian narrative in which repressive, authoritarian rule controls every aspect of the people's lives, including, of course, sex and love.*

*We* and *Brave New World* were popular because they were interpreted as allegories for erotic liberation, which is a natural derivative of a broader social and economic liberation. But sex becomes a perversion when it is used as a political weapon, and sexual and artistic repression was just the most worrisome of a long list of restrictions totalitarian governments would supposedly impose on social and personal freedom. And that scared the daylights out of intellectuals on the political left, and the rich and powerful on the political right, all of them completely certain, for entirely opposing reasons, that a new world order would soon issue in and somehow bring people, each in his or her own station, to ruin.

Fears such as these would, in 1932, have found a wholly sympathetic audience in Grant Wood. Already consummately repressed and struggling to come to grips with the early loss of his father, with his relationship to his domineering mother and repressive sister, with his own sexuality, the Depression, the rise of Bolshevism, Fascism,

Zionism, and Hitler, and if, in fact, he ever read *Brave New World*, he would have found Huxley's language particularly chilling:

> *Our Ford was the first to reveal the appalling dangers of family life. The world was full of fathers—was, therefore, full of misery—full of mothers—full of every perversity from sadism to chastity; full of brothers, sisters, uncles and aunts—full of madness and suicide.**

The reader will recall that earlier I pointed out that in *Phaedrus* Plato compares the soul to a chariot that has as its driver the intelligence of man: he struggles to control an evil black horse, a symbol for man's desire, and a noble white horse, which represents his pride or spirit. If the driver masters the white horse, he can curb the black one. But if the black horse masters the white one, the charioteer loses control and is thrown off. Plato, who draws an alarming distinction between irrational madness and madness that issues from the love of beautiful young boys, argues both one way and the other about the power of reason and art to master the soul. He finally concludes that art corrupts man because it appeals to that element in him most remote from intellect. For that reason Plato condemns art and calls, in its place, for the use of indirect speech—a *cover*—to distance the speaker and his words from what his audience hears him actually say.[14]

The picture of the white and black horse in *Dinner for Threshers* may have been Wood's invention; or he may have seen it countless times in dining rooms all over the Midwest. Either way, in Wood's appropriation of the image he reverses the roles played by the two horses: Wood's white horse—his pride—bites the black horse—his desire—a pretty conceit, given events in Wood's life. As but one timid member of a predominantly property-less population, in 1934, the year he painted *Dinner for Threshers*, Wood was feeling himself under sexual and artistic repression from a rising tide of critics alleging that he, an

---

* George Orwell, the author of *Nineteen Eighty Four*, believed that *Brave New World* was partly derived from the novel *We* by Yevgeny Zamyatin. However, in a 1962 letter, Huxley says he wrote *Brave New World* long before he had heard of *We*.

* Aldous Huxley, *Brave New World* (New York: 1932) p. 25. "Ford" refers to Henry, the quintessential authority figure, consumed with efficiency and dedicated to "transportation consumption" for the masses.

associate professor at the University of Iowa, was a homosexual. Badly mismanaging his clandestine homosexual love life, and perhaps in the process going mad with Platonic passion, his solution was, in Corn's words, to "out of the blue, *fall in love with Sara Maxon, a Cedar Rapids woman with a sketchy career . . . [who] . . . Wood felt understood his ways!*" [Emphasis added]*

In 1934, Wood's enemies were at the gate, bringing disquieting and potentially ruinous charges. He had weathered such assaults all his life, but this time the situation called for extreme measures. Women were, as he had depicted them in *Victorian Survival* and *Clothes*, and as Huxley described them in *Brave New World*, "full of every perversity from sadism to chastity." He knew that to conceal their true characteristics women devise covers, just as men wear coveralls to conceal what they are above all else: *sexual harvesters.*

The color amber is universally understood to signal a need to pause. Was *Dinner for Threshers* to be Wood's *Last Supper* before facing his enemies and a certain end to his public career as an artist and private life as a "bachelor?" The cat in the kitchen is perhaps a symbol for the catalyst required for making such a momentous decision, which is the role fellow Iowan Ruth Suckow asks the cat to play in her short story "Three, Besides the Cat."†

*Dinner for Threshers* is thus an expansive essay, a summing up of Wood's life and his fear for its imminent ruin, and on the ubiquity and utility in a society of covers and of the inevitable, ugly truths that stripping them away will so painfully expose. Wood says here that art itself was both a mask and an unveiling and that the dedicated artist was but a poser: he is saying that to survive, he had learned to present a palatable topic above

another less refined one, the main message, lying underneath. His most versatile symbol for the realization of a truth told yet unseen, omnipresent in Iowa yet unassociated with anything but the need to stay clean, was his signature coveralls, a symbol, like himself, hiding in plain sight.

"Seeing" him in two instances thus *exposed* without his "cover," which is how he presented himself in *Return from Bohemia*, I must conclude that the picture that was to appear on the cover of his autobiography does not commemorate what it was his biographers would have us see: his triumphant turn away from the dissolute bohemian life of the artist in Europe to the clean-living, affable folks of Iowa.

Instead of this sunny explanation, I surmise that in 1935, a year after his profile in *Time* and with his celebrity as a painter rising to a fever pitch, Grant Wood was invited to the Bohemian Grove.[15] In this scenario, he accepted, he clandestinely went, he let it all hang out, and he then "*Return[ed] from Bohemia*" to his public life in Iowa whence he had come.

Herbert Hoover is said to have called the Bohemian Grove "the greatest party on Earth." Membership in the male-only club was—and still is—coveted, and its secrecy fiercely guarded. The club's famed annual gathering has been held since 1879 at the 2,700-acre Bohemian Grove in Monte Rio, north of San Francisco. Every Republican president since Herbert Hoover has belonged. The club has attracted such lesser notables as Dick Armey, Henry Kissinger, Colin Powell, Newt Gingrich, and a gaggle of painters, writers, actors, dancers, and other "free spirits" with whom the forenamed dignitaries would not ordinarily mingle. Members watch plays and comedy shows featuring men in drag in women's roles. Undoubtedly it is a hoot. But why the enclave? What are they really doing in there? Expressing their innermost thoughts and feelings, getting in touch with their feminine sides, like Dick Cheney doing Annie Oakley?

While we are in the mood for conjecture, I have long wondered—and I am not alone here—how best to interpret Wood's enigmatic landscape titled *Near Sundown* (1933), a peculiar, atypical composition in which eight or ten curiously red cows trudge along a hilly path bordered by trees

---

* Wood met Sara in late 1934. *See* Corn, *op. cit.*, p. 47

† Dennis and Corn each suggest that Wood found common ground in *Home Folks*, 1934, by fellow Iowan and author Ruth Suckow, (1892–1960), a minister's daughter whose portraits of Midwestern folk were always warm and appreciative. But Wood and Suckow shared little besides a home state. Wood had a far greater affinity for Jay G. Sigmund, with whom, when describing the Midwestern spinster, he shared a similarly dark and thoroughly mean tone: "a smug and well-kept" woman with a "saintly smile" that betrayed her hypocrisy and "arch-assassin of reputation," whose fangs were "no less cruel and deadly for being hidden."

in autumnal colors winding through an Iowa landscape.[16]

Once owned by Hollywood luminary Katherine Hepburn and then by George Cukor, *Near Sundown* could simply be, as Dennis suggests, a "curvilinear composition" like *Young Corn* and *Spring Turning* that are "all about the formal properties of picture-making." Or it could be indicative of Wood's "expression of love for the general character of eastern Iowa . . . an exhilarating visual experience . . . arousing personal memories or fantasies about rural life."[17] But in 1933, already deeply committed to expressions of either a political or erotic nature, it seems likely that Wood intended *Near Sundown* to carry a much stronger message.

How about this? For Jews, preparing for Passover is an ancient purification process involving the sacrifice of the now extinct Red Cow. If someone in the household, through contact with a dead body, had become impure, the rabbi would ritualistically butcher the Red Cow. Since the Jewish day begins and ends at sundown, the purification must be completed *near sundown*

or the impure person would be unable to bring the Passover.

Or perhaps his message was this: there are infamous passages in Leviticus condemning homosexual acts, even intercourse *before* sundown; would sex *near sundown* be close enough to escape perdition?

More likely than either, I think the picture was intended to decry a series of despicable, so-called "Sundown Laws," prevalent in the Midwest yet not widely known.

In the aftermath of the 14th Amendment,* and even well into the mid twentieth century, northern white citizens, threatened by integration, passed town ordinances to effectively keep out blacks, Jews, Catholics, and other "undesirables," even posting signs at the city limits that

---

* "All persons born or naturalized in the United States, and subject to the jurisdiction thereof, are citizens of the United States and of the State wherein they reside. No State shall make or enforce any law which shall abridge the privileges or immunities of citizens of the United States; nor shall any State deprive any person of life, liberty, or property, without due process of law; nor deny to any person within its jurisdiction the equal protection of the laws."

read: "N——r–Don't let the Sun Go Down on You in [our town]."[18]

Initially receptive to blacks, in the first two decades after the Civil War, towns all over the Midwest that had incorporated around this unholy notion were, after 1890, on the rise, reaching a peak in 1960. In her 1938 autobiography *A Peculiar Treasure*, Edna Ferber makes an astonishing claim for her hometown of Appleton, Wisconsin: "A lovely little tree-shaded, town of 16,000 people. Creed, color race, money—these mattered less in this civilized, prosperous community than in any town I've ever encountered." Appleton may not have engaged noticeably in racism or anti-Semitism, or in what today we might call "life-style" discrimination, and Ferber might well have felt welcomed there by Protestant whites. But to have mistaken as an accident of social geography the complete absence from her town of African Americans (and gays) because their exclusion was by design, would have required a high level of self-delusion: Appleton was a sundown town and Ferber was herself a Jew and a Lesbian.*

In 1932, "Herronvolk" democracy, or democracy for the master class, became official policy in Nazi Germany. Less known is that at the same time—the same year FDR was elected—white Protestants all over this country practiced a similarly vicious, yet unofficial, form of discrimination. The citizens of Pekin, Illinois, for example, while acting unofficially to keep African Americans out of their community, published a brochure that boasted of an altogether nobler sentiment: "Pekin has no social divisions. There are no special neighborhoods in Pekin, social, economic, religious or racial. It is this Democracy or Near-Equality [that] frequently first impresses strangers in this city."[19]

It is hard for us today to imagine how potent official bias against blacks actually was in that era. For example, *Time* magazine (December 24, 1934) sarcastically headlined a story on the election of a black man to political office in Russia: "Negroes

are the Black Hopes of Communism in the U.S." It should not be difficult, therefore, to understand that a homosexual, feeling himself discriminated against by actions perilously near in spirit to sundown laws, would have deplored this widespread form of officially sanctioned, extra-legal bigotry, and especially the hypocrisy that birthed and nurtured it. In Wood's picture, the little red cows trudge obediently into the distance, so as to be out of town *near sundown*.

1 John Manwood Treat, 1542, cited in *Oxford English Dictionary*.

2 Anonymous quote, cited in David K. Johnson, *The Lavender Scare: The Cold War Persecution of Gays and Lesbians in the Federal Government* (Chicago: University of Chicago Press, 2004).

3 *See* Barbara Haskell, *Charles Demuth* (New York: Abrams, 1987), 180–189.

4 Garwood, *op. cit.*, 91, 159.

5 "Happiness is a Warm Gun," music and lyrics by John Lennon and Paul McCartney, The Beatles.

6 Corn, *op. cit.*, 80.

7 Taylor, *op. cit.*, 89.

8 Dennis, *op. cit.*, 77.

9 Corn, *op. cit.*, 90.

10 James Dennis, *op. cit.*, 222.

11 Rosamond Frost, "Tchelitchew: Method into Magic" *ArtNews* 41 (April 15, 1942): 24–25. Cited in Lincoln Kirstein, *Pavel Tchelitchev* (Santa Fe: Twelvetrees Press, 1994), 64.

12 Dennis, *op. cit.*, 196.

13 See first footnote (*) page 20 regarding the curious, orange cast Wood threw over *Return to Bohemia* and *Dinner for Threshers*.

14 Edgar Wind, *The Eloquence of Symbols: Studies in Humanist Art* (Oxford: Clarendon Press, 1983), I, 3–8.

15 The Grove's policy of absolute secrecy prevents me from corroborating the supposition.

16 https://home.isi.org/bard-wapsipiniconbr-assessment-jay-g-sigmund

17 Dennis, *op. cit.*, 222.

18 James W. Loewen, *Sundown Towns*, (New York: New Press, 2005).

19 Loewen, *op. cit.*, 200–201.

* Ferber was a member of the Algonquin Round Table along with Harpo Marx and Alexander Woollcott, both of whom owned works by Wood. Ferber's novels generally featured strong female protagonists, and she usually highlighted at least one strong secondary character, who faced gender, religious, or racial discrimination.

# "Wholesome Tribute to His Favorite Sister . . ."

When we last took it up, Wood's biographers were praising *Portrait of Nan*, Wood's "favorite sibling," for its decorative elements: the bold pattern formed by the dollar-sized polka dots on her blouse, the wavy green drape that echoed the marcelling in Nan's hair, which, in turn, echoed the color of the little chick. The jaunty black ribbons at her shoulders and the wall color that echoed that of the plum, the other, with the chick, of two decidedly odd attributes she "cupped with an abundance of love and femininity in her hands." Wood's biographers arrive at this reading because for them Wood had gone to Munich as an Impressionist, seen the Northern Renaissance painters, and returned having adopted a new style learned from them.

But we now know that Wood operated at a far deeper level than with a preoccupation for mere decorative resonance and homogeneity. Had his biographers, in other words, seen that *Portrait of Nan* was a Verist exposé, they would have introduced to his critics, like Roberta Smith, a man who was not "steeped in pious nostalgia," and Judith Dobrzynski, a man who was trying to capture something altogether more interesting than "the dream-power of his childhood."[1]

We have just seen that Zamyatin and Huxley were popular because they had stirred readers' latent fears that the world's rich and powerful were scheming to perfect domination over their lower- and middle-class brethren. Yet, to Americans, the threat of totalitarianism in the early 1930s was largely an abstraction. Indeed, from the perspective of America's high-born, Hitler did not appear to be such an ogre, especially as they too, quite openly, looked down their noses upon Slavs, Poles, Russians, Gypsies, Communists, blacks, homosexuals, and Jews. News magazines like *Time* and *Life*, their pages filled to overflowing with language reflecting a vivid bias against people of "lower birth," were owned, written, and edited by a white, bigoted ruling class. It is not difficult to understand how racially charged opinions expressed regularly in the American press were easily acquired in the course of everyday life.

White, Anglo-Saxon, Protestant Americans, such as Wood's father Maryville Wood, his wife Hattie Weaver, and their daughter Nan might also have been inclined to regard Hitler from a safe distance of five thousand miles as brutish perhaps, but not entirely wrong. Talk of an evening might well have been laced with racist opinions learned from the oppressors of the world. In order to keep equally clear distinctions between themselves and society's underclass, ordinary American middle- and working-class men and women recited such opinions around their dinner tables. Little Grant was probably accustomed, as were many of his white, Anglo-Saxon peers, to hearing this sort of talk at home.

But as he grew to adulthood, recognizing his homosexuality, Wood came gradually and painfully to identify himself with the victims of prejudice, not with those dispensing it. The

dilemma was that for many the basis for social and political liberation stood in opposition to tolerance for deviants; just as clearly, the basis for universal fear of totalitarianism, fomented by Zamyatin and Huxley, was, at its root, the universal fear—no matter one's own erotic orientation—of sexual repression.[2]

Grant Wood may well have grown up in an atmosphere tinged with militarism, racial and class paranoia. But by 1933 he made common cause with those on the political left, who were disgusted and threatened by it.

Nan had not only acquiesced to sit for Wood as the spinster in *American Gothic*, but she had suffered herself to model for the figure in *Memorial Window*. Both works, we now know, incorporate homoerotic symbols. And so, I suggest that his supposed affection for Nan was not, as his biographers have insisted, entirely unequivocal. Here, then, was the germ of the idea Wood needed to work into *Portrait of Nan*, his "favorite sister."

Detail: *Portrait of Nan*, 1933.

Just as Hitler repressed the impure, Nan was in Wood's mind a surrogate for all those who repressed him. As for those "odd attributes" she holds, a plum and a chick, these cannot—no matter what Grant's or Nan's disavowal—simply be objects with a compelling shape or color.

The German word for plum, *Die Pflaume*, is slang for the pudendum. A plum may well be purple, but it is impossible not to see the cleft into which that little chick so intently fixes his stare as the singular property of the plum that was of interest to him and to Wood. The chick could also be a pullet; but, of course, baby chicks come in two sexes, and it was Wood's predisposition to paint cockerels. What Nan so serenely holds in her two carefully mannered hands is the very engine of Wood's most affecting memory of his sister: the male and female genitalia, just the attributes, after a lifetime of sexual repression, she would want least to hold. And those are not likely "jaunty black ribbons" on Nan's shoulders. They are bats, a rude pejorative for a domineering woman. And the polka dots?

By 1933, the year President Hindenburg of the Weimar Republic (1925–34) appointed Hitler chancellor of the Third Reich, *Mein Kampf* stood atop the German bestseller lists. The book, which first appeared in 1925, did not attract much notice

at home and did not appear in English until 1939, so it is improbable that Grant Wood ever read it. But, in 1928, Wood was in Munich, and he could not have been unaware of the bombastic, small-party politician who was loudly blaming Germany's problems on the Jews and the homosexuals, and expounding a fantastic theory that Germany could regain its lost glory if it but had more land and raw materials, more *Lebensraum*—living space—from which to feed its people. To get it, Hitler suggested that the superior race of German people would simply kill or deport the pesky Jews, and then push out or enslave the inferior populations to the east, in Russia and in Poland—home of the polka, a dance popular among Slavs, Russians, Czechs, and Croats that originated in Bohemia.

Gentle reader: you are marveling at my insistence that there was a convergence between Grant Wood, an avowed American Regionalist, living and painting in rural Iowa, and Hitler, a Nazi monster bent upon purging the impure and undesirable from his society in faraway Germany.

But in 1933 the corpus of conservative Americans—not just Henry Ford, Herbert C. Hoover, Charles A. Lindberg, and Thomas J. Watson—was stridently anti-Semitic and not entirely unsympathetic to Hitler's theories. The electorate had only recently consigned the Republicans to the minority, which was keen to oppose Roosevelt and his "Jew-ridden" New Deal. They preached nonintervention and isolationism, noting that there was, providentially, a "wavy, deep-green ocean between America and Europe's internal politics, a natural barrier." This was indisputably the political climate in which Wood worked and lived; how could a timid, deeply-closeted homosexual speak of his opposition to it when it was all around him, and when calling it out would only bring attention to him?

The expression to "draw back the curtain on" means to expose something otherwise hidden, or to bring clarity to an obscure subject. "Drawn" and "closed" are metaphysical properties of the curtain: we have seen previously how Wood drew back the curtain on Parson Weems, exposing the tale of Washington and the cherry tree as an improbable lie. Here we see that Wood draws back a wavy, deep green curtain such as we see pulled

back over Nan's shoulder, on his sister, removing her cover and inviting revelation.

In answer to my question about Nan's political leanings, Corn tells me that Nan never talked about politics and never expressed negative sentiments about others. Perhaps she did not with Wanda. But in *Portrait of Nan* Wood tells us that his sister was, like so many others in early twentieth century America, hostile to minorities, to Jews and homosexuals. Wood tells us that Nan was an anti-Semite.

How else to explain Nan's proximity to the Star of David that Wood very clearly picked out on the antique drapery knob that holds back the curtain exposing her? How else to explain Nan's extravagantly wavy, so very blond hair and startlingly opalescent, steel blue eyes but as parables of the pure Nordic traits the Nazis—and perhaps the Woods—worshipped in themselves?* In *Portrait of Nan*, his favorite sister to whom he was "making up" for prior insults, Nan *is* Hitler, Wood's own sexual repressor, his own totalitarian tyrant.

The only question remaining—which we cannot answer—is whether Nan knew Grant's secret and how, in his art, he used her. In *Portrait of Nan*, so carefully and thoroughly encrypted, Nan would, in all likelihood, not have seen her brother's uncouth message: she is said to have boasted that, because he was so fond of her, Wood never sold the picture and, in fact, he had it still, at the end of his life. But could she have missed the Star of David? It is ultimately not human to laugh alone; did Wood finally include her—or anyone—in the joke?

Haskell (*op. cit.*, p. 24) scorns my assertion that Wood's inclusion in 1933 of a Star of David (which she sees as a symbol of the American Legion, a symbol that has at its center a star with five points, not six) in *Portrait of Nan* (which Haskell erroneously dates 1931) was a prescient warning about the rise of Nazism in Germany to an America largely oblivious to Hitler. In addition to his own experience, Wood's source was undoubtedly Cedar Rapids friend William Shirer (1904–1993), who with Edward R. Murrow was in Germany from 1925 to 1933 broadcasting for CBS News. Shirer

Detail: *Portrait of Nan*, 1933.

would later publish notes from his journal in *Berlin Diaries* (1941) and *The Rise and Fall of the Third Reich* (1960). Haskell and her coauthors refer four times to Shirer and they even note that Wood based his Aesop's Fables drawing *The Wolf and the Lamb* on Neville Chamberlain's ceding of Sudetenland to Hitler in the Munich Agreement of 1938. But they see no more evidence in Wood's work of his sympathy for the victims of the Nazis and the fascists. Haskell et al also note (as have all Wood's biographers before them) that journalists regularly and rather brutally pilloried Wood for what they interpreted as his jingoism, but they fail to see (as have all Wood's biographers before them) that feelings of sympathy journalists might have accorded to lambs they were disinclined to accord to Jews and homosexuals.

Those wishing to gain a better understanding of Wood's dilemma might consider that in 1929 the Iowa General Assembly created a Board of Eugenics "to investigate persons who were a menace to society."[3] The board recommended for sterilization persons it deemed to be habitual criminals, epileptics, feebleminded, alcoholics, moral degenerates, including the sexually perverted and prostitutes, the blind, the deaf, the deformed, and the indigent. The greatest single promoter of eugenic sterilization in the United States was Wood's fellow Iowan Harry Laughlin (1880–1943). Laughlin began his career as a teacher with an interest in Mendelian inheritance, which soon

* The November 26, 1934, edition of *Time* magazine includes a story in which the writer suggests, with his tongue not altogether in his cheek, that in Germany "Adolf Hitler has driven many a Jew to peroxide . . . but looking like a blond does not make you a Nordic."

led him to eugenics. In 1924, Laughlin provided testimony to the US Congress in support of the Johnson-Reed Immigration Act, aimed at arresting the influx of Russian and Italian immigrants, who Laughlin alleged exhibited "excessive insanity." Laughlin's remedy was compulsory sterilization, laws calling for which spread like wild fire throughout the United States. Between 1907 and 1940, twenty-seven states enacted eugenical laws under which sixty thousand people were involuntarily sterilized. And although American eugenicists disassociated themselves from Nazi Germany's sterilization program, under which 72,000 persons were sterilized in 1935 alone, the American laws were patterned after the Law for

the Prevention of Hereditarily Diseased Offspring, which the Reichstag passed in 1933. If you are not yet persuaded that these events had an effect upon Grant Wood, in 1936 the University of Heidelberg awarded Laughlin an honorary degree for his work on behalf of the "science of racial cleansing."[4]

In this quotidian matter of inclusion and exclusion, a fence line serves in the countryside as the separator between one field and another, dividing neighbors or incompatible activities like haying from grazing, or field from bog. Fences have contradictory metaphysical properties: they can keep certain things out while simultaneously keeping certain other things in. They present a potent barrier, yet, as we have seen in *Clothes*

(*Appraisal*), they are also transparent and pervious. To be sure, they are a common sight in rural Iowa. But the frequent appearance of fence lines in Wood's oeuvre (16) suggests significance well beyond their workaday attributes.

As a homosexual living in Depression-era Iowa, Wood would have constantly felt himself fenced in or out, included or isolated from the people on Main Street, whose regrettable nature it was to feel threatened by persons or orientations foreign to themselves.

In the enigmatic and uncommonly apocalyptic *Death on the Ridge Road* (1935), Wood anticipates the fate of those luckless souls whose path through life, like his own, lies not in the lush, green meadows but on the steep, perilous curves running between the fences, a path starkly delineated by dark, foreboding storm clouds and silhouetted ominously with crosses. For Wood, crosses served as reminders of the power of repressive institutions like the church, the state, and the family.* Death can, of course, be figural as well as literal: 1935 was, not coincidentally but

prophetically, the same year he was married. As he once poignantly carved on a school bench for delinquents, Wood's message here was simply that "The Way of the Transgressor Is Hard."

No one can fail to see the dark atmosphere permeating *Death on the Ridge Road*, but perhaps the most startling aspect of the picture is the zigzag contours of the road as it crests the hill. And when the fences on either side of the road are strung with barbed wire, as they are in both *Death on the Ridge* Road, 1935, and again in *February*, 1941, we have occasion to wonder if the artist is not remarking that, in Germany, fencing was being used to hold something other than farm animals.*

The zigzag is an ancient, eye-catching element of design. In addition to *Death on the Ridge Road*, several other of Wood's mature paintings including *Young Corn*, 1931; *Fall Plowing*, 1931; *Near Sundown*, 1933; *Spring Turning*, 1936; *Adolescence*,

*Approaching Storm*, 1940. Lithograph, 16 × 20 in. (Cedar Rapids Museum of Art, Gift of Harriet Y. and John B. Turner II, 82.1.2.40)

*February*, 1941. Lithograph, 16 × 20 in. (Cedar Rapids Museum of Art, Gift of Harriet Y. and John B. Turner II, 72.12.19)

---

* Cole Porter, arguably the most brilliant songwriter of the twentieth century, lived in Williamstown and, although a graduate of Yale, he made a gift of *Death on the Ridge Road* to Williams College. With "Let's Do It" and "The Gay Divorcee," Porter, famous for his sexual ambiguity, made double entendre an art form all his own.

* On August 8, 1934, the New Republic reported that the Germans had begun restraining political prisoners behind barbed wire at the concentration camp at Dachau, which the Nazis had established in 1933. William Shirer, who arrived in Germany in the summer of 1934, also reported on this, but after the war the Allied forces insisted they did not know about the camps until 1941 at the earliest. https://newrepublic.com/article/119850/1934-report-dachau-concentration-camp

*Iowa Landscape ("The Crik")*, 1934. Oil on board, 12¹/₂ × 14⁵/₈ in. (Minnesota Museum of American Art, Katherine G. Ordway Fund, 91.29.01)

SS collar insignia, 2nd pattern. Photo courtesy of Eddie Stark, London.

1940; and *January*, 1940; a book jacket drawing for Fannie Hurst;* and seven of his lithographs, *January*, 1937; *In the Spring*, 1939; *July Fifteenth*, 1939; *Approaching Storm*, 1940; *February*, 1941; *March*, 1941; and *December Afternoon*, 1941, are all organized around a zigzag theme. These compositions begin in 1931 and continue until Wood's death in 1942—the period coincident with Hitler's ascendancy. Why?

The zigzag is, of course, what gives the letter Z its sizzle; and the letter Z is what gives words like *jazz* and *Nazi* their fizz. In mirror image, the Z is also reminiscent of the twin lightning-strike S's forming the collar insignia worn by Hitler's Schutzstaffel, or SS. The Z is also reminiscent of the large purple Z or *zensiert* stamps appearing on correspondence to and from prisoners in the camps, which indicated that a Nazi censor had reviewed them.

Wood's most obvious reference to the SS appears in a recently discovered painting titled *Iowa Landscape*, or, alternatively *The Crik* (1934), in which the symbol is unmistakable.*

* Fannie Hurst (1885–1968) was a Jewish-American novelist and short story writer whose works combined sentimental, romantic themes with social issues of the day, women's rights, race relations, African American equality, and New Deal programs. Hurst was a friend of Eleanor Roosevelt and a frequent White House visitor. In 1940, she was appointed to the National Advisory Committee to the WPA, and in 1963 she received an honorary award from the Zionist women's organization Hadassah. In 1958, Hurst hosted a television talk show called *Showcase*, notable for presenting the earliest well-rounded discussions of homosexuality. *Showcase* was the first program on which homosexual men spoke for themselves rather than being debated by a panel of "experts." https://en.wikipedia.org/wiki/Fannie Hurst

* *Iowa Landscape (The Crik)*, 1934, is said to have been painted for Eleanor Jessup, whose husband, Walter Jessup, was the University of Iowa president responsible for Wood's appointment to its faculty in that year. *See* Donald Myers, *Our Treasures: Highlights from the Minnesota Museum of American Art*, Kristin Makholm, ed. (St. Paul: Minnesota Museum of American Art, 2011), pp. 76-77 140 https://en.wikipedia.org/wiki/Uniforms and insignia of the Schutzstaffel

When, in 1933, Hitler finally became chancellor, he had but a slim minority and many enemies, whom he is said to have played off against each other, appearing to concede ground first to one, then to the other, advancing neither, upsetting neither, while advancing only himself. "Zigzag" is a sobriquet used by historians to refer to the chancellor, whose infamous, dialectical strategy of advance-retreat-advance, or unity-split-unity, by which he alternately attacked-appeased-attacked his gullible European adversaries, stymieing them while furthering his own agenda during his quest to consolidate his power.

Many of Wood's lithographs are named for seasons or months, leading art historians to suppose that the artist was merely showing us what January, March, July, or December looked like in Iowa. But if Wood instead intended the zigzag as an esoteric reference to Nazi Germany, clearly he was reaching for something more declarative than a paean to the seasons.

The SS, or runes, insignia was introduced in 1933, shortly after Hitler had become chancellor. As a result of SS participation in the Night of the Long Knives on June 30, 1934, the SS insignia became the symbol of Hitler's brutality.[5]

In Wood's lithograph titled *March*, 1941, his most pronounced invocation of Hitler's SS insignia, we perhaps see Wood's response to *Operation Barbarossa*, the code name for Hitler's *march* into the Soviet Union, which began on June 22, 1941. Wood's title *Approaching Storm* is another clear, if less specific, candidate for such an interpretation. Only slightly more rewarding, Germany declared war against the United States in the *afternoon* of December 11, 1941. Perhaps the horse "let out of the barn," so to speak, is a reference to the infamous Molotov–Ribbentrop Pact, officially known as the Treaty of Non-Aggression between Germany and the Union of Soviet Socialist Republics, which provided a written guarantee of peace by each party towards the other. The Pact was terminated when the *Wehrmacht* launched Operation Barbarossa and invaded the Soviet Union (as well as executing the ideological goal of *Lebensraum*).

Because of the remarkable specificity of the title of his lithograph *July Fifteenth*, I looked for some event in the Nazi timeline that occurred on that date, and I found one, but it referred not to Hitler or the Nazis but to Italo Balbo (Italian,

*March*, 1941. Lithograph, 16 × 20 in. (Cedar Rapids Museum of Art, Museum Purchase, 90.6)

*December Afternoon*, 1941. Lithograph, 16 × 20 in. (Cedar Rapids Museum of Art Gift of Harriet Y. and John B. Turner, II, 72.12.14)

July Fifteenth, 1939. Litho-graph, 16 × 20 in. (Cedar Rapids Museum of Art, Gift of Harriet Y. and John B. Turner II, 72.12.14)

1896–1940), an Italian fascist after whom Chicago's Balbo Drive is named. The connection between facism, Balbo, and Chicago, Wood's closest cultural center, excited my curiosity.

After returning home a war hero from World War I, Balbo joined Mussolini's Fascist Party. Wishing to restore what they interpreted as the glory of ancient Rome, the fascists wanted a strong, nationalist state with a powerful leader and no opposition party.

The Italian economy was, like the German economy, in shambles after World War I. Buffeted by criticism from socialists, communists, Catholics, and Democrats, King Victor Emmanuel III, whose reign coincided with the birth, rise and fall of Italian fascism, lived in constant fear of overthrow. Disgusted veterans like Balbo banded into fascist gangs, or *squadristi*, which would fight to replace the government with one backing Mussolini.

Balbo's organizational genius and charisma first shone through during his time in the *squadristi*. Under his leadership, these disorganized bands of hooligans became disciplined paramilitary units. In a matter of months, the paramilitary forces were responsible for transforming Mussolini's marginal movement into a major, national political force. Their actions inspired other *squadristi* in Germany to adopt Balbo's battle tactics and his fighters' uniform: the Black Shirt.[6]

At the 1933 *Century of Progress Exposition*, Chicagoans also sought to restore what they regarded as the glories of ancient Rome and looked to Germany and Italy for a political model that might lead them to a more glorious future.

King Victor, desperately wishing to flaunt his own modernizing vigor, sent a squadron of twenty-four seaplanes under the command of Italo Balbo, the Minister of Aviation, to Chicago on the first transatlantic crossing by the Italian air force. When Balbo arrived on *July 15, 1933*, the city was in such a panic of adulation for this heroic figure and what they perceived he stood for, they installed an ancient Roman column, a gift from fascist Italy uprooted from Ostia, to commemorate Balbo's flight that still stands today on the fairgrounds near Soldier Field.[7]

The unholy trinity of fascism, Futurism, and aviation was a central, cultural, and technological motif of the years from the Wright Brothers to the Spitfire. The political and human consequences of this unholy intersection is the subject of Pablo Picasso's painting *Guernica*, depicting the destruction, at the request of Spanish Nationalists in April 1937, of that town by German and Italian war planes, during the Spanish civil war.

Hermann Göring, the notorious commander of the Luftwaffe during World War I, had himself been a "flying ace," a heroic metaphor combining machine and masculinity. The US had the equivalent figure in Charles Lindbergh, who unabashedly combined aviation with pro-Nazism, anti-communism, anti-Semitism, Nordicism, and eugenicism. For these men, the airplane was the future and the future was "joy through war."[8]

Eugenicism is rooted in utopianism and was the basis in many Western countries of a social philosophy, including sexual orientation and gender. Grant Wood could not have been oblivious to these sentiments taking root in Chicago and, in fact, they terrified him.

In 1933 the horror of the Nazis was not yet widely realized in this country, but Chicago's upper class virtually swooned over Italo Balbo. Loyola University gave him an honorary degree. In 1934 Mayor Ed Kelly had erected Mussolini's gigantic gift, and renamed seventh Street as Balbo Drive. The inscription at the base of the monument would have sent chills down Wood's spine: "Fascist Italy

*The American Golfer: Portrait of Charles Campbell*, 1940. Oil on board, 36 1/2 × 48 in. (92.7 × 121.9 cm). (Crystal Bridges Museum of American Art, Bentonville, Arkansas, 2014.33)

with the sponsorship of Benito Mussolini presents to Chicago . . . in the 11th year of the Fascist Era."[9]

Wood's lithograph *July Fifteenth*, a seemingly straightforward landscape curiously devoid of conventional subject matter, was the strongest statement in condemnation he could allow himself to make of the alarming connection between aviation and Fascism, which in 1934, Chicago had literally set in stone.

That Wood's zigzag paintings and lithographs are not more strident references to Hitler speaks not to the vehemence of his opposition to repressive, autocratic government, but to his habitual timidity. The message underlying *July Fifteenth* is no more obvious to us today than is the phallic symbol in *American Gothic*.

The zigzag design also appears quite prominently in *An American Golfer: Portrait of Charles Campbell* (1940). To those who might see in this picture simply a portrait, I am inclined to speculate, but am unable to corroborate, that Campbell was not only gay—the acorns, one of which is conspicuously out of its sheath suggesting that Campbell was uncircumcised—a

Republican—the patrician "merchant-class gentry of New England"[10] aspect, the golf club, the stately home—a fascist, a eugenicist, and an anti-Semite.

1 https://www.nytimes.com/2018/03/15/arts/grant-wood-review-whitney-museum.html https://www.wsj.com/articles/grant-wood-more-than-american-gothic-1519847743

2 Jonathan Rose, "Abolishing the Orgasm: Orwell and the Politics of Sexual Persecution," *George Orwell: Into the Twenty-First Century*, Thomas Cushman and John Rodden, eds. (London: Paradigm Books, 2004), 28–29.

3 https://ir.uiowa.edu/cgi/viewcontent.cgi?article=9900&context=annals-of-iowa

4 https://en.wikipedia.org/wiki/Harry_H._Laughlin. In 1934, Chicago's Loyola University conferred one on the fascist Italo Balbo. Probably just a coincidence but Wood published his lithograph *Honorary Degree* in 1937.

5 https://en.wikipedia.org/wiki/Uniforms_and_insignia_of_the_Schutzstaffel

6 http://www.chicagomag.com/Chicago-Magazine/August-2008/Dubious-Legacy/

7 http://www.encyclopedia.chicagohistory.org/pages/11277.html

8 http://www.workersliberty.org/node/7929

9 http://www.chicagotribune.com/entertainment/ct-ent-balbo-monument-20170817-story.html

10 Dennis, *op. cit.*, 116.

# Conclusion

Whether or not Grant Wood actually read Zamyatin, Huxley, or Hitler, it is not hard to imagine anything more agonizing than knowing that to reveal one's true self risked harsh reprisals, social ostracism, professional ruin, criminal charges, physical peril, or even violent death. When the wages are this high, secrecy becomes not just an obsession, but an imperative.

Wood's drawing O, *Chautauqua* has always stood out as curiously out of place in his oeuvre. But perhaps it was not so atypical.

Chautauqua was founded in 1874 as a camp meeting for educators, who would gather annually to express their belief that, through openness, everyone in spite of his or her peculiarities should strive to know all that he/she could know, to be all that he/she could be.

Chautauqua spread rapidly across the Midwest, reaching its height in 1920 to 1924; it was particularly popular in Iowa. The secular, essentially ecumenical nature of the meeting gradually succumbed to the broad array of social changes accompanying the Great Depression, and all but disappeared in the late thirties.

I do not know if Wood attended Chautauqua meetings. But his interest in its theme of liberal education, in being open and in "being all that one could be," fans out like the lines holding up the proverbial "big tent," where the crowd gathers dangerously close to, but still outside, the long shadow of Christianity. While ostensibly serving

Book jacket for Thomas W. Duncan's *O, Chautauqua* (New York: Coward, McCann, 1935). (Collection of the author; photo by the author)

the author's purpose illustrating the cover of his novel, Wood typically lays his own message deeply between Duncan's lines.

In his 1944 biography of Grant Wood, Darrell Garwood makes multiple references to a stammering, insecure, and timid man unable or unwilling to look people in the eye, a man who could not help shifting his weight from side to side to quell his feelings of insecurity. To these sad qualities, we can now add that Wood spent his professional life, both in paint and in word, spinning a web of deception in an effort to conceal the person he was, or to present a person he was not. It is a cruel irony that the very qualities for which Wood or his work has been both loved and ridiculed, the clean-cut, wholesome, slyly satirical Midwesterner speaking out against Modernism and in support of good old-fashioned family values, was not only the man he was the furthest from being, but the man he wanted above all else not to be. Seeing now that his outward life and work did not speak forthrightly for his innermost thoughts, it is time for a sweeping reappraisal of his work.

In his groundbreaking book *On Human Nature*, E. O. Wilson argues that with modern-day computers it is theoretically possible for scientists to track every minute action and every variation from the seemingly random meanderings of the honeybee, and from there, to predict the movements of any individual bee's life.[1]

Stretching the point, Wilson wonders if scientists could do likewise for humans. Success in such an endeavor, while very much more complex, would reduce the paradox of Newtonian Determinism versus Free Will to an empirical certainty, removing from contention that most cherished of all human conceits: the notion that the outcome of our lives is merely mechanistic and not guided by intelligence and choice.

But if, as Wilson suggests, human nature is hardwired, then we bear no responsibility for our actions or their consequences, for what we do right or wrong, for crimes or acts of benevolence,

for our sexual preferences, or for any subsequent actions that follow upon the accidental union of two or more lives. Might not the sex organs also be, like the hands, the unwitting agents of the mind, without responsibility for themselves, or does a higher authority, independent even of their host, direct them?

Alas: society is perennially intolerant of the suggestion that external factors cause behavior beyond our control. The Judeo-Christian ethic explicitly teaches that we are responsible for our own actions, which is why, as children, we must learn to make "good" choices. If, and when, some people make poor ones, they will be obliged to pay a price. To preserve the delusion of free will, we cling to choice as the explanation for sexual deviation, granting to ourselves the authority to excuse it where we can, and to punish it vigorously where we cannot. Yet, inconveniently, if unbiased observation of human nature has revealed anything, it is that homosexuality is not only commonplace, it is hardwired and cannot be "corrected."

We are, nonetheless, loath to excuse certain of our cultural heroes when it is discovered they are not straight: Tyrone Powers, Cole Porter, Charles Laughton, Rock Hudson, Cary Grant, Grete Garbo, cowboys, painters, athletes. At best, it loosens the ground under them; at worst, it disrupts ancient convictions that human intellect guides our actions and that we have the competence to make our own choices. Grant Wood is a whole lot more interesting than the yokum we've been told he was, and I hope this book will allow us to look beyond the persona he wanted us to see, and see instead the man he buried deep below the surface.

1 Edward O. Wilson, *On Human Nature* (Cambridge: Harvard University Press, 1978), 76–77.

# Appendix I

Wood painted *Dinner for Threshers* at 5 Turner Alley in 1934, some two hundred years after "Oranges and Lemons" (see page 89) is thought to have originated in England. And it *does* seem a stretch, even for me, to suggest that Wood knew the rhyme and designed 5 Turner Alley—or *Dinner for Threshers*—to echo certain of its lines. Could it have been a favorite ditty of his mother or his sister who, through repetition, lodged it indelibly in his mind? Either way, its affinity with *Dinner for Threshers* is remarkable.

Obviously, certain lines like "Gay go up, and gay go down" would have been of interest. But there are others: The "Bull's eye" or "target" in the rhyme echoes the rug on the floor of the kitchen in *Dinner for Threshers*, which looks just like the rag rug his mother hand-braided for their little garret. According to Corn, the floor of the Woods' garage apartment was scored to resemble "tiles" like those in the poem, for which work, again according to Corn, Wood designed a "chopper" inspired by his mother's cabbage chopper knife. Wood, famously handy with wrought iron, fashioned a "poker and tong" for the studio fireplace.*

Wood was married in 1935, the year after he painted *Dinner for Threshers*, and some think "Oranges and Lemons" was a wedding rhyme: "Old shoes and slippers" were customarily thrown at newly wedded couples. "Old father baldgate" [or baldpate], like the heads of the men in the painting, is slang for the phallus, and "Maids in white aprons," like those in the painting, refers to virgins. The "chopper" in the poem is another vulgar euphemism for the penis. The "head" would be a reference to maidenhead, which the virgin bride, her way in the dark "lit by a candle," i.e., a phallus, will that night lose in her wedding bed.

---

* I am not nearly inventive enough to have made all this up. For a fuller description of the decorations in and photographs of 5 Turner Alley, *see* Corn, *op. cit.*, p. 22.

# Oranges and Lemons

Gay go up, and gay go down
To ring the bells of London town.
Bull's eyes and targets,
Say the bells of St. Margaret's.
Brickbats and tiles,
Say the bells of St. Giles.
Oranges and lemons,
Say the bells of St. Clement's.
Old shoes and slippers,
Say the bells of St. Peter's.
A stick and two apples,
Say the bells of Whitechapel.
Old father baldpate,
Say the slow bells at Aldgate.
Maids in white aprons,
Say the bells at St. Catherine's.
Pokers and tongs,
Say the bells of St. Anne's.

Halfpenny and farthings,
Say the bells of St. Martin's.
When will you pay me?
Say the bells at Old Bailey.
When I grow rich,
Say the bells at Shoreditch.
Pray, when will that be?
Say the bells of Stepney.
I'm sure I don't know,
Says the great bell at Bow
(Here comes a candle—to light you to bed,
Here comes a chopper—to chop off your head!)[1]

1 Roberts, *op. cit.*, 64-65.

# Appendix II

Jay Sigmund, born in Wabeek Iowa, 1885, and who died Cedar Rapids, 1937, in a "rabbit hunting accident," was a friend of Grant Wood's and a writer, who published a book of short stories and poems titled *The Ridge Road* (Cedar Rapids: Torch Press, 1930). Sharing a reference to Wood's painting *Death on the Ridge Road*, painted five years later in 1935, and perhaps some other message about the infamous road's local lore, I found this poem, "Hooked Rug," with its references to hooked rugs, attics and garrets, letters tied with string, a "gayer" house, and pleas not to pry too deeply into secrets, particularly apposite to the furnishings at 5 Turner Alley:

The attic gave its share –
Each raveled, faded shred
Which long had mildewed there
Held kinship with the dead.

This coat a fighter had
Before his lips went mute:
It made a ridge road lad
March proudly to a flute.

This crinolene and lace,
All ribbon-decked and pale
Was worn beneath a face
That later knew a veil.

This spangled crimson frock
Which harbors wasp and mouse
Beneath that broken clock,
Has known a gayer house.

Oh, do not pry too deep
Among these buried things!
Oh, let the dead past keep
These letters bound by strings!

Hand-craft may weave red birds
From garret-gathered cloth
But leave the warp of words
To feed some silent moth!

# Index

# Charles Sheeler and Albert Einstein

*Pioneers in the*
*Exploration of Spacetime!*

*"Sheeler's work records the displacement of the Natural by the Industrial . . . The subject was the style; exact, hard, flat, big, industrial. Anything live or organic was out. There was no such thing as a Precisionist pussycat [sic]."*

—Robert Hughes*

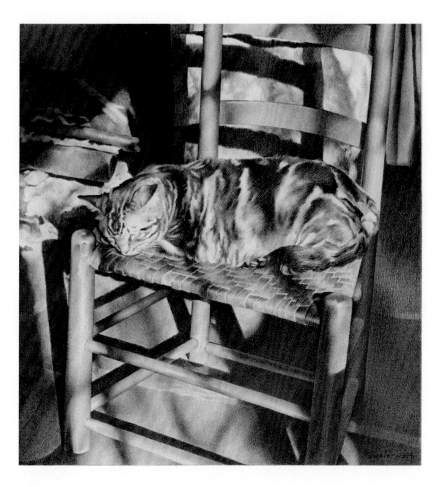

*Feline Felicity*, 1934. Conte crayon on paper, 22 × 18 in. Harvard University (Fogg Art Museum), Cambridge.

* Robert Hughes, *American Visions: The Epic History of Art in America* (New York: Alfred A. Knopf, 1997), 382.

*For Nigel Van Wieck*

# Contents

# Summary

In the ninth (or tenth) century, Saint Andrew the Fool, keeping vigil in a Constantinople church where the robes of the Mother of God were preserved, suddenly saw the Virgin appear and spread her veil over the congregation. Six centuries later, an artist in northern Russia painted an icon on which Saint Andrew's vision happened again—and again and again—right there in the picture. To the faithful, icons are not static pictures of events from the past: they are *tableau vivant* in a constantly renewing present. In such icons, martyrs bleed warm blood, the Virgin weeps salty tears: you look at them and they look back at you.[1]

Notwithstanding the mystical powers with which some believe Russian icons to have been invested, our certain conviction today is that paintings, secular or devotional, inhabit none but static, two-dimensional space. Time and sequence—the depiction on one canvas of live-action or sequential events—is simply not the province of the painted form. While a play, a book, or a musical composition do consume time—to experience these, one must expend time getting from beginning to end—a painting (which may have taken weeks, months, or years to create), once completed, is at best experienced at a look and is, at worst, "dead" on arrival.

1 Holland Carter, "Russian City's Sacred and Secular Visions" in *The New York Times*, Weekend Arts, Section B33, Friday November 18, 2005

# Author's Note

The opinions expressed here are derived *a posteriori*, i.e., not from written documents found in the library but from an amalgamation of information gleaned from the canon and direct observation and interpretation of empirical evidence found in the work. Using this method as my touchstone, it gradually became clear that Sheeler was on a quest for the fourth dimension—a term that does not appear in the Sheeler canon—through which he ventured to include space and time in his work not as mere features of an otherwise two-dimensional construction but as its *parti*, its organizing idea.

Readers are also advised that an understanding of my argument depends on a layman's acquaintance with the arcane and often inscrutable jargon of post-Euclidean geometry and early twentieth-century physics, a survey of which I present in part I.

—James H. Maroney, Jr.
Leicester, Vermont
May 2019

# Introduction

In *Feline Felicity* (1934) (frontispiece), Sheeler gives us a picture of a cat sunning herself on a chair as the light and shadow, coming through the blinds, plays a pretty melody on her patterned fur. The canonical explanation for this "gentle rendering" is that Sheeler was responding to criticism that his "cold, precise style was suitable only for representations of technology."[1] Carol Troyen and Erica Hirshler, together with Theodore Stebbins and Norman Keyes, the four authors of the most recent Sheeler biography, join in this view, describing *Feline Felicity* as a "cozy scene . . . a charmingly domestic, sentimentally engaging rather than cloying" image of his "dozing pet." They note somewhat parenthetically that the drawing is executed in a "meticulous technique of tiny, barely discernable strokes."[2]

It is indeed.

The underlying premise of this paper is that *Feline Felicity*—and many other of Sheeler's finest works, such as his suite of photographs and drawings of his wife Katharine's *Nude Torso* (1920); all his tabletop still lifes (ca. 1920–1931); *Pertaining to Yachts and Yachting* (1922); *Self Portrait* (1923); his suite of photographs of the *Cathedral at Chartres* (1929); *View of New York* (1931); his so-called *Interiors* (1926–1934); *Winter Window* (1941); and *The Artist Looks at Nature* (1943)—do not fit into the canonical interpretation of his work and have had, therefore, to be either forced into it, dealt with summarily, or ignored.

Robert Hughes, irrespective of his great service to American art history, was engaged in the first of these when he wrote that there is "no such thing as a Precisionist pussycat." Hughes should have known that Sheeler never referred to himself as a "Precisionist," and as we will see, his supposed infatuation with "exact, hard, flat, big, industrial" buildings, straight lines, solid forms, "national pride, home and craftsmanship" does not square with his manifesto of 1916, in which he made no mention of these inapposite things.

Sheeler's objective in composing *Feline Felicity* was not to make what Constance Rourke calls "a genre piece" or "a bit of naturalism,"[3] but to assay cyclical and linear time, and a cat asleep on a ladder-back chair in front of a cold hearth provided an opportunity too good to pass up.

First, Sheeler took a photograph of the cat sleeping on the chair, by which he instantly reduced a Euclidean, three-dimensional cat down to a two-dimensional cat. Sheeler, of course, knew that a one-dimensional object with, say, length but no width and no depth, does not exist anywhere in this world. But he approximated a one-dimensional object as best he could by then making a drawing of the cat using the smallest marks he could make on the page. A cat, as everyone knows, has not just one but nine lives to cycle through; but we see her here fixed in time and space forever, a droll rendition of "cyclical time." The sunlight and shadow flowing across the forms

is a metaphor for continuous, linear time. The cold fireplace hearth over the cat's shoulder is an allusion to the second law of thermodynamics, which states that all natural processes proceed in but one direction, implying that there is asymmetry between past, present, and future events.

The ladder-back chair, a form with discreet, step-like features, like the stairs in the Doylestown House or the "sleepers" beneath the railroad tracks at the Ford Plant on the River Rouge, is a metaphor for discontinuous, linear time. The ladder-back chair seems like a gratuitous feature in *Feline Felicity*, but the ladder appears with regularity in Sheeler's pictures throughout his career: *Buggy* (1917); *Spring Interior* (1927); *Salvage Ship–Ford Plant* (1927); a photographic study for the painting *American Landscape* (1930), in which the ladder also appears; *Chartres–St Piat Chapel* (1929); *Installation*, a study for *Suspended Power* (1939), in which it does not appear.

The proliferation of the ladder in Sheeler's work draws my attention to the appearance of other ladder-like forms such as stairs where they are obviously not gratuitous features, e.g., *Staircase to the Studio* (1924), *Staircase Doylestown* (1925), *Classic Landscape* (1931), *Home Sweet Home* (1931), *River Rouge Plant* (1932), *Newhaven* (1932), and *Feline Felicity* (1934).

In the pages that follow, I will explain how and why Sheeler put all this into a two-dimensional drawing of a "Precisionist pussycat."

1 Carol Troyen and Erica Hirshler. *Charles Sheeler: Paintings and Drawings.* (Boston: Museum of Fine Arts, 1987), p. 150.

2 *Ibid.*

3 *Ibid*, p. 150

# Preface

*"Isn't it strange that we talk least about the things we think about most?"*

—Charles Lindbergh (1902–1974)

Before we go further, let us, in spite of the title of this paper, be clear on one point: it is untenable to suggest—and I do not—that Charles Sheeler, age twenty-two in 1905, could have independently conceived Albert Einstein's *Special Theory of Relativity*. It is hardly less so that Sheeler, age thirty-two in 1915, when Einstein published his *General Theory of Relativity*, could have read, comprehended, and incorporated into his work a concept then so arcane that it confounded even the greatest physicists of the era.

I do, nonetheless, vigorously assert that Sheeler, closely associated or acquainted in the period 1909 to 1918 with Leo and Gertrude Stein, Walter and Louise Arensberg, Marius de Zayas, Marcel Duchamp, Morton Schamberg, Patrick Henry Bruce, Morgan Russell, Stanton MacDonald Wright, Max Weber, Walter Pach, John Covert, Man Ray, and other members of Alfred Stieglitz's circle at "291," and dozens more European avant-garde writers, photographers, painters, and sculptors was wholly swept up in the quest for the inclusion of the fourth dimension into two-dimensional art. I further assert that after 1919 this quest became central to Sheeler's work and remained his lifelong pursuit.*

All his biographers agree that Sheeler was restive in William M. Chase's art class and that between 1909 to 1918 he sought a new direction. Yet nowhere in the Sheeler canon could I find the term "fourth dimension" or his affinity for it explored. We are asked instead to accept that while he was in the aura of Henri Matisse, Paul Cézanne, Juan Gris, Pablo Picasso, Francis Picabia, Gino Severini, Umberto Boccioni, El Lissitzky, the Fauves, the Dadaists, the Synchronists, and the Cubists, Sheeler was either stubbornly dedicated to the formal properties of natural objects or blindly adherent to their conventional representation, principles he had learned in Chase's art class.

Putting aside, for the moment, which of Sheeler's apposite affinities—William M. Chase or the avant-carde—affected him more, it bears pointing out that Einstein (1879–1955) and Sheeler (1883–1965) were contemporaries, each coming of age just as twentieth-century physicists in Europe would begin to dramatically revise ancient concepts of time and space. Everybody acknowledges the awakening of this new era: "Einstein [in 1905] changed the way physicists thought about the universe in a way the public could appreciate."[1]

* Charles Howard Hinton, who in his book *A New Era of Thought* (1888) had introduced hyperspace philosophy as the empirical justification for the fourth dimension, carried on a correspondence with William James from 1895 to 1896, the same academic year in which Gertrude Stein was a pupil of James's at Radcliff. Cited in Linda Dalrymple Henderson, *The Fourth Dimension and Non-Euclidean Geometry in Modern Art*, (Revised edition, Cambridge: M.I.T. Press) p. 218. Charles Sheeler, who gets but a footnote in Henderson, does not qualify for inclusion in her monumental work because he did not meet her criteria: Sheeler did not speak on the record or write about the fourth dimension.

"People were ready [in 1915] for something new and Einstein gave them a whole new universe."[2] But few have explored its effect on artists. Might not Sheeler have encountered stories in the American press about Neils Bohr, Albert Einstein, or Erwin Schrödinger and, along with other, well-informed readers, become aware that conventional notions of time were experiencing upheaval?

Actually, no: he would not. In the years 1909 to 1918, Sheeler would not in all likelihood have read or heard anything of relativity, or even of the obscure patent clerk Albert Einstein. The first mention in the popular American press of Einstein's theory of relativity did not appear in 1905, or even in 1915, awaiting proof of the bending of light by the gravitational effects of the sun. When the solar eclipse of May 29, 1919, provided that proof, the English press heralded Einstein as a genius. But *The New York Times* only reluctantly picked up the story two months later, treating it, and its obscure author, as a fantastic joke.

In subsequent editions, the *Times* did publish a series of articles in which topics important to Sheeler (and to my argument) were explicated, such as:

- The puzzle of simultaneity and the illusory perception of the sequence of events;
- A clock traveling a very long distance at the speed of light that gains no time;
- A rod of certain length moving at a high rate of speed that becomes shortened;
- The "fourth-dimension" and the curvature of space and time.

Readers were assured that there was nothing "wrong" in space and that such phenomena were anyway imperceptible; the fourth dimension, they were told, appears only in mathematical equations. "Till now, it was believed that time and space existed by themselves even if there were no sun, stars or earth . . . now we know time and space are not the vessel for the universe and could not exist at all if there were no sun, stars and earth."* Notwithstanding these explications, American scientists remained highly skeptical of Einstein, and *The New York Times* openly derided his theories, writing that the British "seem to have been seized with something like intellectual panic when they heard of photographic verification of the Einstein theory . . . they are slowly recovering as they realize that the sun still rises—apparently in the east." Not content with mere derision, Charles Lane Poor, a professor of celestial mechanics at Columbia University, stated flatly that "the supposed astronomical proofs of the Einstein theory . . . do not exist" and compared their author to characters in Lewis Carroll's *Through the Looking Glass*: "I have read various articles on the fourth dimension, the relativity theory of Einstein, and other psychological speculation on the constitution of the universe; and after reading them, I feel as Senator Brandegee felt after a celebrated dinner in Washington. I feel as if I had been wandering with Alice in Wonderland and had tea with the Mad Hatter." Another critic, George Francis Gillette, suggested that relativity was "cross-eyed physics . . . utterly mad . . . the moronic brain child of mental colic . . . the nadir of pure drivel . . . and voodoo nonsense. By 1940, relativity will be considered a joke. Einstein is already dead and buried alongside Anderson, Grimm and the Mad Hatter."

I cannot say if Sheeler had an epiphany when—or even if—he first read of Einstein or whether lay concepts of time and its curious metaphysical attributes circulated independently in his head. He did not, like some of his friends and acquaintances cited above, ever write or proselytize about the fourth dimension.

Yet in 1916, barely a year after Einstein's second paper and three years *before* the eclipse that confirmed his discovery, and a century before the appearance of this description of Sheeler's nascent aesthetic, the young artist gave this hint of what he would henceforth be about:

---

* "Einstein and Relativity", in *The New York Times* Dec. 2, 1919, p. 12; "Einstein Expounds His New Theory/ Discards Absolute Time and Space/ Improves on Newton" in *The New York Times* Dec. 3, 1919, p. 19; R.D. Carmichael, "Given the Speed, Time is Naught" in *The New York Times* Dec. 7, 1919, p. 18. Philipp Lenard, a physicist who won the Nobel Prize for discovering the photoelectric effect, a result that was finally explained by Einstein's theory, decried that Einstein was a "Jewish fraud" and that "relativity could have been predicted from the start – if race theory had been more widespread – since Einstein was a Jew." Cited in Michio Kaku, *Einstein's Cosmos: How Albert Einstein's Vision Transformed Our Understanding of Space and Time* (New York: W. W. Norton & Co., 2004) pp. 118-120

*I venture to define art as the perception through our sensibilities, more or less guided by intellect, of universal order, and its expression in terms more directly appealing to some particular phase of our sensibilities.*

*The highest phase of spiritual life has always, in one form or another, implied a consciousness of, and, in its greatest moments, a contact with, what we feel to be the profound scheme, system or order underlying the universe: call it harmonics, rhythm, law, fact, God, or whatever you will.*

*In my definition, I used the expression "through our sensibilities more or less guided by our intellects," and I here add "less rather than more," for I believe that human intellect is far less profound than human sensibility; that every thought is the mere shadow of some emotion, which casts it.*

*Plastic art I feel to be the perception of order in the visual world (this point I do not insist upon) and its expression in purely plastic terms (this point I absolutely insist upon). So that whatever problem may be, at any time, a particular artist's point of departure for creative aesthetic endeavor, or whatever may be his means of solving his particular problem, there remains but one test of the aesthetic value of a work of plastic art, but one approach to its understanding and appreciation, but one way in which it can communicate its most profound significance. Once this has been established, the observer will no longer be disturbed that at one time the artist may be interested in the relation of straight lines to curved, at another in the relation of yellow to blue or at another in the surface of brass to that of wood. One, two, or three dimensional space, color, light, and dark, dynamic power, gravitation or magnetic forces, the frictional resistance of surfaces and their absorptive qualities, all qualities capable of visual communication, are materials to the plastic artist; and he is free to use as many, or as few, as at the moment concern him. To oppose or relate these so as to communicate his sensations of some particular manifestation of cosmic order, this I believe to be the business of the artist.*[3]

In this, his first and only manifesto, Sheeler writes so abstrusely we are left to wonder if he intended to convey little or much; who among his readers, in 1916, could have known what exactly he meant by one-dimensional space? If you like, Sheeler says here only what any plastic artist working with the three well-known dimensions of space might. Yet the terminology he deploys connotes not just familiarity with Euclidean space, but time, or its first cousin, sequence: "phase, harmonics, rhythm, law, fact, God [as we shall see later on, God is the antithesis of sequence] . . . *dynamic power, gravitation or magnetic forces, the frictional resistance of surfaces and their absorptive qualities.*" Should we not be astonished that these esoteric terms, heretofore the province of only physicists and mathematicians, were in 1916 coming out of the mouth of an artist?

Charles Sheeler, in 1916, modestly proposes that he had the competence to combine into his pictures what we now call spacetime, including the most recent theories of mass, gravity, and relative motion, scientific concepts he could not yet have heard of, let alone comprehended. He postulated merely that in his hands light, space, and time would be malleable, and that he, a plastic artist, was free to either "oppose or relate" the tangible properties of the natural world to the intangible ones of the unseen world, and to use "as many or as few of them as, at the moment, concerned him." At the beginning of his career, in the second decade of the twentieth century, Sheeler was not attempting to make a working model of four-dimensional spacetime, which he could not do, but only to create a picture in two dimensions that also comprised the fourth dimension as a covariant of the conventional three. To do this, he would have to have thought deeply about time's perplexing and paradoxical properties. Evidence abounds that others had blazed this trail, but Charles Sheeler, virtually unknown to the scientists of his era, was actually in the van.

1 Dr. Michael Turner, Univ. of Chicago, quoted in Dennis Overbye, "The Next Einstein? Applications Welcome," cited in *The New York Times,* March 1, 2005, D1.

2 Ibid., D4.

3 Charles Sheeler, statement in *The Forum Exhibition of Modern American Painters* (New York: Anderson Galleries, 1916), unpaged, cited in Dochterman, *op. cit.,* 105. Carol Troyen & Erica E. Hirshler, *Charles Sheeler: Paintings and Drawings* (Boston: Museum of Fine Arts, 1987), cite on p. 6 the same statement but, curiously and significantly, they replace with ellipses several essential passages.

# A Short History of Time and Space

*"I like to take in hand something that begins at the beginning, and is at the middle when midway, and comes to an end at the conclusion; not a cobbler's job, that's at an end in the middle and at the beginning at the end."*

—Herman Melville, *Moby Dick*, 1851

While man has understood and manipulated three-dimensional space since at least Euclid of Alexandria (fl. 300 BC), it has always been necessary to accommodate time as an unrelated, inalterable fact. Until the nineteenth century. Suddenly, the invention of the train and the telegraph made it possible to travel or communicate over great distances seemingly instantaneously.

With the publication in 1915 of Albert Einstein's *General Theory of Relativity*, time could even experience slowing and bending, depending on the relative speed of the systems in which it was measured. The separate provinces of time and space were now conflated into spacetime, a complex enough notion in theory, yet far more so in application.*

Briefly, spacetime combines time with the familiar coordinates of three-dimensional, Euclidean space. When one adds mass and the force of gravity, the path of light traveling through space behaves as if it were curved, not linear. But light cannot curve through space without involving time; therefore, time too has a shape.[1] For that reason, spacetime disrupts the fundamental conception of cause and effect.

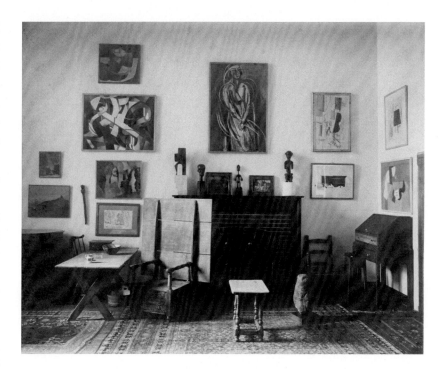

Living Room of New York Apartment of Louise and Walter Arensberg (Section of South Wall), ca. 1918. Gelatin silver print, sheet: 7¹⁵/₁₆ × 9¹⁵/₁₆ in. (20.2 × 25.2 cm). (Whitney Museum of American Art, New York; gift of James Maroney and Suzanne Fredericks, 80.30.4)

---

* The terms "spacetime" and "fourth dimension" have, as jargon, roughly synonymous meanings, the distinction being that the former, since Einstein, has been to the scientific community what, in the late nineteenth and early twentieth century, the latter was to the artistic community. I use them in these respective senses.

Think of a motion picture comprising thousands of individual frames passing through a light projector. As the film rolls, we experience the illusion of spatial events occurring in sequence. Watching the film over again, we see the same spatial relationships occur in the same sequence.

Of course, empirical, human experience gained over millennia tells us that events *do* follow in sequential order, and that life flows unerringly from past to present to future. Alas, all that experience was now useless. In spacetime everything that has happened is happening and will happen, is all there at once just like the individual frames in the film. Spill the frames off the spool, cut them up and look at them in any order, one by one, or upside down or left turned right, at any time today or next week: all frames are still there, all equally true. Sequence is, from this point of view, merely a construct. In a nutshell, this is spacetime.

The theory of relativity rests on two postulates:

- The velocity of light in a vacuum is the same in all frames of reference for all observers moving uniformly relative to each other.
- All laws of nature are the same in all frames of reference moving uniformly relative to each other.

We all know that to measure the speed of a body in motion, one needs a clock and a ruler. Not so in spacetime. The first of these two postulates, the principle of the constancy of the velocity of light, is the troublemaker: the speed of light is constant regardless of whether the observer is moving along with, toward, or away from the source.

Audaciously, Einstein reasoned that since this appeared to defy common sense, common sense must be wrong.[2] Einstein then reasoned that if the speed of light, as measured by an observer at rest relative to a light source, is the same as the speed of light as measured by an observer in motion, then the *measuring instruments* must change from one frame of reference to the other, in just the way that the speed of light appears always to be the same. This would mean that a moving clock must run more slowly than a clock at rest; not only that, the clock continues to slow its rhythm as its velocity increases until, at the speed of light, it

stops running altogether. This phenomenon only appears to an observer who is stationary relative to the moving clock, not to one who is traveling along with the clock, further implying that we cannot measure time for anyone else.

If this seems improbable (or just plain wrong) to you, consider a Vermonter's dilemma as he listens to a Texan boasting about the size of his ranch: "Ah c'n drive an 'our or two goin' nawth . . . turn an' drive another 'our along the fahr side . . . turn an' drive another 'our'—" " Eh-unh," said the Vermonter. "I used t' own a cahr like that."

The Vermonter, confronting unfamiliar frames of reference, altered the measuring device—the car—in order to comprehend Texan distances.

Isaac Newton (1642–1726/27) in his *Principia Mathematica*, published in 1687, defined time as "absolute, true and mathematical: time, of itself and from its own nature, flows equally without relation to anything external."[3] Time, Newton reasoned, had existed in this form forever and would exist in this same form forever.

Newton assumed, as did everyone else prior to Einstein, that there is, somewhere in the heavens, one huge clock ticking off the seconds by which the entire universe grows simultaneously older. But Einstein's discovery that moving clocks change their rhythm, depending upon their reference frames, led to some spectacular revisions in the way we would henceforth see the world.

Newton made one other major mistake: he postulated that the three-dimensional space continuum was separate from, and moved forward in, one-dimensional time. Furthermore, if a body in one space here wants to influence another body in space there, he reasoned that it must traverse or commute the space separating them to effect that influence. But Einstein's theory of relativity says that in spacetime it is better to think of an environment in which events do not so much develop sequentially, as they do just *be*. No matter if two entities are standing in the same room or separated by the extremes of boundless space, there is no before, no now, and no later. Einstein had reduced the once certain and absolute distinction between past, present, and future to an illusion.[4]

Inconveniently, most people of Newton's era thought the universe was created but a few thousand years ago. One hundred years after Newton,

in 1781, this trope unsettled Immanuel Kant (1724–1804): If the universe had indeed been created only several thousand years ago, what was going on prior to its creation? Or more troubling still, if the universe had existed forever, why hadn't the corpus of what had happened in history already happened eons ago?[5]

Notwithstanding what, during their lives, Copernicus, Galileo, and Newton thought of the properties of time, by Thomas Mann's era,* those properties were no longer "absolute, true and mathematical," but several, various, and paradoxical. Sequential time, having relevance to the controversial notion of progress, was measured with the inexorable passing of hours, days, or years.

Cyclical time, on the other hand, had to do with reiteration and was more closely associated with the renewal of the seasons or, like the pendulum of the clock, with reciprocity.[6] Time had two domains: it could not only flow continuously like a river, it could also be discontinuous, atomized into equal parts, measured like the tick-tock of the mechanical clock. Yet, again, it could also be recurring like the seasons of the year or the days of the week. Time was like the universe: never ending and never beginning, immutable, durable and unendurable—but all at once.

In popular parlance, we talk of losing or wasting time, saving time, spending or gaining time, and playing for time—all in an effort to expand or abridge what we know from experience to be heartlessly indifferent to administration. More broadly, private time is *subjective*, while public time is *objective*: the same for everyone. Public or private, time can play favorites: "time is on my side," or the spoiler: "I haven't the time." Time, which is perceived in the same system to move with universal speed, can pass at varying speeds depending on whose reference point is its base: more slowly for the convict "doing time," or more quickly for the young man "making time" with his lover. Time can also be episodic, linear, and finite for the boarding school student advancing

in steps from freshman to senior; infinite, cyclical, and iterative for the headmaster, who admits and graduates another class every year.

The most significant development in the history of uniform, public time was the institution of Universal Time in 1912. In 1886 a Scottish Canadian engineer named Sanford Fleming (1827–1915) proposed its adoption: the use of the telegram, he wrote, "subjects the whole surface of the globe to observation and leaves no interval of time between widely separated places proportionate to their distances apart."[7]

In 1870 train conductors traveling from Washington to San Francisco were obliged to "set" their watches continuously as they traveled from one city to another, faster—or slower—than the sun, previously the universal determinant of advancing time in fixed location.[8] Instead, the adoption of the time zone required only periodic adjustments to watches and clocks, which, by design, could only measure variable, sequential time in one constant location.

Newton had attributed physical reality not just to matter but also to space and time, because Newton's laws of motion implied the concept of acceleration. Newton also ascribed physical reality to empty space, which is identical with extension, an attribute of bodily mass. Immanuel Kant went further. He argued that the postulate "a straight line between two points is the shortest distance between them" must be synthetic (i.e., derived from reasoning that proceeds from the general to the particular) and *a priori* because "[it] carries with [it] necessity, which cannot be derived from experience."[9]

For two thousand years, innumerable mathematicians and philosophers wrangled inconclusively with the notion of the existence of a fourth dimension as a *spatial* element. Euclidean geometry held its ground. Yet a school of thought called non-Euclidean geometry emerged, which was named for its opposition to one of the postulates Euclid had set forth as the basis of his deductive system of geometry: "If a straight line falling on two straight lines make the interior angles on the same side less than two right angles, the straight lines, if produced indefinitely, meet on that side on which are the angles less than two right angles."[10] More easily: through a given point can

* Thomas Mann (1875–1955) was awarded the Nobel Prize for Literature in 1929 for *Der Zauberberg* (*The Magic Mountain*, 1924). Einstein was awarded the Nobel Prize for Physics in 1921; both immigrated to the US—Einstein in 1933, Mann in 1936—and both subsequently worked at Princeton University.

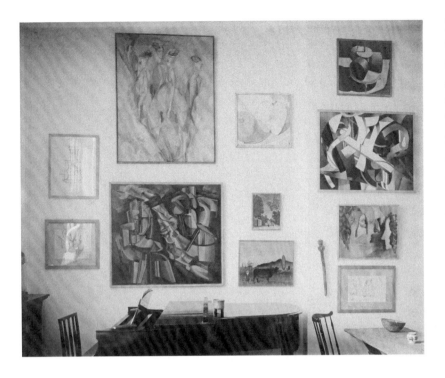

Living Room of New York
Apartment of Louise and
Walter Arensberg (North-
west Corner), ca. 1918.
Gelatin silver print, sheet:
7 ¹⁵/₁₆ × 9 ¹⁵/₁₆ in. (20.2 × 25.1
cm). (Whitney Museum of
American Art, New York;
gift of James Maroney and
Suzanne Fredericks, 80.30.3)

Flatland, a two-dimensional world, would appear the same as the fourth dimension should appear to us, who live in a world of three. This book had a considerable impact, but it was not until 1895, when H. G. Wells wrote his science-fiction giant *The Time Machine*, that the fourth dimension as *time* gained wide popularity. The idea that man could actually travel backward or forward out of current time electrified the public imagination.[14]

From the middle of the nineteenth century to the *fin de siècle*, countless authors, theosophers, artists, mathemeticians, mystics, theologists, and scientists as diverse as Charles L. Dodgson (Lewis Carroll), Henri Poincare, C. W. Leadbeater, J. C. F. Zollner, Claude Bragdon, Bayard Jones, Apollinaire, and Charles Howard Hinton sought in a virtual torrent of heterodoxy each to advance his own peculiar knowledge of, or evidence for, the fourth dimension. Rene de Saussure suggested in 1891 that "heat pressure" might be the underlying cause of the mysterious phenomena of light and electricity, and might, therefore, furnish validity for the existence of the fourth dimension.[15] Hinton's publication of *What is the Fourth Dimension?* (1904) brought up the intriguing notion of hyperspace philosophy, to experience which required only that the observer hone his God-given skills of perception. The author advanced the novel assertion that since the existence of the fourth dimension was ipso facto true, it did not require empirical proof.[16] The physicist Hermann von Helmholtz argued that it is possible for humans to visualize four-dimensional space, provided the brain receives the proper input: unfortunately, he said, our experience is confined to three-dimensional Euclidean space and cannot perceive such exotic data. Writers and poets also got involved. Marcel Proust's most prominent work, known to most by its English title *Remembrance of Things Past*, but by the more apt translation *In Search of Lost Time*, begun in 1909 and first published in 1913, is a story in which the private time experienced by its first-person narrator is out of sequential phase with that of the other characters, and that of his readers, all living in public time.[17] James Joyce, Virginia Woolf, Franz Kafka, Anton Chekhov, Oscar Wilde, William Faulkner, and Joseph Conrad all worked up themes in which they divided time into its constituent properties

be drawn but one parallel to a given line.[11] The necessity, in this instance, to depart from Euclid arose from the fact that all direct and indirect attempts at a hard proof for his important parallel postulate had persistently failed.

Finally, toward the end of the nineteenth century, two competing theories emerged, sharing a provocative idea: the possibility that beyond our immediate perceptions space was not strictly linear but *curved*. This notion, according to the artists who giddily took it up, would put in play the system of linear perspective in place since the Renaissance and afford them a welcome new paradigm.[12]

Euclidean four-dimensional space—adding one to the conventional system of three—must not be confused with a *non*-Euclidean system in which *time* is positioned as the fourth coordinate.[13]

The first published suggestion that time, not space, might be the true agent provocateur of the fourth dimension was made by Jean le Rond d'Alembert (1717–1783) in his 1754 article on "Dimension" in the *Encyclopedie d'esprit de ma connaissance*. The first example in popular fiction to propose the existence of the fourth dimension came in 1884 with the publication of E. A. Abbott's *Flatland: A Romance of Many Dimensions*, a fantastic tale based on the premise that the third dimension, to persons living in

in order to despoil conventional attitudes of time and plot-driving sequence.

But it was Einstein and Hermann Minkowski (1864–1909) who, with the publication in 1905 of *Special Theory of Relativity*, put paid to all this frantic theorizing. A decade later Einstein's classic *General Theory of Relativity* combined real time and gravity with the three Euclidean spatial dimensions into four-dimensional spacetime. The time dimension had always been distinguished from the three spatial dimensions because in space you could go forward or back, and time always and only increases from past to future. But imaginary time is at right angles to real time, so that it behaves like a fourth spatial dimension: it can do things beyond what the railroad track of ordinary time does. Imaginary time can, for example, have an end before a beginning, both at the same time, and even a "shape."[18]

Such was the state of information about the fourth dimension that came over the transom into the laps of the emerging and eagerly awaiting members of the Paris Avant-Garde. By 1910, the fourth dimension, especially in America, had become almost a household word, hurdling like a runaway train into the consciousness of the new millenium.[19] Charles Sheeler, just twenty-seven years old, fresh from academy and looking eagerly for something to propel him and his art into the twentieth century, stood directly in its path.

1 Stephen Hawking, *The Universe in a Nutshell* (New York: Bantam, 2001), 31–35.

2 Albert Einstein, *Relativity: The Special and the General Theory* (New York: Three Rivers Press, 1961).

3 Isaac Newton, cited in Stephen Kern, *The Culture of Time and Space* (1983; Cambridge: Harvard University Press, 2003), 11.

4 P. Speziali, ed., *Albert Einstein and Michele Besso: Correspondence 1903–1955* (Paris: Herman, 1972).

5 Hawking, *op. cit.*, 31–32.

6 Kern, *op. cit.*, 10–64.

7 https://www.thoughtco.com/sir-sandford-fleming-1991817

8 Ibid., 24–35.

9 Immanuel Kant, *Critique of Pure Reason*, trans. by Norman Kemp Smith (London: Macmillan & Co., 1929), 52.

10 *The Thirteen Books of Euclid's Elements*, trans. by Thomas L Heath, 3 vols, 2nd ed. (Cambridge: University Press, 1926), I: 155

11 Henderson *op. cit.*, 3.

12 Ibid., 6.

13 Martin Gardner, *The Colossal Book of Mathematics* (New York: W. W. Norton, 2001) 162.

14 Henderson *op. cit.*, 10.

15 Ibid., 39.

16 Ibid., 26.

17 Ibid., 16.

18 Hawking, *op. cit.*, 61–62.

19 Ibid., 43.

*"Pay no attention to that man behind the curtain!"*

—Frank Morgan, *The Wizard of Oz*, 1939

There is much yet to be learned about how artists perceive the world and how they communicate what they see to us. And while we somewhat grudgingly accept the notion that behind every human expression there may lie a hidden agenda, we have not completely accepted that to gain an understanding of whatever it is artists do relies on careful vision and on even more careful translation.

In William Merritt Chase's class at the National Academy, the emphasis in painting was on seeing real objects in nature and, with as few strokes as possible, capturing them in the fleeting moment; the *statement* was of little or no importance.[1]

Meanwhile, across town, at the very same time, the emerging premise of the Avant-Garde was precisely that painters should *always* subordinate observed objects, or the methodology of their portrayal, to intellectual or emotional subject.* Three of the movement's leading proponents succinctly state the postulate:

*"From the first gesture of a child pointing to an object and naming it . . . [to] a world of intended meaning, the developed mind creates*

*an image whose strangeness and reality stirs our subconscious to its inmost depths, the awakening of [which] is the first step to participation and experience."*

—Man Ray[2]

*"Then it was the artist alone who was able to indulge in the luxury of empirical thought under the camouflage of subject matter."*

—Paul Strand[3]

*"The artist-photographer envelops objectivity with an idea; he veils the object with the subject . . . The more analytical man is, the more he separates himself from the [object] and the nearer he gets to comprehension [of the subject]."*

—Marius de Zayas[4]

Today we are all aware that this is the central premise of the Avant-Garde movement—yet perhaps we have not fully absorbed its radical precept. Where in these statements does it say that the artist who would disguise subjective intent under the camouflage of chosen material objects will only achieve his purpose if his mode is abstraction? Or where that American artists, since they are inclined to be realists, do not qualify taxonomically to be Avant-Garde?

---

* Throughout this paper, I differentiate between the term object, which is a material form found in the natural world, and subject, which is some idea or emotion that the artist by painting objects intends to communicate. The two need not bear any obvious relationship except the latter proceeds from the former.

Americans were not, it is true, among the architects of the Avant-Garde or even ranked high among its practitioners. Max Weber (1881–1961) was the first American artist to mention the fourth dimension, in a 1910 article titled "The Fourth Dimension from a Plastic Point of View," published in Camera Work (emphasis added):

*In plastic art, I believe, there is a fourth dimension, which may be described as the consciousness of a great and overwhelming sense of space-magnitude in all directions at one time, and is brought into existence through the three known measurements.* It is not a physical entity or a mathematical hypothesis, not an optical illusion. It is real, and can be perceived and felt. *It exists outside and in the presence of objects, and is the space that envelops a tree, a tower, a mountain, or any solid.* Or the intervals between objects or volumes of matter if receptively beheld. It is somewhat similar to color and depth in musical sounds. *It arouses imagination and stirs emotion.* It is the immensity of all things. It is the ideal measurement, and is therefore as great as the ideal, perceptive or imaginative faculties of the creator, architect, sculptor or painter.

Two objects may be of like measurements yet not appear to be of the same size, not because of some optical illusion, but because of the greater or lesser perception of the so-called fourth dimension, the dimension of infinity. Archaic and the best of Assyrian, Egyptian or Greek sculpture* as well as paintings by El Greco and Cezanne and other masters are splendid examples of plastic art possessing this rare quality. A Tanagra, Egyptian or Congo statuette often gives the impression of a colossal statue while a poor, mediocre piece of sculpture appears to be of the size of a pin-head for it is devoid of this boundless sense of space or grandeur. The same is true of paintings and other flat-space arts. *A form at its extremity*

*still continues reaching out into space if it is imbued with intensity or energy. The ideal dimension is dependent for its existence upon the three material dimensions, and is created entirely through plastic means, colored and constructed matter in space and light. Life and its visions can only be realized and made possible through matter.*

*The ideal is thus embodied in, and revealed through, the real.* Matter is the beginning of existence; and life or being creates or causes the ideal. Cezanne's or Giotto's achievements are most real and plastic and therefore are they so rare and distinguished. *The ideal of visionary is impossible without form;* even angels come down to earth. By walking upon earth and looking up at the heavens, and in no other way can there be equilibrium. The greatest dream or vision is that which is re-given plastically through observation of things in nature. "Pour les progres a realiser il n'y a que la nature, et l'oeil s'eduque a son contact." [Space is empty, from a plastic point of view.]

The stronger or more forceful the form, the more intense is the dream or vision. Only real dreams are built upon. *Even thought is matter.* It is all the matter of things, real things or earth or matter. Dreams realized through plastic means are the pyramids and temples, the Acropolis and the Palatine structure; cathedrals and decorations; tunnels, bridges and towers; these are all of matter in space—both in one and inseparable.

Morton Schamberg (1881–1918) was the only other, lone American advocate for the fourth dimension. In 1913 he wrote enthusiastically of it:

*It is not the business of the artist to imitate or represent nature. Art is creative, or, rather, interpretive . . . We are all familiar with design in one dimension, the harmonic use of line as exemplified in the art of Ingres, of Botticelli or of the Japanese. We are likewise familiar with design in two dimensions, or "pattern," as in the art of Whistler, but we have hardly given sufficient consideration to the more important problem of design in the third dimension, or the harmonic use of forms . . .*

---

* Sheeler evinced interest in these forms in his photographs of *Aphrodite*, ca. 1924, and of *Assyrian Reliefs*. See Theodore E. Stebbins, Jr., and Norman Keyes, Jr., *Charles Sheeler: The Photographs* (Boston: Museum of Fine Arts, 1987), plates 39 and 81–82.

*If we still further add to design in the third dimension a consideration of weight, pressure, resistance, movement, as distinguished from motion, we arrive at what may legitimately be called design in the fourth dimension, or the harmonic use of what may arbitrarily be called volume.*[5]

Surely Sheeler and Schamberg, two young aspiring photographer/painters living and working together as housemates for over a decade, sharing their innermost thoughts about the challenges presented by artistic expression, knew Weber and understood the argument he was making. Just as surely, Sheeler's biographers have all read Weber's statement yet somehow missed its meaning: Why, when Weber says that material objects shall henceforth *not* be the focus of his art, and when Sheeler says virtually the same thing, do they insist on focusing on the material objects they find in it? Constance Rourke, Sheeler's first biographer, for example, seems to have missed the significance of Sheeler's interest in the movement entirely:

The word plastic, applies to anything that can be shaped; the *form* big and bounding, it may include the most delicate and precise modulation in form. It is the sense of design in *masses*—what the sense of the hand flowing into the material conveys . . . *it is not the movable or the malleable . . . but the boats, water and bellying sails . . . the severely continuous line . . . the squares upon which the vase stands . . . the fine edges of the spiral staircase.* [Emphasis added][6]

Rourke makes no mention in her book of empty space, of the fourth dimension or of subjective insight; there is only talk of conventional representation of line, mass, and form.

Few would refute that, in the period 1909 to 1918, Sheeler was in the aura of the Paris to New York Avant-Garde, or that the Avant-Garde was playing havoc with form. Fewer still that after 1918 Sheeler's work comprised mainly recognizable objects. So it has always seemed reasonable to conclude that Sheeler was, after 1918, indifferent to the direction taken by the Avant-Garde, or that

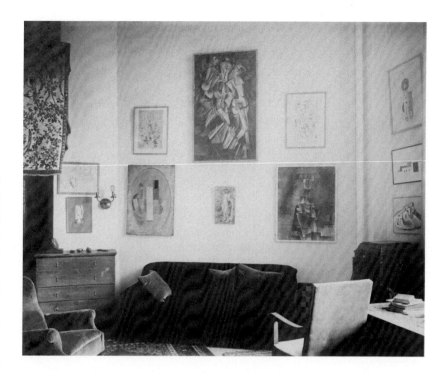

he was determined, in spite of it, to follow in the footsteps of his American predecessors, all conventional, representational painters.

Accordingly, in language designed to justify what they took to be his dedication to realism, his biographers have always characterized him, or his work, as cool, diffident, and thoroughly American.

Not content to leave it there, Samuel Kootz seemed to find it necessary to apologize for Sheeler's realism, praising his intelligence and suggesting that he had sufficient courage to shun "fulfillment" to focus on form and line:

Charles Sheeler . . . one of the most sensitively intelligent of our American painters . . . harbors grave doubts about personal fulfillment . . . The exasperation engendered by this human restlessness *has forced him* to a literal realism in painting, in the belief that there is something he can grasp, an *actuality* by which he can *make terms with humanity.* This new realism exhibits itself in a *studied reproduction of the subject; he avoids all distortion and by a literal combination of forms,* he achieves a camera-like synthesis. Always there is a deep searching for a consistent formal harmony, *a genuine feeling for line, mass and balanced spatial volumes . . . a care for*

Living Room of New York Apartment of Louise and Walter Arensberg (Section of East Wall), ca. 1918. Gelatin silver print, sheet: 7¹⁵/₁₆ × 9¹⁵/₁₆ in. (20.2 × 25.2 cm). (Whitney Museum of American Art, New York; gift of James Maroney and Suzanne Fredericks, 80.30.2)

all there is to see. Friedman, in a word, thanks Sheeler for not being Avant-Garde:

> Sheeler had an *uncomplicated, factual* world view and regarded his paintings *pragmatically, free of romantic or obscure overtones* . . . Sheeler's personal detachment pervades his art. Essentially, he was the anonymous, but acutely aware, selective observer who always *remained outside* of the subjects he analyzed and reordered . . . He maintained that he was not interested in subconscious expression and that *nothing existed in his paintings not immediately perceivable. Sheeler affirmed that his subjects had no connotation beyond their immediate function.* [Emphasis added][8]

Sheeler's biographers all have ample justification for writing the opinions transcribed above because these passages all have their genesis in the artist's unpublished autobiography, or better, they come verbatim right from the horse's mouth.

In a series of interviews throughout his life, Sheeler spun out a consistent line about his art, its meaning, and his intentions, to his friend and critic Henry McBride; he then gave much the same to Bartlett Cowdrey, Charles Millard, Constance Rourke, and Martin Friedman. Seeming to have nothing to hide, Sheeler had no apparent objection to providing factual details, such as dates and professional acquaintances, or even to describing major epiphanies. He appeared to be lucid and self-revealing. But he continued, until his death, to coyly deflect inquiry into his real intentions—those I will describe shortly—speaking indirectly, obfuscating, and dissimulating, consciously or unconsciously guarding his privacy by politely deceiving his inquisitors.* Art historians, writing after Sheeler's death, now repeat these colloquies and accept their interpretations as received wisdom.

Notwithstanding all that he told McBride, Cowdrey, Millard, Rourke, Lowe, and Friedman,

Living Room of New York Apartment of Louise and Walter Arensberg (South-east Corner), ca. 1918. Gelatin silver print, sheet: 7 15/16 × 9 15/16 in. (20.2 × 25.2 cm). (Whitney Museum of American Art, New York; gift of James Maroney and Suzanne Fredericks, 80.30.1)

*detail and for an eager exactness.* [Emphasis added][7]

Harry Lowe does much the same:

> There is nothing obscure about Charles Sheeler. [His] consistent, aesthetic convictions [comprise a] vocabulary of *forms* . . . in a strong, straight *line* [that] conformed to the spirit and cultural history of his country . . . There persists a sense that the accumulation of knowledge of him is fragmented [yet] he was always within easy reach. [Emphasis added]*

Martin Friedman also accedes in the by now universal interpretation of Sheeler as a man concerned only with the conventional properties of line and form. Friedman even expresses palpable relief that what he sees in Sheeler is, in fact,

---

\* Harry Lowe, in Forward to Martin Friedman, Bartlett Hayes, Charles Millard, *Charles Sheeler* (Washington, DC: Smithsonian Institution Press, 1968), p. 7. Lowe, who sees in Sheeler's work the recurrence of motifs, organized the 1968 NCFA Sheeler Retrospective into seven object categories (still life, landscape, interiors, buildings, cityscapes, industrial architecture, and variations), proof that he along with most critics failed to see beyond Sheeler's subjective veil.

---

\* In a December 1958 interview with Bartlett Cowdrey, Sheeler, age seventy-five, managed over four hours to say virtually nothing of substance regarding his art and methods. He also repeatedly scolded his wife, Musya, for trying to steer the conversation in that direction.

we simply cannot any longer take Sheeler at his word. (Pay no attention to that man behind the curtain!)

In 1936 to 1937, while looking back on his early career, Sheeler noted in his autobiography, "In the presence of Giotto, Masaccio and Piero della Francesca, [I] first became conscious of design . . . as a primary consideration . . .that would be outside of time, place or momentary conditions."[9] And then this:

I couldn't resume where I had left off. I had to bail out . . . for about ten years, before I really got started on a new direction. There was no more possible justice of the model or to go out and paint a landscape. I had to plan ahead of time what ingredients a painting would have in it that would be to my satisfaction as nearly as I could arrive at them. The period of about ten years [I] was neither fish nor fowl.[10]

Awareness of the need to "bail out" thus came in 1909. Ten years spent "bailing out" would put him in 1919, coincidentally, the same year as the story of Einstein's relativity appeared in *The New York Times*. Wrote Sheeler, presciently:

Everyone who is sincerely trying to solve the enormous difficulties of artistic expression is an experimenter and remains so as long as he is artistically alive.[11]

Since the identification of familiar objects in a picture was too often mistaken for the cessation of investigation, it was [my] intention to *divorce the object from the dictionary and disintegrate its identity.* [Emphasis added][12]

This startling expostulation is wholly inconsistent with what his many biographers understood him to have said when they ascribed to Sheeler a motivation for painting "real" objects, the representation of which would comprise only form,

line, and mass. But instead of a "cessation of investigation," Sheeler goes, in the period 1909 to 1919, beyond the form to new concepts of space and time. By 1916 Sheeler had begun to suspect that, in order to depart from the short, strictly linear time gaps explored in Cubism, he would have to somehow span a greater time interval than from one moment to the next. And the wonder is not that Sheeler had this epiphany; the wonder is that he felt obliged to occult it for the remainder of his life.

1 Constance Rourke, *Charles Sheeler: Artist in the American Tradition* (New York: Harcourt Brace, 1938), 17–19.

2 Man Ray. *The Age of Light*, in James T. Soby, ed., "Man Ray Photographs 1920–34" (Paris: East River Press, 1934), cited in Alan Trachtenberg, ed., *Classic Essays on Photography* (New Haven, CT: Leete's Island Books, 1980) 167.

3 Paul Strand, *Photography and Photography and the New God* in *Broom*, vol. 3(4), 1922.

4 Marius de Zayas, "Photography," *Camera Work* 41 (1913), cited in Trachtenberg, *op. cit.*, 131.

5 Morton Schamberg, statement in "Post-Impression Exhibit Awaited," *Philadelphia Inquirer* (Jan. 19 1913): sec. 2, p. 3; cited in Henderson, *op. cit.*, 174.

6 Rourke, *op. cit.*, 105–7.

7 Samuel M. Kootz, *Modern American Painters* (New York: Brewer & Warren, 1930) 51.

8 Martin Friedman, *The Precisionist View in American Art* (Minneapolis: Walker Art Center, 1960), cited in ibid., 37–40.

9 Charles Sheeler, *Autobiography* (unpublished ms., ca. 1937) film NSH-1. Detroit, Archives of American Art, frame 61. Cited in Lillian Dochterman, *The Stylistic Development of the Work of Charles Sheeler* (State University of Iowa, Ph.D., 1963), University Microfilms, Inc., Ann Arbor, MI, p.8.

10 Charles Sheeler, *Autobiography* (unpublished ms., ca. 1937), Film NSH-1, (Detroit: Archives of American Art), cited in Abigail Booth, Catalogue of the Exhibition and Catalogue Notes, in Martin Friedman, Bartlett Hayes, Charles Millard, *Charles Sheeler* (Washington, DC: Smithsonian Institution Press, 1968), 11.

11 *Autobiography*, cited in Lowe, *op. cit.*, 11.

12 *Autobiography*, cited in Dochterman, *op. cit.*, 13.

Piero della Francesca, *The Flagellation of Christ*, ca. 1468–1470. Oil and tempera on panel, 23 in × 32.1 in. (58.4 cm × 81.5 cm). (Galleria Nazionale delle Marche, Urbino)

*"Time travels in divers paces with divers persons. I'll tell you who time ambles withal, who time trots withal, who time gallops withal and who he stands still withal."*

—William Shakespeare, *As You Like It*

Here is a good time to remind the reader that until the Quattrocento, the inclusion of even the third dimension onto flat, two-dimensional artwork was unknown. The invention in fifteenth century Florence of vanishing point perspective—accepting the notion that painting is an imitation of nature—introduced to human eyes the illusion that three-dimensional space could be captured in two.

Here, too, we should recall that in his manifesto Sheeler (as did Weber before him) mentioned Giotto (Ambrogio Bondone, 1267–1337), the first painter in history to present a scene as if it were viewed from a stationary point of view. Giotto's "proto-perspective," with each painting representing one moment in time and viewed as if it were on a stage, thence became the universal, Western convention for making pictures in two dimensions look as if they included the third, even into the modern era.

Sheeler (as did Weber before him) also invoked Masaccio (Tommaso Cassai, 1401–1428?), the first painter in Western art to use full perspective. Masaccio was also the first to illuminate human forms as if from a single source of light, a technique that gave his figures a natural, realistic quality unknown in the art of his day.

And Sheeler (as did Weber before him) also named Piero della Francesca (Borgo San Sepolcro, 1416–1492), the first painter to introduce shadow as a device into his art. Together with Masaccio, this pioneer brought to painting an intuitive leap of understanding about the nature of form and light. Piero's shadows (chiaroscuro) fell consistently on the side of forms opposite the source of light. The new technique gave the illusion of substance to form; but the illusion, unexpectedly or not, also implied motion and, therefore, imputed to forms not just a spatial but a temporal dimension.[1]

Curiously, Sheeler makes no mention of Leonardo da Vinci (1452–1519), who toward the end of the fifteenth century, invented aerial perspective, postulating that contrasts of color and between light and dark appear greater, and contours more defined, in near objects than in far, which augmented the illusion. When, in 1829, Joseph Nicephore Niepce (1765–1833) and his colleague Louis Jacques Mande Daguerre (1787–1851) invented the heliograph and the daguerreotype, photography made the illusion commonplace.[2]

As a painter *and* photographer Sheeler would have known that for roughly the next hundred years photographers reveled in the capacity of the new medium to record in an instant what previously painters could only have despaired of producing in days, weeks, or years. At first blush, the camera's ability to record in minute detail near-perfect simulations of the natural world threatened to put painters out of business, until, that is, the early twentieth century, when both painters and photographers realized that the two

Eadweard Muybridge
(1830–1904), *The Horse in
Motion, Annie Gardner at
a Gallop*, 1878. (Lebrecht
Music and Arts Photo
Library, Alamy Stock Photo)

media were in pursuit of separate ends and could survive side by side on their own terms.

As a painter *and* photographer, Sheeler knew that the representation of nature in two dimensions through either medium is not art, per se, but it could be made to *be* art. The difference is that in the first, objectivity of form is presented for its own sake while, in the second, objectivity of form is subordinated to the expression of a preconceived idea, emotion, or insight. The first is a process through which man tries to represent something *outside* himself; in the second, he tries to represent something *inside* himself. In the first, the artist seeks to present the natural object in its own, inherent detail; in the second, he upstages the object with selected attributes of a preconceived idea.[3]

As a painter *and* photographer, Sheeler also knew that in the history of art the inclusion of time and motion was a relatively new phenomenon, making its inchoate appearance in the stop-action photographs of Eadweard Muybridge (1830–1904). In the early twentieth century, painters such as Gino Severini (1883–1966) and the Futurists attempted to incorporate motion by overlaying multiple images of legs, or other body parts, onto the same canvas. Painters, for their part, attempted

to render time by painting a sequence of views. Contemporaries—Thomas Moran's (1837–1926) paintings of the Green River and Claude Monet's (1840–1926) pictures of Rouen Cathedral or of a lowly haystack—painted series of pictures of the same subject experienced at different times of the day or in different seasons. The French photographer Anton Bragaglia (1890–1960) tried leaving his shutter open long enough to produce blurring, a technique he called photo-dynamism, through which he hoped to convey motion.

Franz Marc (1880–1916) and Wassily Kandinsky (1866–1944), cofounders in 1916 of Der Blaue Reiter, took an anti-materialist stance for their artistic theory, in which the fourth dimension would play a logical part. Marc, an admirer of Robert Delaunay (1885–1941), documented his interest in the fourth dimension when, in 1916, he wrote enthusiastically to his wife about the progress of science to explore space beyond the three dimensions. Jean Metzinger (1883–1956), Vincent van Gogh (1853–1890), Albert Gleizes (1881–1953), Giorgio de Chirico (1888–1978), Salvador Dalí (1904–1989) all professed an ability to make a synthesis in the passage of time: "Where previously a picture took possession of space, now it reigns in time."[4]

Alas, all these attempts were ultimately fatuous: painting was irrevocably fixed in a single moment on a two-dimensional platform. The illusions these artists created were forever, and incontrovertibly, still, captured, like bugs in aspic, in two—or in sculptures in no more than three—dimensions.

The introduction of moving pictures, first seen in New York in 1896, changed everything. While experimentation in the form increased rapidly into the next century, subject matter was, until 1903, almost entirely confined to natural phenomena, everyday people and events. George Melies (1861–1938), a Frenchman, was the first to discover that he could introduce a story line of sequential events into a film, and that he could manipulate his lights, camera, and props to create synthetic effects.

Sheeler knew that the "moving picture" produced only an illusion of sequential movement by stopping each frame in quick succession to allow the brain to record minute differences in the spatial relationships of otherwise motionless forms, without noticing the pauses. "Moving pictures" conveyed an intriguing illusion: but the medium would provoke Sheeler, foremost a still photographer, to try to capture motion in two dimensions on a two-dimensional canvas.

We today vastly underestimate the challenge as he saw it: we are so accustomed to these conventions that we no longer appreciate how, without them, representational art, or film, would be virtually unthinkable. Neither are we at all aware of how deeply embedded into our subconscious are notions of sequence in time and space, conventions as seemingly unremarkable as alphabetic letters that accumulate modestly from left to right as they construct individual words, and then go on to compile sentences, read one after the other, which, in sum, build a flow of thoughts on sequentially succeeding pages. Consider, too, that in Western culture, we think of the future as being somewhere out ahead of us, and of the past as gone by and now behind us. But in Eastern cultures, it is the future that comes unexpectedly up from behind and it is the past that stretches out plainly in sight, ahead. Likewise, shadow, so commonplace in Western art, is not a predominant feature of Eastern painting, since the artist wishes to give his audience no spatial references to interfere with making a "timeless" work of art. What is more, empty space in Eastern painting calls attention to the importance of nothingness, instead of to a part of the composition the Western artist may have simply left undelineated.

1 Leonard Schlain, *Art & Physics: Parallel Visions in Space, Time and Light* (New York: Perennial, Harper Collins, 1993), 50–55.

2 Trachtenberg, *op. cit.*

3 Kern, *op. cit.*, 10–18.

4 Ibid., 22.

# Sheeler and the Avant-Garde in Pursuit of the Fourth Dimension

*"Thoughts without content are empty, intuitions without concepts are blind."*

—Immanuel Kant (1724–1804)

Advancing the theory, as I do, that Sheeler's primary objective was to include the fourth dimension into his work begs two questions: Exactly when did he begin and where should we look?

As an exhibitor at the 1913 New York Armory Show, Sheeler would have already encountered Analytical and Synthetic Cubism, the Avant-Garde attempt by French painters to augment the conventional perspective of the same object observed at one time and place to include two or more perspectives. There is no dispute among scholars that, in the period 1912 to 1918, Sheeler was employing strong, vibrant color and faceted, black-outlined, overlapping planes in a somewhat mannered and plainly derivative attempt to break into a pattern of changing perspective surfaces experienced in the natural world. Sheeler had recognized that the inclusion, on the same, flat canvas, of a short step along the line of sequential time was inherent in Cubism.

But merely altering spatial perspectives in a moment of time wasn't a lasting solution to incorporating the fourth dimension into plastic art, and Cubism didn't entertain Sheeler for long. After 1918, the few American artists including Sheeler who had tried Cubism summarily abandoned it. For one, the attempt to express force of energy or dynamic movement within Cubism's stylistic limits could not be sustained. For another, American collectors were generally unresponsive, if not outright hostile, to European modernist styles.[1]

*Landscape*, 1915. Oil on panel, 10¹/₂ × 14 in. (Museum of Fine Arts, Boston, Lane Collection)

After Schamberg's unexpected death,* Sheeler went to New York City where he, Duchamp, and other intellectuals and artists met regularly at the apartment of Walter and Louise Arensberg. There, talk of infinity, of mathematics, of an ideal vision of higher reality and of the fourth dimension proliferated.

By all accounts Sheeler had returned, in 1918, from abstraction back to realism. And by

* Morton Schamberg, Sheeler's closest friend, with whom he shared his house in Doylestown from 1910, died in October 1918.

*Bucks County Barn*, 1923. Tempera, charcoal, and graphite pencil on paper, 19¹/₂ × 26 in. (Whitney Museum of American Art, New York, Gift of Gertrude Vanderbilt Whitney, 31.468.) Photo by Sheldan C. Collins.

all accounts, he then went, between 1918 and 1923, into the Pennsylvania countryside looking for forms that could be painted as organized, aesthetic objects, and found the barns and sheds in and around Bucks County. These he rendered in a mind-set of the modern aesthetic that would later be termed Cubist-Realism.*

The Cubist-Realist style had the following characteristics: "... objects were handled as large

* Henry McBride first used the term "Precisionism" in "Work of Charles Sheeler Attracts Attention" in *The Sun and New York Herald*, February 22, 1920, p. 7. Milton Brown in *American Painting from the Armory to the Depression* (Princeton: Princeton University Press, 1955) referred to this style as "Cubist-Realism." John I. H. Baur in *Revolution and Tradition in Modern American Art* (Cambridge: Harvard University Press, 1954) referred to this style as "Immaculate," while Milton Friedman in *The Precisionist View in American Art* (Minneapolis: Walker Art Center, 1960) calls it "Precisionism."

smooth masses; edges of objects were hard or sharp and objects were handled as cubic volumes; a clear or even light washed over all. Color was used in large un-modulated areas, composition was more structural than emotional, the subject was predominantly architectural and the scenes were usually in a non-atmospheric setting."[2] Proportions were refined and the masses were given a rhythmical relationship while the decorative qualities of textures were maintained. Sheeler said of these paintings: "I sought to reduce natural forms to the borderline of abstraction, retaining only those forms I believed to be indispensable to the design of the picture."[3]

American proponents and practitioners of the Cubist-Realism style, in addition to Sheeler, were Charles Demuth, George Ault, Niles

Spencer, Ralston Crawford, Luigi Guglielmi, Oscar Bluemner, Edwin Dickinson, Elsie Driggs, Peter Blume, Louis Lozowick, and Patrick Henry Bruce.[4] The categorical term most often (and invariably) applied to this style is Precisionist, a classification the essential qualification for which is slavish adherence to the rectilinear nature of observable form. But unfortunately, the mode was provincial, not Avant- Garde, and therefore strong justification for it had to be found.

Wolfgang Born interpreted Sheeler's "extremely simplified realism" as "a direct outgrowth of his American artistic heritage," while others like Forbes Watson remarked on Sheeler's "ultimate literalness" or even his "style- less style."[5] These qualities and his faithfulness to forms bounded by straight lines, points, corners, and planes were what qualified Sheeler, according to these critics, for artistic success. Constance Rourke's biography is rather an encomium on Sheeler's success, the justification for which, according to her, was Sheeler's adherence to the "Precisionist style."

Lillian Dochterman, who continues in this vein, suggests that in compositions like *Flower Forms* (1919)* (Terra Museum of American Art, Chicago), Sheeler's purpose is "to allow the natural character of objects to suggest in his pictures their own dynamic properties." Then, in the seemingly placid still lifes that followed, such as *Tulips–*

*Suspended Forms* (1922) (Private Collection) and *Chrysanthemums* 1923 (Columbus Museum of Art), Sheeler settled—for a spell—into the idea that such objects could, or would. I concur to that point with this assessment.

But I fervently depart from Dochterman when she states that, after 1923, Sheeler "fully committed himself to the American, realistic tradition in order to compose his interiors, directing his eyes always *outward* toward the formal properties of objects."[6] And yet in this opinion, Dochterman is joined by virtually all of Sheeler's subsequent biographers. We will return later on to Sheeler's so-called "interiors" and to where, while composing them, he was directing his eyes.

1 Dochterman, *op. cit.*, 21.

2 Dochterman, *op. cit.*, 38.

3 Ibid., 23.

4 *cf.* James H. Maroney, Jr., *Lines of Power* (New York: Hirschl & Adler Galleries, 1977). The Author wishes he could now disown this catalog. And he wishes the reader to know that the article titled "Charles Sheeler Reveals the Machinery of His Soul" (*American Art*, Summer, 1999, p. 26) is not entirely misconceived, but is merely half-baked.

5 Wolfgang Born, *American Landscape Painting* (New Haven, CT: 1948), 214, and Forbes Watson, "Charles Sheeler," in *The Arts* 3 (May 1923) 338–341 both cited in Troyen & Hirshler, *op. cit.*, 15.

6 Dochterman *op. cit.*, 46.

* *Flower Forms* is sometimes dated 1919 in the literature, including in *The Elite and Popular Appeal of the Art of Charles Sheeler* (New York: James Maroney, 1986), pp. 66–69. However, while the date on the painting could be read either 1917 or 1919, according to the present analysis, and to judge *Flower Forms* stylistically, the correct date of the picture is more probably 1917.

*"There is so much dependence upon reading the latest [art] book. Why not look at the work?"*

—Charles Sheeler[1]

It is now time to consider whether our conviction that Sheeler was a Precisionist hopelessly hooked on realism is our failure, not his, and to ask whether Sheeler's purported interest in architectural form, antiquarianism, Shaker furniture, barns and machinery is a shibboleth in need of revision.

Sheeler, Grant Wood, Edward Hopper, Norman Rockwell, and Andrew Wyeth, today regarded as the five leading proponents of American Realism, had the misfortune to come of age just as the art world was shifting its attention—*all* its attention—to abstraction. I, of course, must accept this, but only if you will accept that Abstract Expressionism was not as appealing. This meant that some intellectual defense had to be contrived for it, a defense that its proponents ardently hoped might also serve to show that we as a people had advanced beyond, and disposed of, the provincialism so evident in American Realism.*

I concede that between 1918 and 1923 Sheeler was—for lack of a better term—a "Cubist-Realist," or if you insist, a "Precisionist." And I concede

* For an excellent analysis of why at the advent of Abstract Expressionism American art historians all felt it necessary to diminish Realism, even as Alfred Barr was acquiring Andrew Wyeth's *Christina's World* for MOMA, which is still its most popular painting, see Henry Adams, "Andrew Wyeth and the Artist's Fragile Reputation," in *The Conversation*, https:// theconversation .com/andrew-wyeth-and-the-artists-fragile-reputation-79804?mc cid=6a4febdd9e&mc eid=e147811d59

that from 1920 to 1941 he appears to have been a strict proponent of Realism. But the several criteria for the practice of Cubist-Realism and/or Precisionism enumerated on the previous page make no mention of the *spaces* that fly around and among solid-object, linear forms, and these were of equal interest to Sheeler as were his lines and forms.

I contend that Sheeler realized, before 1916, that empty space has a constitutive function in a picture. Such was, at least theoretically, the fundamental precept of Cubism, which Sheeler seems to have absorbed more thoroughly than the movement's earliest proponents. Anyway, we all know that empty space is what separates and distinguishes one object form from another, but the plastic artist who put it in a picture must regard form and space not as independent but complementary. Moreover, if there is a relationship between one form and another, if one object would influence another, then the artist must somehow commute the space between them. Patently, there is room for only so many objects in a picture, which is already tightly bounded by its borders. Why then would the thinking artist leave undefined so large a proportion of his/her allotted working space as that existing between objects?

Perhaps the difficulty is that conventional understanding of art composition tends to credit solid forms as material subject matter, while giving empty space subordinate or no significance.

*New York Towards the Woolworth Building*, 1920. Gelatin silver print. (Museum of Fine Arts, Boston, © Lane Collection)

Be that as it may, in the last analysis "background" is a positive element of equal importance with all others.[2] A Cubist-Realist might very well use forms and planes to impute substance to a building or a church; but a building is not just a box defined by lines, planes, and corners. A material object "box" occupies space, but there is also space *surrounding* the box and more space the box *encloses*.

A good place to start when trying to get one's head around this point is that every object in the real world, no matter what its exterior Euclidean shape, has (relative to us) a top, a bottom, a front, a back, a left and a right side, or six faces. The cube, likewise, has twelve edges and eight corners. This means, philosophically, that the cube also has a center, and that center, whether or not it is "visible," has a constitutive function.

Surely there is no better explanation for his photograph *New York Towards the Woolworth Building* (1920) than quite irrespective of our conviction that a city is a conglomeration of buildings, the subject of this picture is the spaces in between them, which Sheeler presents as its black "empty" center. Yet, when Charles Millard called Sheeler's photographs of New York "architectural photographs" he unwittingly shifted attention away from the spaces and back onto the buildings.[3] This shift laid the foundation for categorizing Sheeler as a "Precisionist," a label that stuck to him for fifty years.

Millard also refers to Sheeler's photographs as "astringent" and he quotes Howard Devree, who "feels an Emersonian coldness . . . something vegetarian rather than carnivorous in [his] approach."[4] But contemporary critics looked at Sheeler's photographs and failed to see that his principal concern was not the lines defining the boxes of which he was supposed to have been so fond, but the empty spaces that enclose and surround them. Nor did they see in his pictures the dimension of time.

Time is conventionally defined as the locus at which events occur in succession in the space that bodies occupy in simultaneity. According to that definition, time and space reside in different domains. Yet, combining the two into one system of four dimensions is something we do every day.

Imagine you have an appointment to meet a friend on the fourteenth floor ($z$ coordinate

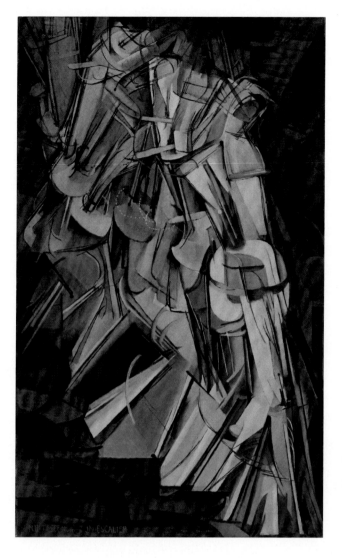

in a Cartesian system of three dimensions) of a building standing at Thirty-fourth Street and Fifth Avenue (its *x* and *y* coordinates) at 2:00 p.m. on Wednesday, June 12 (time). Obviously, the meeting cannot take place unless you both arrive at the three appointed coordinates of space *and* at the appointed time, the fourth coordinate.

Sheeler was a visual artist; but since he knew that time is not a constituent part of a picture, he would have to disrupt this seemingly invincible construct in order to make it one.

Sometime prior to his 1916 Forum *Statement*, it dawned on him that time also had a pictorial property to exploit and that he could conflate space and time in the same way as you and your friend did when arranging a meeting. But his first inclusion in one work of two distinct time frames did not come as an overnight transition out of

Precisionist/Cubist-Realism; he would make his first such attempt in 1917, in the photographs of the Doylestown House. He waited three years before attempting it in a painting. For both, he used as a springboard "stills" from his motion pictures; it was not until 1923 that he hit upon a formula that did not require the sort of "kinetic" antecedents that were so prevalent at the time. More about this breakthrough in a moment.

Marcel Duchamp (1887–1968), another near-exact contemporary of Sheeler's, was a French painter and theorist, a major proponent of Dada, and one of the most influential figures of twentieth-century Avant-Garde art. After a brief, early period in which he, too, was influenced chiefly by Paul Cezanne and Fauve color, Duchamp developed a dynamic version of Facet Cubism (similar to Futurism), in which the image

Marcel Duchamp (1887–1968), *Nude Descending A Staircase, No. 2*, 1912. (Philadelphia Museum of Art, Collection of Walter and Louise Arensberg, 1950)

*Doylestown House—Stairs from Below*, 1917. (Metropolitan Museum of Art, NY, Alfred Stieglitz Collection 33.43.343.) © The Metropolitan Museum of Art. Image source: Art Resource, NY.

depicted successive movements of a single body. It closely resembled the multiple-exposure photography documented in Eadweard Muybridge's book *The Horse in Motion* (1878) of which Sheeler would have been keenly aware.

Some years after he had created it, Marcel Duchamp commented that in his *The Bride Stripped Bare by Her Bachelors, Even* (1915–23, Philadelphia Museum of Art) he had explored in two dimensions ways to create a four-dimensional bride. Sheeler, who in 1916 was well aware of Duchamp's purpose and the meaning of his statement, was undoubtedly excited by the effort.

Duchamp's *Nude Descending a Staircase, No. 2* (1912), in which the artist attempted to present a figure not only in motion, but *descending a flight of stairs*, broke like a thunderbolt upon the art world. Stebbins and Keyes report that Sheeler "made several beautiful photographs of Duchamp's *Nude Descending a Staircase*, which could have encouraged his interest in the stair theme."[5] This is an understatement: the *Nude Descending a Staircase, No. 2* must have made Sheeler nearly delirious.

In 1916 to 1917,* Sheeler tentatively explored the fourth dimension in the stairs, windows, doors, and stove of the Doylestown House, where he first discovered that he could dramatically extend three-dimensional, Euclidean forms in confined rooms by pushing them out, not in space, as had Duchamp, but in time.

By 1917 Sheeler had concurred with Duchamp that stairs, whether abstractly or realistically presented, add emotion and energy to a picture. He had already learned this from Weber, who as we have already seen, wrote in 1910, "The stronger or more forceful the form, the more intense is the dream or vision."

Invoking Weber and Duchamp, Sheeler asserted at Doylestown that stairs, which are constructed of serial treads, are a vehicle by which we move from one plane into another, unavoidably consuming and, therefore, connoting time. "Two things are going on at the same time in the pic-

ture [in which there are stairs] irrelevant to each other, but relevant to the whole: one [thing is going on] in the room downstairs, one leading to the room upstairs."[6]

Sheeler was at the threshold of actualizing a theory that windows and doors are not only forceful, they comprise a range of ambiguous, metaphysical properties: they can be closed and yet open, open yet impassable, transparent yet opaque. A stove, which is a common metaphor for warmth and comfort, is a vehicle for fire, from which heat and smoke radiate. Invoking de Saussure, Sheeler enlisted a stove at Doylestown, because, while sitting perfectly still, it could yet exert its influence through waves (what de Saussure called heat pressure) across space to other objects.*

Of course Sheeler knew that stairs, windows, doors, and stoves, otherwise stationary objects, do not move. He also knew that Duchamp had tried in his picture to assign to a nude the job of "descending" the staircase in order to project motility. And while the result was impressive, from a certain point of view, he had failed: the picture was still.

Sheeler now realized that he might conscript the architectural constructs of the Doylestown House and ask them to stand *on their own* for the purpose. He realized that the plain representation of a window, a door, or a staircase could *imply* motility without the nude, since the representation of such an object implies time spent, just as heat or smoke, because they radiate away from their source, imply time spent.

Sheeler also knew, or at least suspected, that motion has no meaning except in a relational sense: the velocity of object A can only be described relative to the velocity of object B. In 1917 Sheeler did not need Einstein to know this: Plato, Aristotle, Pythagoras, Descartes, Galileo, Mach, and Newton all conducted experiments in relative motion. Irrespective of whether he knew of their work, Sheeler would invoke motility by realistic representation of conventional objects that, by our common experience, imply it, while

---

* The date of the Doylestown House suite, because it is not exactly known, is often given as 1915–17. According to the present analysis, the date of the suite would not predate his epiphany as expressed in his Forum manifesto of 1916.

* Rene de Saussure in 1891 was the first to advance the notion of "heat pressure" as motility through the fourth dimension. See Henderson, *op. cit.*, p. 39.

they are yet still. More than that, he could expand time beyond the brief, absolute linear dimension of forward, sequential time of the Futurists, the Dadaists, and the Cubists. His conception of time would permit him to frame time not only in the next few successive moments, as in Duchamp's *Nude Descending a Staircase*, but out ino infinity. Sheeler would ask the naturally occurring architectural features of a simple eighteenth-century farmhouse, the Doylestown House, to stand up for time's perplexing, incongruous, and limitlessly expanding properties. That insight would add a power boost to otherwise perfectly still objects, all set in a plaintively quiet, perfectly bare, country house.

From one point of view, the photographs of the interior of the Doylestown House are form un-distilled: just quotidian, architectural features, still, timeless, and classical. As object, Sheeler first explored, then lit, then framed and photographed the formal properties of the house. This is the canonical interpretation of his vision.

Yet, from another, its doors, stairs and windows, stove, and most especially its gloxinia plant, define a time frame specifically linked to his particular perception of the space. As subject, Sheeler explored properties of the house that extended well beyond its material form; Sheeler's work thus informs the *house*, the house does not inform *him*. Whether in 1917 Sheeler knew it—and he doubtless did not—he and Einstein were singing from the same page.

Outside and inside, up and down, form dialectics of separation that cause philosophers to think of being and nonbeing. Thus, profound metaphysics is rooted in the explicit geometry of such common things as doors and windows, which may present themselves implicitly as metaphors.

But here is where it becomes complex: stairs, windows, doors, and stoves all evoke time spent

Nude, 1920. Graphite on paper, 4⁹/₁₆ × 6 in. (Museum of Fine Arts, Boston, M. & M. Karolik Fund)

of this important property of time leads one to contemplate the beginning of earthly time, and as did Pythagoras, to contemplate creation and even cosmology.[8]

With the Doylestown Suite under his belt, so to speak, Sheeler quickly found another opportunity to explore the new idiom in time, with his 1918 to 1920 suite of drawings and photographs—also derived from a short film—of Katharine Baird Shaffer.

Sheeler recognized that Katharine's nude, material torso—whatever else one might think today about the female form—surrounded a *center*, which, because Sheeler assigned it substance other than flesh, blood, and bones, would become to him as workable, interior spacetime. We will return momentarily to the *Nude* and its place in Sheeler's esthetic.

Sheeler would follow these works with the 1927 suite of thirty-two photographs of the Ford Motor Company at the River Rouge, where he documented not, as is always supposed, the classical, material forms that accompany American industry, but a concept he found *within* the plant, wherein the sequential process of industrial creation took place.

Sheeler's photographic suites at Doylestown, of Katharine's nude torso, and of Ford's factory at the River Rouge are sufficiently conventional in appearance that we could reasonably consider them as such; justifiably, all his biographers have.

But why would an early twentieth-century American painter, whose work to date had centered on conventional, tabletop still lifes of fruit and flowers, some rural barns, a few cityscapes, a suite of nudes, and an automobile factory, just up and book passage to France to photograph the Cathedral at Chartres? It simply cannot have been to compare the material, exterior form *cathedral* to the material, exterior form *factory*, or to the material, exterior form *nude*.

No: it was to compare their *interior* spaces. And where on earth, in the 1920s, would a young man go to assay creation but in the body of a woman or at a huge factory—or in a cathedral? To Sheeler these forms all had a property in common: a large, conceptually workable *interior* space in which a sequential, creative process could be reimagined in spacetime. Bear with me.

in a linear fashion referred to as time's arrow.* Notwithstanding, stairs, windows, and doors occupy a *symmetrical* property of linear time: what as stair is expressed as up, in full significance, is also presented simultaneously in negation as down.[7] Obviously, one can go in or out, up or down, or from one space into another and back again without permanent consequence—except for the passage of time.

Stoves, on the other hand, occupy an *asymmetrical* property of linear time: as linear time passes, smoke and heat rise. But they cannot return to the wood from which they emanated. We are all familiar with this natural property: words are spoken, candles burn down, trees and gloxinias grow up, eggs break, and as each occurs, time passes inexorably forward: we cannot un-break eggs, un-melt candles, un-grow plants, or un-speak words. Time will not flow backward to allow for these events to be undone.

Because our existence is only measured in one-directional time, and because we experience time as a sequence of events occurring in forward motion, then we have acknowledged that it all had to begin somewhere. An awareness

* Sir Arthur Eddington introduced the term "time's arrow" in *The Nature of the Physical World* (Cambridge, UK: Cambridge University Press, 1928).

Henry Ford's factory pioneered a sequential manufacturing process whereby iron ore, wood, rubber, and glass went in at one end and—miraculously—cars came out at the other. To the artist, a two-dimensional picture must have a form; for Sheeler, the object form *factory* presented him with an opportunity to survey the interior where the process, which is sequential in space and reiterative in time, is taking place. Similarly, the object form *woman* set up, as subject, an opportunity to metaphorically survey the sex act, which is also sequential in space and reiterative in time, and contrast it with the very system of creative reproduction, which, from our ancestors into the indefinite reaches of future generations, is linear in time. The reiterative sex act leads to linear generation.

The Cathedral at Chartres (1194–1221) is a monument to the Virgin Mary, the Mother of God. In the stained glass of Chartres, human history is displayed as a linear sequence, beginning in the north transept and running around the nave to the south transept: first the creation, then the coming of Christ, finally the resurrection of the dead. In 1929, two years after Charles Lindbergh's solo flight, Sheeler would travel to France* for the singular purpose of appropriating Chartres, an exterior construct of stones and glass surrounding an empty space, wherein its twelfth-century designers commemorated a creative plan that proceeds not, as at Ford, from material, linear sequence, but—even more miraculously—from nothing at all! We will return to the importance to Sheeler of this distinction between the material and the spiritual worlds in a moment.

In the meantime, sequence, as a variable property of linear and cyclical time, which he

*Chartres—View from Near Porte–Guillaume, 1929. Gelatin silver print. (Museum of Fine Arts Boston © Lane Collection)*

* Charles Lindbergh's solo flight to France in 1927 introduced the era of intercontinental flight, which today we take pretty much for granted. But in 1929, when Sheeler traveled to France, he had to book passage on a steamship, requiring that he devote some few weeks at a minimum just to go there and back. Yet, aside from visits to Stuttgart and Bavaria, the only record he made of this trip was the suite of photographs he took of the Cathedral at Chartres, suggesting that photographing the cathedral was his main purpose for going.

*Slag Buggy – Ford Plant,*
1927. Gelatin silver print.
(Museum of Fine Arts, Bos-
ton © Lane Collection)

*Doylestown House–Stairway,
Open Door,* 1917. Gelatin
silver print. (Museum of
Fine Arts, Boston © Lane
Collection)

wished to inject into his work, was on Sheeler's mind in 1918.* At just the same phase of his life, he was courting, and soon to marry, the same Katharine Baird Shaffer. Sheeler would ask his fiancée's material torso to symbolize the recurring, motile force we know as sexual attraction, and the property of never-ending, sequential time we know as generation: that the female plays just one role in a process that takes two, begs the question of whether a young man could ascribe to her alone the power to *move* him to accomplish that purpose.

While noting, parenthetically, that there are, in the Ford suite, no actual cars depicted, no effort to record Ford's innovative system of

* Sequence was on the collective mind: Arnold Schönberg (1874–1951), another near contemporary of Sheeler's, wrote with an intensification of harmonic strangeness, formal complexity, and contrapuntal density. When in 1908 the concept of atonality arrived, elements of key, tonality, thematicism, and rhythmic constraint were all left behind.

assembly from raw material to product, and but few people at work, critics invariably impute to Sheeler a singular devotion to the form *factory*, as these same people had earlier, to the forms *house* and *nude*. Yet Sheeler's photographs and drawings of these unequivocally different objects arose out of an identical concern for exploring the fourth dimension, or spacetime. In order for him to present such a formless subject, it would be necessary to surround it with something material: a house, a body, a factory, and a cathedral. These "tangible" objects are forms, certainly, but for our purposes they are better understood as boxes that surround conceptually workable spaces into which he could insert, or would reveal, subject matter. To achieve this purpose, Sheeler would add to the conventional notions of three-dimensional, Euclidean space a new dimension—time and sequence—even while working within the familiar paradigm of two-dimensional, plastic art.

Sheeler had told us, in 1916, that color, light, and dark are just a *few* of the dimensions a plastic artist can put into a picture. Others are hue, pitch, brightness, intensity, scale, volume, empty space, and density. Sheeler also said he wanted to introduce phase, harmonics, rhythm, law, fact, weight, pressure, resistance, movement, God, temper, timbre, even durability, all properties he could *only convey* through representation of tangible objects. Sheeler knew that he must oppose or relate time and space through opposing properties like black and white, zero and one, grasping and letting go, time past and time present, solid and void, upstairs and down, or inside and out. Failure to comprehend that this was his business has caused immense difficulty for art historians, who look only at his solid forms and proceed to interpretations of his purpose from the conventional, Euclidean attributes of those forms, or from inferring conventional functions associated with those forms. Accept this interpretation for now, if you can: I will provide further justification for all these assertions "in good time."

1 Bartlett Cowdrey, *Interview* with Charles Sheeler, December 9, 1958, Archives of American Art, Detroit.

2 Kern, *op. cit.*, 153.

3 Charles W. Millard, III, "Charles Sheeler: American Photographer," *Contemporary Photographer* (Culpepper, VA: Community Press, 1967), VI, 1, n.p.

4 Howard Devree, "Exhibition Reviews: Sheeler Complete," *Magazine of Art*, xxxii, 11 (November, 1939, p. 465), cited in *Ibid.*, n.p.

5 Stebbins and Keyes, *op. cit.*, 10.

6 Charles Sheeler, *Autobiography*, cited in Susan Fillen-Yeh, *Charles Sheeler: American Interiors* (New Haven: Yale University Art Gallery, 1987), 18.

7 Gaston Bachelard, *The Poetics of Space* (Boston: Beacon Press, 1958) 212.

8 Brian Greene, *The Fabric of the Cosmos* (New York: Alfred A. Knopf, 2004), 10–18.

*"I speak of the Kingdom of God, which may not be seen with the eyes. And if one shall say 'See it, it is come,' or 'it shall come' or 'it is here or there,' do not believe him. The Kingdom of God has neither time nor place, because it is within you."*

—Jesus of Nazareth[1]

Sheeler must have realized, by 1917, that all photographs, still or moving, connote time. After all, the camera could do what no other invention of man had ever done: chop time into discreet segments or stop it altogether.

In 1920 he and Paul Strand produced a short, silent "moving" picture called *Manhatta*, the effect of which was a flowing, sequential message experienced in one, constant location: on the screen. Moving pictures were capable of capturing movement in time: How could he evoke movement in time in a painting?

In his first such attempt, Sheeler painted *Church Street El* (1920) from a single frame of his film *Manhatta*, charging the composition with all the speed and motion of which a still-life photographer, in his time, was capable. The picture appears, at first, to throb with energy, and his object forms are powerful. But while they are highly wrought, almost mannered, they are indisputably still.

To heighten the effect, Sheeler invokes da Vinci in his use of aerial perspective, using only warm colors and deep shading to emphasize the recession and extension of planes that are otherwise quite still and flat. He raked his light and canted his forms, borrowing from the Futurists, in an effort to denote speed and movement. In an urban scene ostensibly full of people, the louvers on a church spire provide the only vestige of humanity. We do not know if the train is stopped

*Church Street El*, 1920. Oil on canvas, 16⅛ × 19⅛ in. (The Cleveland Museum of Art, Mr. and Mrs. William H. Martlatt Fund)

at the station or if it is speeding through the city; Sheeler has not yet, as he would later, delineated the tracks with ties to indicate the measured progress of objects in linear time. The long, heavy shadows in the composition imply the smooth passage of continuous time; the ochreous palette of rust-red, black, and sienna yellows evokes a seasonal reference to fall.* Together with the long shadows that enforce our assumption of the rustle of commuters at the end of another working day, the picture implies both cyclical and linear time. There had not been, before this, any more powerful expression in a painting of motion through space in time by a realist, American artist.[†]

Yet, considering what he had wanted to achieve, the effort was not wholly successful: there is, in *Church Street El*, something constricted, something bound or frozen that confines any sense of "motion" to the composition's four borders.

Sheeler's second attempt to indicate, in one painting, movement through space in time, also borrowed objects from one frame of a motion picture. *Pertaining to Yachts and Yachting* (1922) has about it overtones of Cubism or Futurism mixed with Dada. The action, which owes an obvious debt to Duchamp's *Nude Descending a Staircase No. 2*, is similarly apparent, but forced, as if Sheeler would have the boats burst the edges of the composition. Yet, even with all that wild cacophony of wind, shards of light, billowing sails, and surging water, they do not. They cannot.

Curiously, in all three media of *Pertaining to Yachts and Yachting*—the drawing, the print, and

*Pertaining to Yachts and Yachting*, 1922. Oil on canvas, 20 × 24 in. (Philadelphia Museum of Art, Bequest of Margaretta S. Hinchman, 1955-96-9)

Marcel Duchamp, *Nude Descending a Staircase, No. 2*, 1912. Oil on canvas, 57⁷/₈ × 35¹/₈ in. (Philadelphia Museum of Art, The Louise and Walter Arensberg Collection, 1950-134-59)

* Sheeler used the rust-red and brown palette of autumn to signify closure at particularly important episodic life passages, all having to do with a change in domicile. First in *Church Street El* (1920) when he left Philadelphia for New York; in *Staircase Doylestown* 1925 (Hirshhorn Museum and Sculpture Garden) a few years after he quitted the Doylestown House and in *Newhaven* 1932, (Private Collection) just prior to moving from South Salem to Ridgefield. There does not appear to be any such composition to accompany his move to South Salem in 1927 unless it was *Americana*, coming a few years later in 1931, which we will talk about anon.

† Max Weber, an American living in Paris, assimilated the fourth dimension into his art in a Cubist mode first in his *Composition with Three Figures* 1910 (Ackland Art Museum) and *Russian Ballet* 1916 (Brooklyn Museum). He continued in the mode of the Futurists with *Rush Hour, New York*, 1915 (National Gallery of Art). The only other American prior to Sheeler to try his hand was John Covert with *Time* 1919 (Yale University Art Gallery.) Marsden Hartley was also in Paris, 1914 to 1918.

the oil—the action moves from right to left, not the "conventional" left to right direction, in Western culture, of forward- running time-sequence.* The palette, which is blue/green in the bottom right corner moving along with the boats to red/brown at the upper left, is perhaps an attempt to create "motion" through tonal migration. At either event, Sheeler did not find, in *Church Street El* or in *Pertaining to Yachts and Yachting*, the presence of the fourth dimension he sought, while painting in the conventional two.

In 1923, Sheeler produced his first important essay on the fourth dimension, but not on movement through space, only in time. *Still Life: Audubon 451-* (Museum of Modern Art, New York) (now called *Self-Portrait*) is a less strident, more characteristically soft-spoken, yet somehow ectoplasmic drawing.

The telephone was, perhaps, the most devastating agent ever to intrude on the bond between time and place. The instantaneous nature of communication by telephone, especially over great distances, had "shortened" a centuries' old comprehension of the relationship between time and place. Sheeler's own title for the work, *Still Life: Audubon 451-*—the first part of his own telephone number—reflected his interest in time and place: the title accentuates the new reality, unambiguous prior to the invention of trains and the telegraph.

The reflection of the artist in the window also made the distinction between interior and exterior spaces ambiguous; we are uncertain if the artist is behind us, reflected in, like a mirror, or seen through the transparent glass. There is no room here to go into all the metaphysical properties of the mirror (e.g., mirrors make your reflected right hand into a left hand, reversing things from right to left, yet they do not reverse things up and down, i.e., switching your head and your feet), but the window would act throughout Sheeler's life as a metaphor for the separation of metaphysical states, interior and exterior, closed and open, transparent and opaque. Spacetime is, thereby,

* The second law of thermodynamics describes how entropy of a physical system increases with the forward sequence of time. However, entropy also increases symmetrically and simultaneously moving backward in time toward the past. It is tempting to think but unlikely that Sheeler was attempting, in 1922, to illustrate this phenomenon. See Green, *The Fabric of the Cosmos op. cit.*, pp. 161–180.

*Still Life: Audubon 451–* (now called *Self Portrait*), 1923. Conté crayon, gouache, and pencil on paper, 19³/₄ × 25³/₄ in. (The Museum of Modern Art, New York, Gift of Abby Aldrich Rockefeller.) Digital Image © The Museum of Modern Art/Licensed by SCALA/Art Resource, NY.

Charles Demuth (1883–1935), *Red Poppies*, 1929. Watercolor, 13⁷/₈ × 19⁷/₈ in. (Metropolitan Museum of Art, New York, Gift of Henry and Louise Loeb, 1983.40.) © The Metropolitan Museum of Art. Image source: Art Resource, NY.

imputed to the form *still life*, to a composition with the forms reflection, window and telephone, just as it was to the form *stair*, and to the form *nude body*, of Katharine.

I do not suggest, in making his photographic suites of the interior of the Doylestown House, of his wife's torso, or his paintings of the Church Street El, or of the telephone standing before the window that Sheeler denied these objects their formal properties. He was, in fact, keenly aware of their formal properties, and he arguably chose these objects both for their formal allure and for their emotive power. But I do suggest that it was his preoccupation with the objects' *subjective* qualities, and his wish to subordinate their Euclidean properties to his growing fascination for spacetime that has given these otherwise prosaic essays their lasting appeal.

Sheeler's work in all media, while apparently composed of solid forms, or the spaces between them, would, from this point forward, be at its root episodic; that is to say, wound around the

armature of some specific, autobiographical event in his life. In others, he might render a more general, impersonal event, like a season or a seemingly simple life-form to invoke spacetime. But according to Einstein, a thing cannot exist at some *place* without also existing at some *time*; nor can a thing exist at some *time* without existing at some *place*. And while, as we shall see, his view of them continued to evolve, Sheeler would never again think of space and time apart from one another.

At this point in our inquiry, it is important to contextualize Sheeler's work within the nascent spacetime idiom, which in the 1920s hardly made him unique in the art and literature worlds. In *Chez Mondrian*, Andre Kertesz assays the incongruities of space and time by using the same objects as Sheeler chose for *Spring Interior*: a vase of flowers on a table and a flight of stairs. Similarly, Charles Demuth in his monumental *Red Poppies* (1929) assays discontinuous time through the object of four blossoms in the various stages of life, all on one canvas: the youthful bud, the

proud and glorious prime, a faded middle-age, and finally a desiccated old age.

In William Faulkner's 1929 novel *The Sound and the Fury* the idiot Benjy responds in the present to sensory stimuli as he once received from similar events in another time and place from his past. To make matters worse, the reader, trying to make conventional sense of serial events told in stochastic order, discovers, only later, that there are two characters in the novel named Maury, which was—to make matters even worse—Benjy's name before he changed it. And if that weren't enough, there are also two characters in the novel named Quentin. In Virginia Woolf's 1923 novel *Mrs. Dalloway* the author makes a purposeful muddle of Clarissa Dalloway's rambling recollections and chops and dices events in the story line out of conventional, sequential time. Woolf said: "[It is] precisely the task of the writer to go beyond the formal railway line of sentence [and plot], to show how people feel or think or dream . . . all over the place."

And T. S. Eliot, in 1935, writing his poem "Burnt Norton," on the pervasive theme of cyclical patterns in time:

*Time present and time past*
*Are both perhaps present in time future*
*And time future contained in time past.*
*If all time is eternally present*
*All time is unredeemable.*
*What might have been is an abstraction*
*Remaining a perpetual possibility*
*Only in a world of speculation.*
*What might have been and what has been*
*Point to one end, which is always present.*

Obsessed with time and space, in the early decades of the twentiethth century, Charles Sheeler, who, with Joyce, Faulkner, Proust, Woolf, and Eliot also fragmented and reordered the "formal railway line" of sequential time, was in esteemed company.

1 Cited in Thomas Jefferson, *The Life and Morals of Jesus of Nazareth* (first published, Washington, DC: Library of Congress, 1904).

*The Artist Looks at Nature*, 1943. Oil on canvas, 21 × 18 in. (The Art Institute of Chicago, Gift of Society for Contemporary Art 1944.32)

*Interior with Stove*, 1932. Conté crayon on wove paper, 32³/₁₆ × 23 in. (National Gallery of Art, Gift [partial and promised] of Aaron I. Fleishman)

*"It's a queer sort of memory that only works backwards."*

—The Red Queen, Lewis Carroll,
*Alice's Adventures in Wonderland*,
1865

We have now seen Sheeler's earliest attempts to include the fourth dimension in his work and perhaps some readers will not yet see it. But if one were to begin (as I did) with *The Artist Looks at Nature*, the presence of the fourth dimension becomes impossible to deny.

In *The Artist Looks at Nature* (1943), a painting that Troyen and Hirshler call "his most baffling work," Sheeler presents himself drawing his well-known *Interior with Stove* (1932), itself a throwback to a photograph of the same subject, *Interior with Stove*, composed in 1917, while a resident of the Doylestown House.

Troyen and Hirshler find this picture "baffling" because they do not ask how, as Sheeler helpfully tells us in his title, that it represents his view of nature. Clearly, it does not comport with the canonical interpretation of his work: it is not an essay on line or form, or a "Precisionist" painting on an industrial, or a Shaker theme. But neither is it "an anomaly."[1] It is a tour de force: Sheeler is boasting that he has found a workable solution to incorporating the fourth dimension into his work.

This is the moment to review a peculiar property of photography that we may have taken for granted, but that Sheeler certainly did not.

A photograph is only a medium, to make which, the camera's lens captures light emanating from three-dimensional objects, then inverts and reverses it, producing, the instant it strikes the film, two-dimensional images. Sheeler would have found this property of photography very neat: the camera reduces three dimensions to two in the same way that the cardinal number 8, when coming from the three dimensions of Euclidean geometry into the flat, two-dimensions of a picture, is transformed by taking its cube root, to make 2.*

Sheeler's purpose in composing *The Artist Looks at Nature* was to exploit this mathematical certainty. He started with the three-dimensional objects in the Doylestown House—the room, the window, the fireplace, and the stove. He then took his photograph, thereby reducing these three-dimensional objects to two-dimensional objects. He then made a drawing of the composition using dots, the smallest strokes he could make, which for his purpose he regarded as one-dimensional. And finally he made the painting, which comprises all three dimensions plus one more, the fourth, which fixes them all in time.

We take them all in at a glance, yet are we disconcerted: the two staircases that take us up or down and up or down again are, like the facing mirrors, either taking us to no destination in particular and returning us to where we started. The two stairs rising up promisingly but going nowhere

---

* Sheeler's conté crayon drawings, like *Feline Felicity, Interior with Stove* and *Williamsburg Kitchen*, comprise a thousand little short strokes. Sheeler employs these time-consuming, approximately one-dimensional strokes as metaphor for the further reduction of forms that were once three-dimensional objects into photographs in which they are now two-dimensional.

Renato Giuseppi Bertelli
(Italian, 1900–1974),
*Continuous Profile of Il Duce
(Testa di Mussolini)*, 1933.
Terra-cotta, 280 mm ×
340 mm × 280 mm. (Impe-
rial War Museums, London
© The artist's estate. Art
IWM ART LD 5975)

himself, working on a drawing he made in 1932, of a photograph he exposed in 1916–17. The effect is not of movement in space, but of memory seeking renewal by traveling in time, three life phases into his past. We see him here, working on it, but we will not see Sheeler's painting until it is finished, adding an additional time phase away from its base, all four of which, he captures in one, two dimensional work.

In two photographs cited as studies for the oil,[2] Sheeler poses himself before the easel, working on *Interior with Stove*. The composition of the two photographs is the same, except in one there is behind him, over his shoulder, a photographer's lamp. As we learned in the Doylestown pictures, the stove (or in this case the lamp) is a notation of energy and movement, because a light, or stove, conveys energy across space through waves. But this time the lamp is switched off, implying no energy, no movement. In the second photograph (I do not know which actually came first) the lamp is gone; now the artist holds a lighted cigarette in his left hand, in his lap as he works. Smoking—in the movies of the early forties, the lighted cigarette was a virtual plotline—is a stronger notation of energy and motion. The energy notation that is part of the photographs is not a part of the oil, in which neither the lamp nor the cigarette appears.

Ultimately, *The Artist Looks at Nature* calls into question the very nature of being: Sheeler asks us to acknowledge, with Faulkner, Woolf, Proust, and Eliot, that in spacetime there is no progress, no sequence, no yesterday, no tomorrow, and no motion—there is only the *Eternal Now*.[3]

And there is, to my knowledge, no better illustration in twentieth-century Modernism of the *Eternal Now* than in Renato Giuseppi Bertelli's sculpture *Continuous Profile of Il Duce* (1933), in which the artist presents multiple phases of sequential motion in simultaneity.[4] The sculpture, looking at first glance like a glass insulator on a utility pole, is at once stationary, in motion and left-right symmetrical from wherever around its infinite circumference one stands. From a conventional standpoint, Bertelli's sculpture invokes the two-faced Roman god Janus, always depicted in two dimensions; but by inclusion of the third dimension, the artist also captures the fourth, and does so in the most elegant terms.

presents a philosophical state in which we have no ground beneath our feet: we float, in some ambiguous time and space disassociated with what we had previously thought defined "nature."

*The Artist Looks at Nature* is Sheeler's invocation of Proust, of recycled memory, and memory resides in the time dimension; it recalls the past by contrasting it to the present. Memory is not synonymous with movement: it cannot "travel" back from the present without the pull exerted on it by the past. To make the future possible, memory measures time intervals as it seeks constant renewal.

Seeing one's self in a mirror facing another mirror is also not motion, but in spite of the facing mirrors' capacity to extend space indefinitely, the effect is ultimately a reminder that we are standing in one place at one time: in the present.

Instead, *The Artist Looks at Nature* is an exercise in paranesia: the artist has, in 1943, painted

*Winter Window*, 1941. Oil on board, 30 × 24 in. (Myron Kunin Collection of American Art, Minneapolis, MN)

In *Winter Window*, which scholars never describe as typical, so they must either ignore it or force it into the canonical interpretation, Sheeler also invokes Janus, but in a very different incarnation.

Through a large casement window we behold a mountainous, snow- covered landscape, through which six skiers (one partially obscured) noiselessly descend. Before the transparent barrier there stands an arrangement of still-life objects—an empty, covered glass compote; a piece of green folded notepaper; a green succulent plant; and a patterned cover—in a spatially ambiguous interior. In this picture the window virtually fills the picture space from the top edge and from left to right—an indication

of Sheeler's immoderation in the deployment of these symbols.

Sheeler once said that everything that was to be learned from one of his paintings was right there, on its face. This statement is wholly disingenuous: Sheeler obscured the messages in *Winter Window* in a complex weave of encrypted subject motifs organized in the way of a Renaissance narrative altarpiece. To "learn" anything from what he presents on the face of this *Ballo in Maschera* would require a key.

The key is narrative, epistemological time; and the debate, over the nature of knowledge, is a debate between epistemological externalists, on the one hand, and epistemological internalists, on the other.

Many people refer to this picture as the "skier picture," and yes, it is one among Sheeler's many paintings that actually portrays motion. But of course the picture is about time and motion, not skiing. While Troyen and Hirshler state that Sheeler had "accurately recorded" the huge double window in his Ridgefield studio, the window, which looked out on a prosaic Connecticut landscape, not on a snowy mountainside, had only six panes across.[5] Sheeler's addition in the painting of one more pane in each row to make seven across was intended to resemble the blocked frames of a wall calendar, in four rows of seven panes, or twenty-eight—a metaphor for cyclical, monthly time.

The snowy landscape is another: it is a seasonal reference to January. Janus, from whose name we derive the name of the first month, was the Roman god of windows and doors, of inside and outside. These motifs are all general references to universal public time, to calendrics, seasonal cycles, and contrasting spaces. The following motifs, on the other hand, make episodic references to Sheeler's private life.

Janus, the two-headed god, who, like Bertelli's sculpture of Mussolini, appears to look simultaneously to the left and right, is in antiquity the god who looks both forward and back. As such, he is a metaphor for beginnings and endings. The snow in Sheeler's picture is, therefore, a metaphor for the end of one episode in his life and the beginning of another. The snow notwithstanding, the date of April 2, 1941, that appears on the sketch for

the oil painting,[*] is springtime, the time of lovers and of the Easter season, the time of propitiation and rebirth. The piece of notepaper that unfolds in the soft light is green, the color of spring and of renewal. There is nothing written on the paper, which is, like a tabula rasa, indicative of a fresh start.

The pattern, painted on the top of a chest in the foreground, is decorated in an up and down, up and down, step-like pattern, comprising thirty-nine steps.[†] The succulent plant is a broad, time notation symbolic of a being that is dormant in winter, yet evergreen, a reference to one who is asleep or, at any rate, out of phase. The clear-glass, lidded compote is an age-old symbol of feminine purity. The compote and the plant rest on distinct surfaces separated by a chasm.

The plant, on the far side of the chasm—the chasm separates the past from the present—is in the shadows cast by the casement; the glass compote, on the near side of the gulf, is in the present. The plant, seemingly dormant yet alive, would be Katharine, Sheeler's first wife, to whom he had been married for twelve years; the glass compote would be Musya, his second and very much alive wife to whom he has been married just one year.

The six skiers descending toward the glass compote refer to the six years (one of which is, except for his tracks, almost hidden from view) that passed between the death of Katharine, in 1933, and the date of his marriage to Musya Sokolova on April 2, 1939.[‡] Three and a half trails

---

* Sheeler dedicated the pencil sketch for *Winter Window* "To Musya/ April 2, 1941." Musya is a Russian name, but in Latin it is the word for "muse." He dedicated the sketch to her on the occasion of their second anniversary, implying that the painting impounds symbols of their relationship.

† The number 39, hardly an everyday number, crops up in Sheeler's life with something like totemic significance. In 1939 Sheeler produced the Power Series, MOMA gave Sheeler a retrospective exhibition, Havelock Ellis died, Sheeler married Musya Sokolova, and the tessellated pattern of steps on the tabletop in *Winter Window* total 39. I am not a numerologist or looking for traces of conspiracy, but Alfred Hitchcock's much-acclaimed movie *The Thirty-Nine Steps* had recently come out (1935), which was itself adapted from Scottish author John Buchan's adventure novel of the same name, published in 1915, coincidentally or not the year Einstein published his *General Theory of Relativity*.

‡ Troyen & Hirshler, *op. cit.* p. 223. Constance Rourke, Patterson Sims, and Martin Friedman erroneously give 1942 as the date of Sheeler's marriage to Musya.

*Wheels*, 1939. Gelatin silver print. (Museum of Fine Arts, Boston, © Lane Collection)

have descended through separate frames, on the left, into the space occupied by the plant, on the windowsill. Importantly, unlike the six skiers who are all but one, out in the open, these three and a half are all hidden from view, behind the plant; we only "know" of them because we see their trails. But since they are now gone, Sheeler indicates that their trails refer to events that predate the other six, which are in view. Sheeler, famously diffident and reticent, tells us sotto voce that while still married to Katharine, he was secretly seeing another.*

Troyen and Hirshler call this picture "fanciful," "fictional," "witty," and "playful." They see in it a joke Sheeler is playing on us. But I see

* Lindsey Pollock suggests that Sheeler had a secret liaison with his dealer Edith Halpert, which began in 1934, after Katharine's death. But she also reports that Halpert broke off the relationship in 1935, while Sheeler was in Williamsburg. Do the math: if the three ski trails in *Winter Window* record a three-year relationship with Edith and if it broke up in July 1935, it must have begun ca. January 1932, about the time he moved with Katharine from South Salem to Ridgefield. See Lindsey Pollock, *The Girl with the Gallery* (New York: Public Affairs, 2006), pp. 202–204.

it quite differently. *Winter Window* is a serious picture, a summing up of the important personal events to date in Sheeler's love life, presented—all quite clearly on its face—through a completely conventional iconography of discernible forms, but in his own, encrypted, idiomatic vocabulary of cyclical and linear time.

Sheeler also invoked the property of linear time moving in one direction by comparing it to a train on a track. Sheeler's interest in the form arguably stemmed from this popular and useful figure.

*Wheels* (1939) is not as is often contended, a study for the painting *Rolling Power* (1939).[6] By presenting the material forms *train* and *track*, Sheeler assays time's various dimensions to metaphorically frame events from his life.

Sheeler again uses the camera to reduce the three-dimensional Hudson locomotive to a two-dimensional Hudson locomotive. And now he adds the fourth.

Let's look first at the objects in the photograph. Sheeler closes in tight on the driving wheels that are the slave of the locomotive's power, and the steam that is the spirit of it. The linkage, or

transmission, between the two states—the actual fastening between the steam piston and the driving rod—is where nondirectional steam is translated into linear force, which rotates the wheels of the train, driving it along the linear track. Sheeler positions the intersection of the two at the exact center of the diagonals of his picture, implying its importance to the composition and its theme.

Steam or heat, you will recall from our discussion of the stove in the Doylestown House, is a nondirectional, asymmetrical force converted into symmetrical, linear force through the sequential action of reciprocating rods and rotating wheels. The singular purpose of all that machinery is to harness the potential energy in steam and direct it; but for Sheeler's purpose, steam drives motion and motion consumes time, both cyclical and episodic linear time.

To compose the painting *Rolling Power*, Sheeler extended the scale, format, and composition of the photograph *Wheels*, in order to commute the same material object into a new time frame. To achieve this shift he would add sleepers—railroad jargon for ties—and another driving wheel to the engine in the photograph. This is important: a wheel, by accomplishing its circumference over and over, converts the pan-directional energy of steam to linear motion. A train gains ground, by quanta, as measured by the spatial and temporal intervals between sleepers, much as one ascends a ladder, rung by rung, a

clock second by second, or a stair, tread by tread.

With the addition of four ties and a second driving wheel to the engine in the photograph, the ratio of the distance between the ties in the painting to the large driving wheel becomes exactly 22:7, which is the ratio of the diameter of a circle to its circumference (3.14, or $\pi$). This sort of punctuated progress intimates a time notation dependent on conventions of forward motion—the train is presented, like readable type, as moving from left to right—that we, because we are familiar with the forward motion of events and of type in books, unwittingly supply. As we know from *Feline Felicity*, sleepers are stationary; yet like the cat, they invoke the stair motif, or discontinuous, episodic time: eight sleepers in the photograph, twelve in the painting. In both compositions, Sheeler "opposes and relates one, two, three dimensional space" with time's two paradoxical properties: reciprocating and linear.

One could suppose, as have all his biographers, that Sheeler put twelve ties beneath the Hudson locomotive in his painting *Rolling Power* because he found twelve ties under it. But if his subject was to assay mathematical relationships, then the extension of the format to include twelve quanta in the painting from the six he captured in the photograph requires us to give his purpose a little more thought.

To help us do that, I quote rather than attempt to paraphrase Guy Murchie:

*It was Pythagoras (ca. 570 – ca. 495 BC) who first noticed that the sympathetic relationship we call an octave comes from exactly doubling (or halving) the string length on a lyre, i.e., changing its length in a 1:2 proportion, while the harmonious fifth has a 2:3 relationship and the fourth a 3:4 relationship. These discoveries led to deep contemplation of the abstract ratio of numbers and geometric figures and particularly to a new mathematical relation, known as the harmonious mean.*

*The harmonious mean expresses a pitch ratio between neighboring musical notes that is a good deal subtler than the arithmetic mean, which merely averages them, or than the geometric mean, which equally tempers their proportions. Thus, if we take, for example, the numbers 6 and 12, their harmonic mean is 8 (which exceeds 6 by one third of 6 and is exceeded by 12 by one third of 12), their arithmetic mean is 9 (which differs from both 6 and 12 by the same number, 3) and their geometric mean is approximately 8.486 (such that 6 : 8.486 = 8.486 : 12). In this way, the harmonic mean came to appear to the Pythagoreans as one of the most divine endowments of nature, not only in music and the heavens but also in flowers and hills, and in moving animals and the waves of the sea. Even the cube was held sacred because its eight corners form the harmonic mean between its six faces and its twelve edges.[7]*

Sheeler's purpose in creating *Wheels* and *Rolling Power* was to assay two different phases of the time and space the Hudson locomotive occupies. Again, some may find this explication fanciful or even outlandish. But I find my justification for advancing it—in fact, my justification for explicating all his pictures—in Sheeler's *Statement* of 1916, where we find no basis whatsoever for asserting that his purpose was to "expound the exciting technological developments of the machine age."[8] We will see in chapter 3 how Sheeler adapted his art to the coming of the nuclear age by expanding upon Pythagoras's observations in the natural world.

But before we go there, let's explore why in the early 1920s and off and on again throughout his career, Sheeler occupied himself with still life.

Sheeler's still lifes always carry, within their composition, references to time, and they are, therefore, not strictly speaking, "still." To achieve a sense of motion Sheeler's still-life paintings always include a transitory life form: flowers, apples, or snow. Sheeler used these props because they make seasonal references, which like haiku poems, more closely define specific spans of time, within the generality of limitless time.[9]

In *Feline Felicity* (1934) and *Spring Interior* (1927), Sheeler presented the classic elements of still life. But Sheeler did not define "life-form" as narrowly as we might; in fact, his definition extended to objects as unalive as rocks.

In *Silo* (1938), Sheeler reminds us that hay for silage is gathered each fall, a seasonal reference to cyclical time, and kept each winter in a silo, the construct where man has stored energy for cows through the ages, a reference to linear time. In *Rocks at Steichen's* (1937), Sheeler invokes both cyclical and linear time: as we all know, trees and other flora are temporal, but relatively speaking, rocks are too. The continents, to cite a very large example, have not always been where they are today; they moved eons ago and they are still moving. "In time, the Rockies may crumble, Gibraltar may tumble, they're only made of clay . . ."[10]

In *Feline Felicity*, Sheeler's message is again time's cycle and time's arrow: the cat sleeps (a metaphor for standing still in time: in his picture, the cat will pose frozen forever) on a ladder-back chair, a form with step-like features, which, like the stairs in the Doylestown House or the sleepers beneath railroad tracks, are a reminder of discontinuous, linear time. The sunlight and shadow flowing across the forms is a notation of continuous, linear time. The fireplace in the left background like the stove in the Doylestown House is Sheeler's metaphor for energy and motion. But there is no fire in the hearth. The cat and the fire are both suspended between life and death.

It verges on the utterly fantastic to suggest that in *Feline Felicity* Sheeler anticipated by a year one of the most celebrated paradoxes in quantum theory. And yet he seems to have done just that.

On June 7, 1935, Erwin Schrödinger (Austrian, 1887–1961) wrote to Albert Einstein to describe a state of matter and energy in which

polar, exclusionary opposites, like in and out, black and white, dead and alive, and off and on can exhibit both properties at once, a state of duality he referred to as a "cat state." Schrödinger posed the following model: A cat is placed in a box, together with a radioactive atom, a bottle of prussic acid (HCN), and a Geiger counter. If the atom decays, the Geiger counter detects an alpha particle causing a hammer to hit the flask of acid, killing the cat. The paradox lies in the clever coupling of quantum and classical domains: quantum mechanics doesn't allow the strict dichotomy between "observer" and "observed" of our macroscopic world. Before the observer opens the box, the cat's fate is tied to the wave function of the atom, which is itself in a superposition of decayed and undecayed states. Thus, said Schrödinger, the cat must itself be in a superposition of dead and alive states before the observer opens the box, "observes" the cat, and "collapses" its wave function. The Schrödinger equation is the fundamental equation of quantum mechanics, which governs the microscopic world. It is contrasted with Newton's equation of motion, which is the fundamental equation in classical mechanics. By

solving the Schrödinger equation, all the results from Bohr's quantum theory have been derived completely, and the mysteries apparent in the microscopic world have been resolved one after another.[11]

In *Spring Interior*, a picture of forsythia blooming in a vase of water placed on an octagonal table before a staircase and fireplace mantle, all set in his house in South Salem, the stairs carry the message of sequential, measured time; the forsythia, a message of cyclical time.

*Feline Felicity, Spring Interior* and *Rocks at Steichen's* were not intended as "an answer to those who felt that hardness and coldness were Sheeler's only expressions."[12] Neither did he intend them to be "non-geometric designs that caught the play of light and shadow on irregular surfaces."[13] Sheeler's organizing idea for all three of these pictures is that on a cosmic scale all matter—vegetable, animal, or mineral—beats and wears in time. In these pictures, silos, flowers, rocks, and cats are merely props for a consistent, underlying subject message about the variable, paradoxical properties of space and time. The fireplace behind the forsythia, and the hearth

behind the cat were, to Sheeler, constructs like coal stoves or steam engines, in which combustion of fuel into energy connotes movement through space, and its corollary, time. Likewise, there is a little burst of steam coming out of the power piston that drives the locomotive in his well-known photograph *Wheels*, and also in the painting *Rolling Power*. Steam is a notation of heat and motion reminding us that a still life of train wheels, objects we think of as cold and hard, are only that way relatively speaking.

The little octagonal table (Museum of Fine Arts, Boston, Gift of James Maroney) appearing in *Spring Interior*, which Sheeler included in many of his still lifes from the mid-'20s, again symbolizes how the artist, in the very act of making pictures, transforms three-dimensional objects into two-dimensional ones in the same way that taking the cube root of 8 produces 2.

While not a still life in the traditional sense, we must look in this context at Sheeler's painting *Fugue* (1940), an exposition on what he had referred to in his manifesto as "the profound scheme, system or order underlying the universe: call it harmonics, rhythm, law, fact, God, or whatever you will."

The fugue is a contrapuntal compositional technique in two or more voices built on a musical theme that is introduced at the beginning and then imitated several times but in different keys over the course of the composition.[14] Sheeler's interest in the form was not unlike that of artists from classical times, who without any knowledge of quantum mechanics or of relativity, hoped that through its tonal, harmonic scaffolding they might express thoughts about the greater world around them. Sheeler's interest coincided with a revival in the 1920s and '30s of the fugue by Avant-Garde composers such as Joseph Maurice Ravel (1875–1937), Bela Viktor Janos Bartok (1881–1945), and Igor Stravinsky (1882–1971). With Sheeler's title as their guide, Troyen and Hirshler easily relate *Fugue* to the musical form. But they do not relate remarks he made in his manifesto about rhythm, harmonics, and the universal order to *Fugue*'s — and four other works with musical themes, *Music in the Air* (1941), *Incantation* (1946), *Polyphony* (1947), and *Counterpoint* (1949)—*parti*, or organizing idea.[15]

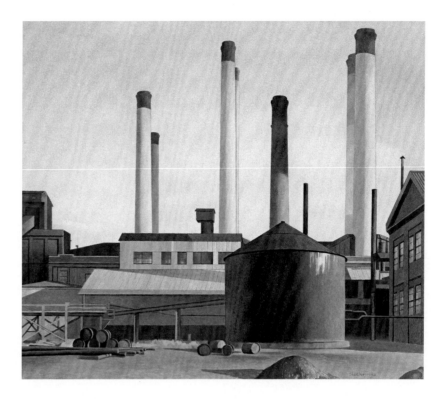

*Fugue*, 1940. Oil on gessoed panel, 11 1/2 × 13 1/4 in. (Museum of Fine Arts, Boston, Arthur Mason Knapp Fund)

1 Troyen and Hirshler, *op. cit.*, 183.

2 Karen Lucic. *Charles Sheeler in Doylestown* (Allentown: Allentown Museum of Art and Washington University Press, 1997) 111.

3 Alan Watts, *Talking Zen–Time and Convention* (New York: Weatherhill, 1994), 119–123.

4 Christopher Wilk, ed., *Modernism: Designing a New World* (London: Victoria & Albert Museum, 2007) no. 231, p. 365.

5 Troyen and Hirshler, *op. cit.*, 178.

6 *See* Millard, *op. cit, Charles Sheeler: American Photographer*, [List of] Illustrations (n.p.).

7 Guy Murchie, *Music of the Spheres: The Material Universe from Atom to Quasar, Simply Explained* (New York: Dover, 1961) vol. 2, pp. 361–2, used with permission.

8 Troyen and Hirshler, *op. cit.*, 168.

9 Soiku Shigematsu. *Zen Haiku: Poems and Letters of Natsume Soseki* (New York: Weatherhill, 1994).

10 *Our Love is Here to Stay*, music and lyrics by George and Ira Gershwin, first performed by Ella Fitzgerald in *The Goldwyn Follies*, 1938.

11 For a fuller description of this postulation, *see* http://www.nytimes.com/2005/12/27/science/quantum-trickery-testing-einsteins-strangest-theory.html

12 Troyen and Hirshler, *op. cit.*, 150.

13 Dochterman, *op. cit.*, 68.

14 https://en.wikipedia.org/wiki/Fugue#Musical form or texture

15 Troyen and Hirshler, *op. cit.* 176.

*"It's like that river that goes on forever . . . How do you think I stand it?" she said challengingly. "I have to hear it all the time . . . Oh, all the time and all the time and all the time!" she said with a kind of weary desperation. "If they'd only leave me alone for five minutes some time, I think I'd be able to pull myself together, but it's this way all the time and all the time and all the time. You see, don't you?"*

—Thomas Wolfe, *Of Time and the River:*
*A Legend of Man's Hunger in His Youth*
(New York: Charles Scribner & Sons, 1935)

Beginning in 1926 and lasting until 1934, Sheeler composed a number of pictures that have become known collectively as his *Interiors*. These compositions, usually preceded by photographs he cropped for transfer to oil paintings, were all derived from views in his homes in South Salem, New York, and Ridgefield, Connecticut. Beginning, as they do, before his 1927 trip to Chartres, and continuing after his highly acclaimed 1929 trip to the Rouge Plant in Detroit, they represent an oddly inward-looking, almost locked-down outlook for a man whose professional prospects were just breaking out.

Because Sheeler's biographers see in his work at the Rouge Plant and at Chartres, a concentration on form, they further suppose that his *Interiors* are also essays on material form. His concentration on material form, they say, reveals his appreciation for the timeless, economic utility of the Shaker sect's furniture, which, after a fashion, Sheeler collected, along with some other old, but not very well pedigreed, tables and chairs.

It is not insignificant that, at just this same time, Henry du Pont, Wallace Nutting, Electra Havemeyer Webb, Abby Aldrich Rockefeller, and Maxim Karolik were all avidly collecting Americana—an idea with its roots in the Eugenics Movement—to reassert, through an appreciation of simple wares, the primacy of wholesome, Anglo-Saxon, Protestant values.[1]

Notwithstanding arguments over the legitimacy of this pursuit, all of Sheeler's biographers see in his *Interiors* an infatuation with naïve, nineteenth-century pattern, or with the economic utility of flawlessly designed Shaker form, which because nineteenth-century folk furniture and decorations avowedly appealed to the modern sensibility he is said to have favored. But Sheeler was not an antiquarian; nor was he—as were du Pont, Nutting, Webb, Rockefeller, and Karolik—interested in the reestablishment of aristocratic notions supposedly inherent in the purity of Yankee design.

Sheeler clearly did arrange his interior compositions to convey a sense of immobility. But in composing them he intended to convey not, as has always been supposed, the state of "timeless durability" but the state of transitory arrest. The difference between the two is a dimension of time: and it is a dimension not infinitely large but infinitesimally small.

It bears mentioning that during the period of 1933 to 1936, at the encouragement of Edith Halpert, Sheeler designed seven fabrics to be used in the manufacture of women's sport clothing. In a letter to Louise Arensberg, Sheeler reported that Marcel Duchamp—of all people—was "enthusiastic" about the fabrics. More to the point, Morton Schamberg, in his statement of 1913 (which *see pp. 126–127*), refers to pattern as "an observed property of the natural world for plastic artists to explore."

Sheeler's prominent inclusion, in his *Interiors*, of patterns, like the tessellated tiles, coverlets, and rag rugs in his South Salem and Ridgefield

houses, clearly expands on some property of the materials. It has been said that their purpose to Sheeler, in the context of his interiors, was to invoke the Greeks and Romans, and the timeless, classical beauty of mosaic.

But in my view, in the context of his personal life, periodic, tessellated patterns serve as beat markers, which, like the *basso-continuo* of musical composition, keep time while making no linear, forward progress, i.e., a state of immobility.[248]

Sheeler provides an invaluable key to understanding his *Interiors* in his photograph titled *South Salem Interior* (1929).

Sheeler positions the viewer at a long-range vantage before three curiously arranged ladder-back chairs standing in the immediate foreground like sentinels, resisting our entry. We can see, beyond an open doorway, another chair, this one a rocker, off to the side facing inward. Beyond these, we see yet another ladder-back chair, the last stop before our eye reaches a bed, seemingly insignificant to the composition. On the floor, we see a patterned rug and, on the distant wall, a Pennsylvania coverlet.

The bed is set in a distant room at the far end of a passageway, not in the foreground where we might expect to find a picture's subject; yet it is in the middle of the composition framed, in a square of light, and set like an altar beyond the crossing in a cathedral. Sheeler thereby directs our eye along a visual path leading from the frontal plane, where the chairs stand guard, into the middle ground, where a doorway further constricts the way, past a chair—all reminiscent of Charles Willson Peale holding back the curtain to his museum—and finally, to a frame formed by the doorjamb and the leading edge of the rug. There, after accomplishing these hurdles, we are finally admitted into the subject of the picture: the poignantly empty bed. Sheeler places ordinary obstacles—chairs—not to celebrate the beauty of their material forms, but to enlist them as sentries to deflect attention away from the picture's main subject.[3]

Sheeler seems to want to clutter our approach with obstacles, yet he also provides a clue to help explain his purpose in composing this photograph as he does. Prominently placed on the wall, in the antechamber outside the bedroom—not positioned in the center of the wall where one usually expects to find a picture hanging and strangely off center, as if leaning into the center to get our attention—Sheeler places a Pablo Picasso pochoir, *Untitled* (ca. 1922.)

Fillen-Yeh suggests because Sheeler's first concern in selecting and arranging objects for inclusion in his *Interiors* was for their timeless, formal, aesthetic properties, that his inclusion in his works of stairs, windows, and doors sought to block off causality and, thereby, to deny these constructs their conventional meanings as instruments of transition. She cites as evidence for this assertion that Sheeler's windows are often opaque, that his doorways are "images in permanence" not thresholds, and that the skiers in *Winter Window* are not really kinetic.

Troyen and Hirshler also see something out of joint in his interiors but are unable to reconcile their at once inhospitable yet cozy atmosphere:

*Oddly, the paintings [many of which followed from photographs like* South Salem Interior*] are often more tightly framed and more eccentrically cropped than the photographs. The cropping frequently eliminates windows and doors precluding any sense of contact with the outside world. The interiors become hermetically sealed spaces, permitting no entry and no exit . . . [resulting in] a sense of claustrophobia . . . The emptiness of the interiors seen in the paintings introduces an ironic undertone to the patriotic, sentimental titles Sheeler gave them. These cozy spaces, with their friendly, familiar forms, which at first glance appear to provide a kind of refuge from the urban, industrial present, begin to seem less welcoming, less hospitable, less real.*[4]

I agree that there is something unsettling about his interiors. But if *South Salem Interior* is really meant as a paean to the "timeless, formal, aesthetic properties" of Sheeler's collection of Americana or to the "sparkle and shine of [his] glass collection and a harmonious arrangement of unadorned, functional artifacts typical of the industrious Shakers," why would he choose to place in his photograph not a Pennsylvania-Dutch

fraktur or a New England needlework sampler but a work by the world's most famous Avant-Garde painter?

Troyen and Hirshler see no contradiction between their assertion that Sheeler held his collection of Americana in high esteem and yet was incurious about the authenticity of the objects for which he is supposed to have had so great an affection.[5] None of his biographers had ever noticed the Picasso hanging quietly in Sheeler's *South Salem Interior*, not Rourke, McBride, Cowdrey, Millard, Lowe, Friedman, Watson, Dochterman, Fillen-Yeh, Stebbins, Keyes, Hirshler, or Troyen. Surely his choice of a Picasso is no accident, and just as surely his decision to interpose one with an assemblage of Americana was intended not to sooth but to jolt. Seen this way, Sheeler's intention in *South Salem Interior*—and all his *Interiors*—could not have had anything to do with the "proliferation of modest, functional, and unadorned bric-a-brac" that he is so often said to have favored.[6] Might this inclusion of a Picasso in this otherwise placid, American interior have upended their entire argument about Sheeler's purpose?

I completely agree the *Interiors* are cluttered with objects and they do produce a sense of claustrophobia. But Sheeler captures this mood not by adulation of New England forms but by arresting them in space and time: linear, as in the case of the ladder-back chairs (one with five, one with four, and two with three slats marking I don't know what private events), cyclical and reciprocating, in the case of the rocker. The net effect of *South Salem Interior*, coming, as it were, eight years after his marriage to Katharine, is more likely a comment on the state of things between them, as matters had come not to joyfulness, but to stasis and despair.* Given the objects he chose for inclusion in the picture, and the way he arranged them, there is really no argument to support an intention to convey a joyful or expansive mood.

I suggest therefore that Sheeler's *Interiors* are not, as has been always supposed, "full of appreciation for the form of his furnishings," but are instead a reflection of a different mood: morbid

---

* Seven years is colloquially said to be the point at which the marriage bond becomes strained.

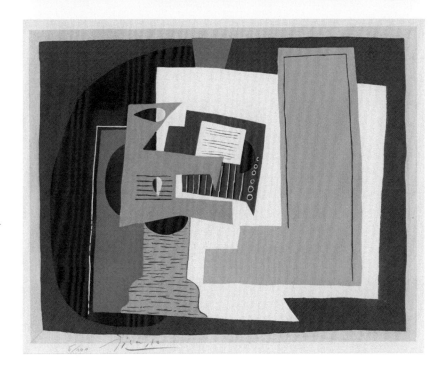

*South Salem Interior*, 1929. Gelatin silver print. (Museum of Fine Arts, Boston © Lane Collection)

Pablo Picasso, *Untitled*, ca. 1920. Pochoir, 11 9/16 × 9 7/16 in. (Metropolitan Museum of Art, NY. Gift of Paul J. Sachs, 1922 22.86.5)

*American Interior*, 1934. Oil
on canvas, 32½ × 30 in. (Yale
University Art Gallery, Gift of
Mrs. Paul Moore)

*South Salem Living Room*,
1929. Gelatin silver print.
(Museum of Fine Arts,
Boston © Lane Collection)

and inward looking. He cropped out the windows
and doors in most of his *Interiors* precisely because
he wished to project a sense of entrapment. He
selected as objects the ordinary furnishings in his
own home—perhaps once loved—but which now
served not as companions, but as silent witnesses,
even gaolers. Sheeler conveys a sense of claustro-
phobia by crowding these objects into his frame,
focusing in tight, and using the murky idiom of
constricted-space-arrested-in-time as a metaphor
for his unhappy state.

Starting just three years after his marriage, in
1921, with *Still Life and Shadows*, in 1924 (shadows
are universal metaphors for dark premonitions),
and ending, in 1934, after Katharine's death (from
some unknown malady), all seven of the *Interiors*
might be symbolic not of "happier times"[7] but of
an unfulfilled and loveless home life, a childless
marriage, a sense of betrayal or disillusionment,
or even of a sprung trap, from which he was des-
perate to disengage.[8]

*American Interior*, 1934 (Yale University Art
Gallery) is the last of the series of seven *Interiors*,
of which five were painted at his South Salem
house between 1926 and 1931, while the sixth,
*Newhaven*, 1932 (Private Collection), painted
after moving to Ridgefield, was nonetheless of
the South Salem interior. The inclusion in the
titles of these works of the words *Americana* or

*American* is at best a red herring or at worst a
broad, sardonic social commentary somewhat
akin to the brooding interiors of Eric Fischl.

Perhaps Sheeler's biographers have miscon-
strued the mood of Sheeler's interiors because
they have misconstrued the distinctive rust-red
and ochreous palette—Troyen and Hirshler call
it "warm and glowing"[9]—that he used to signify
closure at particularly important life passages,
usually accompanied by the loss of a loved one
or a change in domicile; first, in *Church Street El*
(1920) when he left Philadelphia for New York;
next in *Staircase Doylestown* (1925), a few years
after he quitted the Doylestown House; then in
*Newhaven* (1932), just prior to moving from South
Salem to Ridgefield. There is no such compo-
sition to accompany his move to South Salem
in 1927, but since it is painted in this palette,
*Americana*, painted four years after the move, is
likely to commemorate this event.

At first blush, *Americana* appears to be an
"atypical" picture—so scholastically ungainly that
it goes unmentioned in Troyen and Hirshler—
leaving curators at the Metropolitan Museum to
attempt to try to force it into the canonical dogma:

*Sheeler and Charles Demuth, among others,*
*worked in a style of painting called Precision-*
*ism. Sheeler's sharply focused depictions of*

*buildings, machinery, and interiors were often based on his own photographs . . . [Americana is] filled with a profusion of precisely rendered objects but no people, [the picture] seems oddly frozen in time and emotionally distant. The floor and furniture seem to tip upward toward the viewer, making them look off-balance and rather two-dimensional. The long trestle table and the two side benches hover like flat boards over the other furniture and the floor. The conflicting geometric and linear patterns of the four rugs, two pillows, woven sofa covering, backgammon set, and cast shadows add to our visual discomfort, as does the unusual cropping of objects. The verity of Sheeler's realism, however, makes us willing to accept these inconsistencies. The painting is . . . a statement about national pride and the values of home and craftsmanship.*[10]

The "verity of Sheeler's realism" is indeed on display in *Americana*, but it was never his intention to compose "conflicting" forms or to "discomfort" his audience. At an impressive 48 x 36 inches, *Americana* is Sheeler's largest picture, usually an indication of its importance to its creator. And yes, its subject is "frozen in time"; but it is not "emotionally distant" any more than it is "off balance."

Sheeler's inclusion of a backgammon game in *Americana* is a metaphor for cyclical time that passes, but, like the hour, the day, and the year, once accomplished returns to the start. Backgammon is a game in which players move in opposite directions around the board, one moving his pierces clockwise while the other moves his pieces counterclockwise. Backgammon is a betting game and, in accordance with the margin of advantage a player perceives, he will advance the stakes geometrically, 1, 2, 4, 8, 16, and so on. In this way, the game increases in energy, rather like a chain reaction, while occupying the same space. This particular game is not yet over, but white, with five counters off, is in a better position; black, with but three counters off, is rather too far in the back of the home board. Sheeler uses the eight counters already off to record the passage of eight units of sequential time, the eight years he had by then known his future wife, Musya. The

tessellated patterns that are so prominent in the picture act as beat markers, counting the time that makes no linear progress.

It is unlikely that Sheeler's inclusion of tessellated patterns in *Americana* refers to the Greeks or to the "timeless, classical beauty of mosaic." The seven tessellated patterns he designed are in deference to the harmonic intervals of the seven notes of the diatonic scale (do, re, mi, fa, so, la, te) once explored by Pythagoras. These notes have certain correspondences to the intervals of the seven planets of antiquity, to the intervals between the seven octaves of the piano keyboard, and the intervals between the seven octaves of the periodic table of elements.[11] His deference is not to the *notes* but to the *intervals* between them. Likewise, the seven-day week is based on the structure of objects in space, which as noted previously have six faces: top and bottom, right side and left side, front and back. But, such objects also have a seventh, occupying the center point between the others, their interior. Because it is not a "side," the interior has no extension and takes up no volume of physical space. Every item in the physical world, irrespective of its exterior configuration, must have these attributes and since only six are physical, the seventh must be spiritual. The week, for example, comprises but six days, while the seventh, the Shabbat, resides not at the beginning or the end but at the center of the other six. By connecting the six attributes of a material shape with its center, Sheeler could, as we might say today, "channel" Pythagoras and make an attempt to assay the nature of all things. The number eight, the meaning of which to Sheeler we will explore shortly, represents that which is beyond the three dimensions of this world.

Sheeler was a painter; he knew that the seven notes of the scale also correspond to the seven colors of the rainbow. When these colors of light are combined, they produce white light. But he also knew that when the painter combines these same colors in pigment, they produce the color brown, implying that the combination of all colors of light produces something ethereal, while the combination of all colors of pigment produces the color of the earth.[12]

As odd as it may seem, these arcane properties of the physical universe are the fundamental

*Americana*, 1931. Oil
on canvas, 48 × 36 in.
(Metropolitan Museum of
Art, New York. Edith and
Milton Lowenthal Collection,
Bequest of Edith Abraham-
son Lowenthal, 1992.24.8.)
© The Metropolitan
Museum of Art. Image
source: Art Resource, NY.

building blocks of Sheeler's art. Factories, barns, locomotive wheels, still lifes of fruits or flowers, stairs, stoves, windows, cathedrals, and nudes were only the vehicles he chose to expound upon them.

This is a fine moment to remind the reader that to compose his photographs Sheeler artfully chose and/or arranged material objects in space. His photographs often appear to be preliminary to paintings of the same, or related subjects, but the paintings invariably serve other texts and are rarely—if ever—composed *verbatim* from them. In either medium, his pictures are, ultimately,

not about *form* but about *time*; and time, being formless, must be given some sort of shape.

*Americana* is sepulchral and claustrophobic, but its palette betrays a man making expressions not of joy, but of despair. Lest you think that I am being morbid by suggesting that Sheeler was feeling trapped in his marriage to Katharine and relieved at her passing, let's look at *Ephrata* (1934), where we find further proof of Sheeler's brightened mood following Katharine's death.

The painting takes its central subject from an earlier photograph, *Ephrata Cloister from the Cemetery*, dated by Stebbins and Keyes ca. 1917. The photograph affords a view of a graveyard in the foreground, beyond which we see the silent and austere buildings of the cloister, from which presumably the picture gets its title. There is, in the photograph, a startlingly apocalyptic aspect: the cemetery takes up almost a third of the composition.

To frame the painting, Sheeler cropped the photograph on all sides, completely eliminating the graveyard. We have moved up closer to the buildings, giving them the disquieting aspect of a butterfly pinned through its thorax to a board.

I think we should not believe, in spite of its title, that the picture—either picture—is about buildings. It is about the cemetery, and more precisely, its absence.

I mentioned earlier that Sheeler was inordinately interested in life-stage transitions. With this in mind, I would assign to the photograph a date of 1919, the summer after Schamberg's death in October 1918, and coincident with Sheeler's removal from Doylestown to New York, each traumatic and significant events. His visit to Ephrata is evidence of his darkened mood after Schamberg's death. But why Ephrata?

Ephrata, a town in Pennsylvania, was the ancient name for Bethlehem, the town where Jesus, the symbol of redemption, is said to have been born. Sheeler's decision to revisit Ephrata, in 1934—he did not need to literally go back to Ephrata to make the oil, as the mostly leafless tree in the left background of the photograph is still mostly leafless in the painting, indicating that he simply made his painting from the photograph—would follow close on the death of his wife, in 1933, and augur the promise of new

*Graveyard and Buildings, Ephrata Cloister from the Cemetery*, ca. 1917. Gelatin silver print. (Museum of Fine Arts, Boston © Lane Collection)

*Ephrata*, 1934. Oil on panel, 19 1/2 × 23 1/2 in. (Museum of Fine Arts, Springfield, MA. The James Philip Gray Collection)

life—his own life—now that she was gone. The dramatic change of mood, from the photograph to the painting, betrays the change in his moods during these two life-stage transitions: the first, in 1919, of morbidity for the time with Schamberg that had passed, and the second, in 1934, of optimism for what lay ahead.

Sheeler produced his most candid essay using the form *stair* as metaphor in 1923, the tectonic *Stairway to the Studio*.

Troyen and Hirshler describe this drawing: "With its unremarkable subject matter and subdued palette, *Stairway to the Studio* seems somewhat static, even bland . . . the space seems thoroughly logical, organized according to classical doctrines of single-point perspective . . . [yet its] subtly shifting vantage points generate a sense of insecurity, unease [which] give way to motion . . . the strong, straight lines of the drawing create an image that is at once dizzyingly three-

dimensional and emphatically abstract . . . the space throbs with contradictory motion." They go on to say that the gate at the top of the stairs "bars access to the subject announced by Sheeler's title: the artist's studio. Thus the stairway . . . and its barrier . . . becomes a metaphor for Sheeler's diffidence about the creative process."[13]

I agree with Troyen and Hirshler until this point. Sheeler's message was about transition—or, because a gate at the top the stairs blocks passage, arrested transition—through symmetrical, linear space and time. *Stairway to the Studio* is monochromatic; the only color in it is the color of the earth, the color he habitually chose for transitions.

*Stairway to the Studio* recalls directly Morton Schamberg's photograph of Sheeler titled *Charles Sheeler* (1913–18). It bears mentioning that in 1987, at the time of their publication of *Charles Sheeler: Paintings and Drawings*, Stebbins and Keyes gave

this picture to Sheeler, not to Schamberg, who may have pushed the shutter, but in my view, Sheeler composed it.

We see him at the end of a short hall, before a closed door positioning himself as if trapped in this tight environment, first by the constricted space above, below, and to the right and left of him, and then by the closed door before which, as if barred, he stands, arms akimbo. But he is not trapped; he has on his face a studied look of contentment mixed with cautious optimism.

The space he occupies is (again) reminiscent of the six sides of a cube that proscribe every form in this world, and the spirit of it that resides at its center. Sheeler is standing at a watershed moment, and the message in this photograph, as in *Stairway to the Studio*, is of transition, of standing at a threshold separating one phase in linear time from the one following; but because he strikes a self-confident pose, the effect is not of anxiety about a lost past, but of optimism for the future.

I would assign to the photograph not 1913, when it was inconceivable, but 1918, the year of Schamberg's death and the year before Sheeler reached the end of his formative years, a year before he had "bailed out" of his academic training, and ventured into *spacetime*.*

1 https://www.nature.com/scitable/forums/genetics-generation/america-s-hidden-history-the-eugenics- movement-123919444

2 Cited in Fillen-Yeh, *op. cit.*, 55.

3 Fillen-Yeh, *op. cit.*, 19.

4 Ibid., 24.

5 Ibid., 22; Jean Metzinger, "Cubisme et Tradition," cited in *Paris Journal*, August 16, 1922.

6 Ibid., 24.

7 Fillen-Yeh, *op. cit.*, 154.

8 Ibid., 154.

9 Troyen and Hirshler, *op. cit.*, 104.

10 http://www.metmuseum.org/art/collection/search/486014

11 Guy Murchie, *Music of the Spheres* (New York: Dover, 1961), 593.

12 For a fuller description of the significance of the number seven, see http://www.betemunah.org/seven.html

13 Ibid., 102.

* If my analysis of Sheeler's work obtains, in general, and if it can be extended, in particular, to *Charles Sheeler,* which Stebbins et al. date 1913 to 1918, then this photograph could not have been taken prior to 1916.

*Conversation—Sky and Earth*, 1940. Oil on canvas, 27$^{15}$/$_{16}$ × 22$^{15}$/$_{16}$ in. (Amon Carter Museum of American Art, Fort Worth, Texas, 2009.7)

*This day and age we're living in*
*gives cause for apprehension:*
*with speed and new invention*
*and things like fourth dimension.*

*Yet we get a trifle weary*
*with Mr. Einstein's theory.*
*So we must get down to earth at times*
*relax—relieve the tension.*

*And no matter what the progress*
*or what may yet be proved,*
*the simple facts of life are such*
*they cannot be removed.*

*You must remember this:*
*a kiss is just a kiss, a sigh is just a sigh;*
*the fundamental things apply—*
*as time goes by.*

—"As Time Goes By," 1931; music and lyrics by Herman Hupfeld

Havelock Ellis (1859–1939), in his important, autobiographical work titled *My Life*, deployed the metaphor of the river as sexual power, and the dam as a futile attempt to hold back an inexorable force. Sheeler's use of the dam, in *Conversation–Sky and Earth* (1940) evokes this same, strangely disquieting power.

The ancients knew that ecstatic spiritual experiences—dimensions beyond everyday human reality—were as accessible through sex as through meditation or shamanic practices. In "The Dynamo and the Virgin," Henry Adams (1838–1918) also relates mechanical force with spiritual and sexual power. Adams, when confronted by the force of industrial power, felt as Sheeler must have when he painted constructs like fireplaces and boiler rooms: the dynamo was but "an ingenious channel for conveying somewhere the heat latent in a few tons of poor coal, hidden in a dirty engine-house, carefully kept out of sight." Both men must have felt machinery to be symbolic of a moral force, much as the early Christians felt about the Cross. But "no more relation could he discover between the steam and the electric current than between the Cross and the cathedral."*

* Henry Adams, *The Education of Henry Adams: The Dynamo and the Virgin* (Boston: Houghton Mifflin, 1918) pp. 381–383. When Adams wrote in the third person of his travels, they always became journeys in time as much as in space. "My idea of paradise is a perfect automobile going thirty miles an hour on a smooth road to a 12th-century cathedral."

Furthermore, says Adams: "The force of the Virgin implies faith, and faith, since it contains no sequence, implies the deity." The force, which in the twelfth century built the cathedrals, seemed, to Adams, to be as strong as X-rays in the twentieth, but in America, neither Venus nor Virgin ever had value as force. "St. Gaudens at Amiens and Matthew Arnold at the Grande Chartreuse felt the force of female energy, but neither of them felt goddesses as power." They felt a railway train as power; yet they complained "the power embodied in a railway train could never be embodied in art. Venus and the Virgin divided two kingdoms of force, which had nothing in common but attraction. *All the steam in the world could not, as did the Virgin, build Chartres.*"[1] [Emphasis added]

"Satisfied that the sequence of men led to nothing, and that the sequence of their society could lead no further, while the mere sequence of time was artificial, and the sequence of thought was chaos, [Adams] turned at last to the sequence of force; and thus it happened that, after ten years' pursuit, he found himself lying in the Gallery of Machines at the Great Exposition of 1900, his historical neck broken by the sudden eruption of forces totally new."[2]

So we see: the *Power* pictures are not, as conventionally thought, about *industrial* power. In the *Power* pictures Sheeler succeeds in equating the sequential power of the machine with the

power of Venus, which he actualizes through his customary device: time's arrow and time's cycle.

In *Primitive Power*, the water wheel is cyclical and the water flowing over it is linear; in *Rolling Power*, the wheels of the engine and the steam piston are reciprocating, while the track, on which the engine runs, is serial. In *Conversation—Sky and Earth*, the river, which is time flowing, is held by a dam, a metaphor for time's periodic check. *Suspended Power* depicts an engine that, through rotation, converts waterpower to electricity, which will run on linear lines. To the *Fortune* magazine people, the generator would produce power for decades, with few stops, no fuel, and very little supervision. But Sheeler's interpretation was "of driving, domineering sexuality."[3]

Driving, domineering sexuality notwithstanding, there is, in each of the *Power* pictures, an eerie silence, an arrested potency, as before a storm. The puff of steam in *Rolling Power* accompanies an engine that is unmistakably not rolling. The train sits sheathed, rather than in motion, upon tracks that presumably could, or did, take it through time as measured, in sleepers.

Sheeler's subject in the *Power* series takes its cue directly from Adams, who asked himself whether he knew any American artist who had ever insisted on the power of sex: Adams could only think of Whitman. All the rest of them, he said, had used woman as sentiment, never as force. American art, like the American language, seemed as far as possible, to be sexless.[4]

Likewise, when Sheeler accepted the *Fortune* commission and composed the *Power* pictures, he had not industry on his mind but love—and sex. Here is my evidence.

In *Rolling Power* Sheeler extended the painted engine from its photographic antecedent, in which it sat upon eight ties—a measure of eight units of sequential time—so that it now sat, in his painting, portentously upon twelve, twelve units of

sequential time. The transition from photograph to painting is, thus, both a shift in reference from eight to twelve, and a transition from two dimensions into three. But the two pictures, like other Sheeler photograph-to-painting transitions, must be read as distinct texts.

Here is the underlying message in *Rolling Power*:

Sheeler had been married to Katharine for twelve years when she died in 1933. After six years as a widower, 1939 was the year in which he composed the *Power* series, and, not coincidentally, the year of his impending marriage to Musya Sokolova. *Rolling Power*, a singularly recondite theme, is, like *Silo* with its deceptively engaging candor, a painting about potentiality. It symbolizes the passage of twelve years with Sheeler's first wife, and it covertly, but quite powerfully, adumbrates marrying his second. In 1939 Sheeler felt his sexual power to be (presumably) arrested in anticipation of his marriage to Musya, whom he had known for eight years. Adams: "In any previous age, sex was strength. Neither art nor beauty was needed. Every one, even among Puritans, knew that neither Diana of the Ephesians nor any of the Oriental Goddesses was worshipped for her beauty. She was Goddess because of her force; she was the animated dynamo; she was reproduction—the greatest and most mysterious of all energies; all she needed was to be fecund."[5]

In the *Power* series Sheeler does not, as is so often said, present a picture of American industry. He presents the power of arrested sexual energy, especially as he is himself confronted by the power of Venus or of the Virgin. "Symbol or energy, the Virgin had acted as the greatest force the Western world ever felt and had drawn man's activities more strongly than any other power, natural or supernatural, had ever done."[6]

Recall now that following his trip to Detroit, in 1927, where, in his third most important essay in time and space he documented the creative process that is American industry, Sheeler produced at Chartres another, important essay into spacetime.

The Cathedral at Chartres, as were all the early Christian churches, built on the site that preceded the present building, is devoted to the Virgin Mary, the instrument of the Incarnation.

A cathedral is really a structure for upholding pictographic windows, which one must view from within. But Sheeler's suite on Chartres leaves out the thing that most believe to be the greatest glory of the Gothic cathedral—its stained glass windows. In fact, Sheeler takes no pictures at all from inside the cathedral. Also missing are any views of the cathedral's North or South Porches, its Gothic sculptures, and the Royal Portal, the all-important, celebrated architectural features of the building. It is also remarkable that, in *Chartres–St Piat Chapel* (1929), Sheeler gives more prominence than he does to Gothic architecture a fence, a flight of stairs and, at the center of the composition, a place where we usually find important subject matter, a workman's ladder, leaning inconspicuously against the wall, which are all conduits to time transition or a barrier to it.

To Sheeler, the Ford plant at the River Rouge and the Cathedral of Chartres were not about "the harmonic design and the dynamic rhythms in both buttresses and conveyors."[7] He did perhaps celebrate, at each, the "sense of communal purpose that built the cathedral and the sense of teamwork that drove the Rouge,"[8] but I vigorously dispute that Sheeler found some connection between the iconographies and proportions of the exterior form *River Rouge* and the exterior form *Chartres*.

I said earlier that we would explore the meaning of the cardinal number 8 to Sheeler and we have yet to fully answer the question of why he felt it imperative to go to France to photograph the Cathedral at Chartres.

The number eight was the medieval numerological symbol for the Virgin Mary, whose birthday is said to have been September 8, a number, as we have seen, that represents entities outside the limits of the tangible world. For Sheeler, both Ford and Chartres were empty boxes in which he could find workable space, and into which he could develop subject. Ford and Chartres both represented power, to be sure, and the power at both was expressed "in spiritual metaphors and with religious zeal."[9] Yet Charles Sheeler does

not relate the Cathedral at Chartres to the American factory. The American factory—specifically the factory that was the Ford Motor Company—derives its purpose from the notion of a linear, sequential manufacturing sequence where each step is preceded by a step necessary to the initiation of the one following. Henry Adams says of sequence:

> Satisfied that the sequence of men led to nothing and that the sequence of their society could lead no further, while the mere sequence of time was artificial, and the sequence of thought was chaos, [Adams] turned at last to the sequence of force.

Sheeler was intrigued by Ford's boast that the Rouge plant created cars completely from scratch: ore from Ford's mines went in at one end, and cars, bearing his name, came out at the other.[10] Ford was thus the epitome of earthly, sequential process.

Chartres was also a place where men celebrated the creative process, but this creative process was starkly different. Adams: "God produces beings, but not like the factory, according to the succession of time. Creation is more lofty than generation—it derives from nothing at all."[11]

Sheeler was famously diffident about the meaning of his art, but Adams provides us with an explanation of Sheeler's purpose in photographing Chartres:

> Of all the elaborate symbolism that has been suggested for the Gothic cathedral . . . faith alone supports it. The improbability of it lurks in every stone. The peril of the heavy tower, of the restless vault, of the vagrant buttress, the uncertainty of its logic, the inequalities of the syllogism, the irregularities of the mental mirror—all these haunting nightmares of the Church are expressed as strongly by the Gothic cathedral as though . . . its aspiration [were] flung up to the sky. The pathos of its self-distrust and anguish of doubt is its last secret.[12]

Sheeler's Chartres suite is about a force unlike any other on earth, one without sequence: it is the force that built the cathedral, and the force that holds it up. This is the message Sheeler went to Chartres, in 1929, to propound, this and nothing more.

Adams, writing just three years after the publication of Einstein's *General Theory of Relativity* and ten years before Sheeler visited Chartres, perfectly describes the relationship between Sheeler's realistic representation of object boxes, be they train engines, barns, torsos, or cathedrals, and his subject, the workable, empty spaces that they surround. Adams was not a member of the Avant-Garde, and yet, by substituting the word *art* for the word *education* the following statement might serve as a manifesto for any member of that group:

> The object of study has been the garment, not the figure . . . a manikin on which education is to be draped in order to show the fit or misfit of the clothes. The young man, the subject of education, is a certain form of energy; the object to be gained is force. The manikin, therefore, has the same value as any other geometric figure of three or more dimensions, which is used for the study of relation. For that purpose, it cannot be spared; it is only the measure of motion, of proportion, of human condition; it must have the air of reality; it must be taken for real; must be treated as though it had life. Once [these are] acquired, the manikin may be thrown away.

Charles Sheeler presents his art, as would all conventional painters, in the language of three-dimensional form, which is but a manikin on which he drapes his message: spacetime, energy, and force. He knew his art must have the structure of reality; it must be taken for real. But once the painting is finished and the message delivered, the manikins, on which he draped his object forms—houses, factories, cathedrals, nudes—may all be thrown away.

1 Ibid., 388.

2 Ibid., 389.

3 Troyen and Hirshler, *op. cit.*, 170.

4 Adams, *op. cit.*, 385.

5 Ibid., 388.

6 Ibid., 389.

7 Troyen & Hirshler *op. cit.*, 126.

8 Ibid., 126.

9 Ibid., 17.

10 Ibid., 17.

11 Ibid., 673.

12 Henry Adams, *op. cit.*, 695.

13 Ibid., preface to the 1918 edition, p. x., Trachtenberg, Alan, ed., *Classic Essays on Photography* (New Haven, CT: Leete's Island Books, 1980), 130.

*Ore into Iron*, 1953. Oil on canvas, 24⅛ × 18⅛ in. (Museum of Fine Arts, Boston, Lane Collection, 1990.381)

# CHAPTER THREE

# Sheeler Alters His View for the Post-War Period

*"The past is never dead. It's not even past."*

—William Faulkner, *Requiem for a Nun*, 1951

To review, Sheeler's mature, artistic vocabulary, painstakingly deciphered in this paper, developed slowly after 1919, and only after a few false starts in the idioms of Cezanne, of the Cubists, and of the Blaue Reiter. Proponents of these movements concerned themselves with the incorporation, through arrested movement, of the elusive fourth dimension, but they perceived the new dimension as a spatial element, not one of time. Americans were unreceptive to the language of the Cubists, and ultimately their solution proved unsustainable; for these, and other reasons, Sheeler departed from the dynamic-movement-in-space approach, making dynamic-movement-in-time his focus instead.

Even before the advent of World War II and the powerful bomb that leveled Hiroshima, as popular awareness of modern physics grew, Sheeler became convinced that neither space *nor* time, taken as separate solutions to the fourth dimension, would yield satisfying results. He realized that specific events in time are nowhere particularized by location, and he could not, therefore, present them in spacetime as if they were. The two dimensions seemed to have no separate identities: they needed to be folded in together, as a compound to express meaning. But attempting to augment a two-dimensional picture by the addition of one more dimension that comprised two immiscible properties doubled upon each other, would require him to adopt a

new dialect, one that, in the twilight of his life, he might possibly never fully apprehend.

Partly because his disposition took him away from abstraction, and partly because he was an American, in 1919 Sheeler determined that his vehicle to the representation of spacetime would be realism, requiring that he invent, as he went along, a syntax uniquely his own. In essence, however, Sheeler continued, after the cataclysm of the war, to explore whether, in a new idiom, he could yet resolve the old problem: how best in two-dimensional paintings and photographs to depict energy and time. It is difficult to say if he succeeded or failed in this attempt; just as in contemporaneous serial, atonal music, the new language of both experienced at once is unfathomable.

Anyone who takes even a causal look at Sheeler's work after 1941 will see that he had taken a new tack. By 1941, Sheeler knew, in the gathering mood for war, that we live our lives in a relatively limited environment of low velocities. To any human being, the speed of sound seemed extremely fast,* and the speed of light simply incomprehensible. He knew that to expand understanding through art, beyond the limitations of this environment, it would be necessary to drastically rearrange conventional, conceptual constructs of space and time.

---

\* The first flight at faster than the speed of sound did not occur until October 14, 1947. The aircraft was the Bell X-1 and the pilot was Captain Charles Yeager.

THE
ABSOLUTE
INTERVAL
SPACETIME

VARIABLE
SPACE →

VARIABLE
TIME

VIEW OF
MUCH SPACE
LITTLE TIME →

SPACE

TIME

VIEW OF
MUCH TIME
LITTLE SPACE

Schematic drawing of the spacetime interval, cited in Guy Murchie, *Music of the Spheres: The Material Universe, From Atom to Quasar, Simply Explained.* (New York: Dover Publications, Inc., 1961) vol. ii, *The Microcosm: Matter, Atoms, Waves, Radiation Relativity,* p. 547. Used and redrawn for clarity with permission.

Movie audiences today are comfortable with the paradox that an event, in linear time, can occur both now and then again later, from the comedy *Groundhog Day*, in which a reporter on assignment to Punxsutawney finds himself reliving February 2 over and over again. The application of the postulation in "real life" would be untenable; but a movie affords Bill Murray the unreal opportunity to learn from his previous day's experience, and then to alter his behavior the following day, when he will again participate in the same events. Still, because there is no overarching sequence, he cannot alter the script sufficiently to affect his escape.

That the spacetime interval between two events is really an absolute is the platform upon which the film *Groundhog Day* was constructed. But while the spacetime interval appears the same to all those (besides Bill Murray) trapped in Punxsutawney, relativity demonstrates how observers in different frames of reference can observe the same two events and calculate the spacetime interval between them but get different results.

To say that the fourth dimension comprises both time and space requires us to express the relationship between time and space mathematically; we cannot envision it any other way. Mathemat-

ically, the relationship between time and space is defined as the relationship between the sides of a right triangle, where the sum of the squares of the two shorter sides equals the square of the longest side.[1] This relationship we recognize as the Pythagorean theorem: $a^2 + b^2 = c^2$.

One of the first references to the fourth dimension as mathematics appeared in De Stijl literature, in 1917, in an article by Theo Van Doesburg. Writing for the movement, which counted Piet Mondrian among its adherents, Van Doesburg posited that man does not possess any point in front of him, beside him, or in back of him, toward which he could identify a "dimension." This sounds rather like relativity, which Einstein had only introduced in 1915. But probably without the slightest familiarity for the antecedent, Van Doesburg went on to say he accepted the fourth dimension as a valid element in modern art, but that "When the new, plastic artists use mathematics, they may be compared to a Renaissance artist using anatomy: no more can we make a Renaissance work of art by a great deal of anatomical knowledge than we can make a modern work of art with a thorough knowledge of mathematics (including the fourth dimension.)"[2]

The leading physicists and mathematicians of Sheeler's era had been saying, since at least 1931, that light came not, as previously thought, in a wave, but in jerks of discreet packets, which Max Planck called "quanta." Light itself is, therefore, discontinuous and atomic. But exactly like a motion picture, which is likewise made up of stills flashed on the screen in sequence one after the other such that we perceive continuity, light's darts or bullets follow upon one another so rapidly that what we see looks again like continuity.[3]

Unbelievably, Sheeler knew, or sensed this; yet he was not, so far as is known, a mathematician.* No mathematician, and yet Sheeler's titles include words (or concepts) such as *periodicity, convergence,*

---

* Einstein, in a league of his own as a physicist, was not, strictly speaking, a mathematician. "Do not worry about your difficulties in mathematics," he once wrote to a junior high school student complaining to him about her math class. "I can assure you, mine are still greater." Hermann Minkowski, a friend who saw early drafts of Einstein's work, famously lamented: "Einstein's presentation of his subtle theory is mathematically cumbersome—I am allowed to say so because he learned his mathematics from me, in Zurich." Cited in David Bodanis, *E=MC2: A Biography of the World's Most Famous Equation* (New York: Berkeley Books, 2000), p. 205.

limit, set, sequence, progression, continuity, and power, all mathematical terms. His use of these terms as titles has never been explored: but if he did have even a layman's understanding of early twentieth-century mathematics, Sheeler might have made a very fine picture of the fourth dimension.

Assuming, for the sake of the argument, that Sheeler did have this understanding, if he were to have substituted space for one of the legs of the right triangle described in the Pythagorean theorem, and time for the other, the hypotenuse would become the absolute spacetime interval. He would then have had a relationship *conceptually* analogous to the relationship between space, time, and spacetime that appears in the Pythagorean theory. Graphically, the relationship would look like the schematic drawing on the preceding page.[4]

Regardless of whether Sheeler consciously made the transition from mathematics to art, or whether without any understanding of modern mathematics he somehow intuited the convergence, the similarity between this diagram and Sheeler's postwar paintings, such as *Counterpoint* (1949) and *Composition Around White* (1959) is at least startling, if not unmistakable.

Murchie:

*"It is hardly possible to explain how a length of space and a length of time can each appear differently to differently moving observers, while their combined spacetime interval remains the same for all, except by pointing out a peculiar mathematical fact: that the interval squared always equals the difference between its space squared and its time squared, a difference that is constant and unaffected by shifting observers' viewpoints or the relative proportions of space and time involved."*[5]

Whether one is willing, or not willing, to see that similarity, the conventional understanding is that Sheeler's double-exposed, overlaid images convey the simultaneity of concurrent events which, in a post-Hiroshima world, take place both now and then. So far, so good. Yet pictures made from such a formulation must draw on an intuitive awareness, if not a deep understanding, of relativity. This awareness allowed Sheeler, the photographer, to constantly alter the proportions of space and time in a continuity

*Counterpoint*, 1949. Conte crayon on paper, 20 × 28 in. (National Gallery of Art, Washington, DC. Gift of Daniel J. Terra in Honor of the Fiftieth Anniversary of the National Gallery of Art, 1991.471)

*Composition Around White*, 1959. Oil on canvas, 30 × 33 in. (Shein Collection, Providence, RI)

*Ballardvale*, 1946. Oil on canvas, 24 × 19 in. (Addison Gallery of American Art, Phillips Academy, Andover, Museum purchase 1947.21.) Photo credit: Addison Gallery of American Art, Phillips Academy, Andover, MA/ Art Resource, NY.

*New England Irrelevancies*, 1953. Oil on canvas, 29 × 23 in. (Museum of Fine Arts, Boston, Lane Collection, 1990.382)

playing upon the same object, be it a barn, an empty mill, or an industrial installation. Call it mathematics or intuition, this solution for visualizing spacetime is at the root of all Sheeler's work from 1942 onward. "It was [Hermann Minkowski's] way of saying that the interval is the sole objective, physical relation between events, the mathematician's fundamental invariant, the prime ingredient of world texture and probably one of the few absolutes left in our fathomless new ocean of relativity."[6]

To put it in plain English, Sheeler and the mathematician would each postulate that one observer of *Composition Around White* is in a state of motion such that for him, there is a time and a distance involved between the two events. Sheeler and the mathematician would also both postulate that there is another observer in a different state of motion and at a remove, whose measuring devices indicate a different distance and a different time between the same events. But seeing both, they must also conclude that the spacetime interval between the two varying accounts is exactly the same.[7]

The absolute dimension, defined in the model as the square of the hypotenuse, does not preclude a state in which there is, on one leg of the triangle, little time and much space or, on the other leg, much time and little space. Therefore, the

infinitely variable ratio between the two states— time and space—would provide for an infinite number of conceptualizations.

In other words, there are infinite combinations of different-sized legs on either side of the right angle that, when squared, all calculate to the square of their hypotenuse. Since Sheeler had realized, in about 1942, that both time and space were necessary and sufficient components of the fourth dimension, adjusting their ratio instead of representing one but not the other would be, for the remainder of his life, an elegantly neat, artistic solution.

1 Gary Zukav. *The Dancing Wu Li Masters* (New York: William Morrow, 1979), 157–180

2 Henderson, *op. cit.*, 314.

3 Waldemar Kaempffert. "How to Explain the Universe? Science in a Quandary", *The New York Times* (January 11, 1931): 120.

4 Guy Murchie, *Music of the Spheres: The Material Universe from Atom to Quasar, Simply Explained* (New York: Dover, 1961), v. ii, p. 547.

5 Ibid., 547.

6 Ibid.

7 Gary Zukav, *The Dancing Wu Li Masters: An Overview of the New Physics* (New York: Bantam), 175.

# Conclusion

In his inchoate 1915 to 1941 attempts to incorporate spacetime into his art, we have seen how Sheeler chose real objects such as buildings, factories, cats, flowers, houses, staircases, trains, cathedrals, and even nudes as boxes that surround what was to the artist workable space. Sheeler appropriated that space to assay the power evident in his wife's nude torso, the Cathedral at Chartres, and the Ford Motor Company, where in each the process of creation was underway. Sheeler used his camera to add the inexorable forward movement of time in space—i.e., sequence—to these three-dimensional subjects, which satisfied his quest to add the fourth dimension to two-dimensional works of art.

In 1941, Sheeler would update this model by choosing as objects the virtually empty boxes that were the now-abandoned manufactories such as we see in *Manchester* (1949), *Ballardvale* (1946), and *New England Irrelevancies* (1953). In these structures, the once mighty, sequential, creative process had literally ceased, leaving only the vacant, architectural boxes that had once housed it. The appearance of these buildings in Sheeler's postwar work, in spite of their unmistakably new contours, would cause art historians to continue to assert that the appearance of factories, in and of themselves, was proof of Sheeler's ongoing interest in line-, angle-, and solid-form-based realism.

But the buildings at Manchester, Ballardvale, and Amoskeag drew Sheeler's attention primarily

*Manchester*, 1949. Oil on canvas, 25 × 20 in. (63.5 × 50.8 cm). (The Baltimore Museum of Art, Edmund Joseph Gallagher III Memorial Collection, BMA 1960.2)

because abandoned factory hulks did not require him, prior to making a picture, to conceptually empty them, as had the forms Katharine, Chartres, and Ford. Here, emptiness was the embodiment of non-process, stasis in time, which ipso facto created nothing. This "happy coincidence" gave rise to apposite titles such as *Counterpoint*, 1949; *Convergence*, 1952 (Private Collection); *Convolutions*, 1952 (Mathew Wolf, New York); and *Continuity*, 1957 (Private Collection). All of these themes inwardly address subjective properties of expanded, four-dimensional spacetime, not, as has always been supposed, outwardly objective properties of Euclidean, three-dimensional forms. As before, his pictures were about internal, sequential process in time, not about exterior form: for example, the title *Ore into Iron*, 1953, speaks clearly and directly of internal *process*, not of external forms.

# Index

# The Case for Reattributing George H. Durrie's "Genre" Paintings to James Goodwyn Clonney

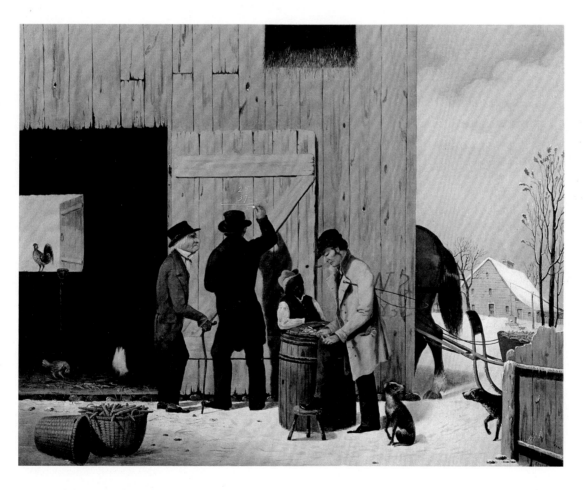

James G. Clonney (English, 1812–1867)(Formerly attributed to George Henry Durrie) Formerly called *Farmyard in Winter*; also once called *Selling Corn*; Lately called *Settling a Bill*. Bearing signature *G H Durrie*. Once bearing date *Aug 1857* ("7" stricken out). Now bearing date *1851*. Oil on canvas, 20 × 25 in. (Private Collection).

*For Bob*

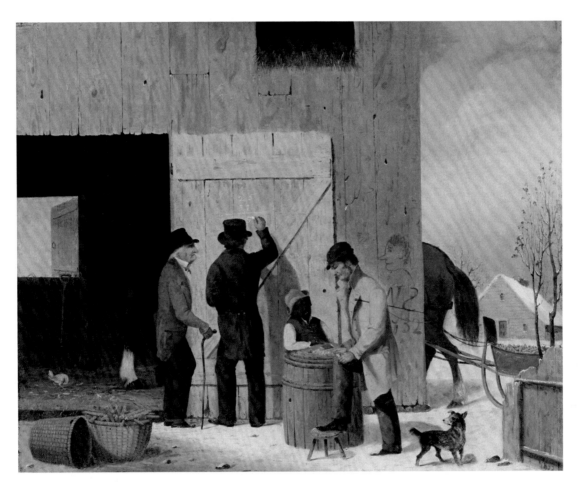

James Goodwyn Clonney (English, 1812–1867), (formerly Attributed to George Henry Durrie), formerly called *Farmyard in Winter*; also once called *Selling Corn*; lately called *Settling a Bill*. Bearing signature *Durrie* and date *185[?]*. Oil on wood, 19 $\frac{1}{2}$ x 23 $\frac{7}{8}$ in. Collection of Shelburne Museum, gift of the children of Mr. and Mrs. P.H.B. Frelinghuysen, in memory of their parents. 1963–197.1. Photography by Bruce Schwarz.

# Introduction

*Farmyard in Winter*, or sometimes *Selling Corn*, but now referred to as *Settling a Bill*, *185_?* and a close variant with the same string of alternate titles,* have long been given to George H. Durrie, (New Haven, 1820–1863), as has another painting called *Holidays in the Country*, *The* [or A] *Cider Party*, as has another called *Sledding*.† But there are notable problems with the choice of subject matter in these four works, with their dates, their execution, their titles, their provenances and, consequently, their attributions.

Hermann Warner Williams, in the 1970s, curator of American Paintings at the Corcoran Gallery in Washington, DC, writes:

> Durrie['s] fame rests on the Currier & Ives lithographs[1] based on the winter landscapes he produced from about 1850 until

his death . . . Almost all of Durrie's somewhat primitive landscapes are enlivened by small figures hauling wood or grain, or engaged in other rural activities, such as making cider or cutting ice, details in what are essentially landscapes . . . The figures in [Durrie's] landscapes lack volume; It is apparent that Durrie was not adept at painting figures, which explains why he did not produce more true genre paintings. Were it not for these [three,] atypical paintings by George Henry Durrie, he would have no place in this survey. Despite this technical weakness, the [three "genre"] paintings stand as good-natured, modest but authentic and personal depictions of American, rural life.*

Martha Young Hutson concurs in Williams' assessment of Durrie's work:

> Durrie was not a genre artist nor was his skill that of a folk painter . . . The *Ithiel Town's Bridge* paintings of 1847 show [Durrie's] lack

---

* Although the American Art Union (AAU) made no prints based upon paintings by George Henry Durrie, the artist notes in his Record Book that the work he called *Settling A Bill* was destined along with other works "for the American Art Union." See Martha Young Hutson, *George Henry Durrie, American Landscapist: Renowned Through Currier and Ives*, (New Haven and Santa Barbara: Santa Barbara Museum and American Art Review Press, 1977) p. 216, no. 73.

† Martha Hutson records that she never personally examined *Sledding*, which has been, over the years, attributed to various artists. See *M. and M. Karolik Collection of American Paintings 1815-1865*, (Cambridge: Museum of Fine Arts, Boston, 1949)

* Hermann Warner Williams, *Mirror to the American Past*, (Greenwich, CT: New York Graphic Society, 1973), p. 96. Williams refers to three genre paintings by Durrie, counting as one *Settling a Bill* (Private Collection), which he illustrates on p. 97 and dates 1857. Notably, Durrie recorded that he made the first version of *Settling A Bill* in 1851 and a copy in 1852.

of skill with a large complex composition . . . Durrie included figures and animals from the beginning, in spite of their poor construction. His naiveté and enthusiasm led him to attempt compositions beyond his ability . . . As early as 1853, the question arises of how important a role genre elements will have in Durrie's landscapes . . . [his] figures are flattened, with stiff outlines. The spontaneity of [William Sidney] Mount's compositions* has become a frozen tableau in Durrie's hands.[2]

Aside from noting that, in the early 1850s, Durrie hadn't the skill or the training to paint genre subjects, Williams, the first authority on American genre paintings, and Hutson, who was to emerge as the expert on Durrie, were both content to give Durrie the four genre paintings under discussion in these passages. But neither scholar seems to have noticed that all four exclude passages or phrases typical of Durrie's work—with the single exception of the flesh-toned, or more often, pale yellow saltbox house at the extreme right of *Settling a Bill*, which appears with frequency in Durrie's work—and all four include passages typical of the work of his contemporary, James Goodwyn Clonney, born in England, 1812, who immigrated to New York City as early as 1834, where in 1867 he died. Williams, who was writing a survey, illustrates several paintings by Clonney, whose known body of work numbers around two dozen.[†] Hutson, who was writing a monograph on Durrie, does not mention Clonney.

James Goodwyn Clonney (English, 1812–1867), *Which Way Shall We Go?* Signed and dated *Clonney 1850*, lower right. Oil on canvas, 17 × 14 in. (Private Collection, Courtesy of Kennedy Galleries, NY)

George Henry Durrie (1820–1863), *Winter Landscape.* Signed lower left, *Durrie*, and dated *1859*. Oil on canvas, 18 × 24 in. (Yale University Art Gallery, New Haven, CT, Mabel Brady Garvan Collection 1932.281)

1 See Hutson, *op. cit.*, p. 216, nos. 75-76

2 Hutson, *op. cit.*, p. 42; p. 56.

* Hutson *op. cit.*, is suggesting that Durrie [although the remark would apply equally to Clonney] had seen either William Sidney Mount's *The Power of Music*, 1847, (Cleveland Museum of Art) or *The Dance of the Haymakers*, 1845 (Long Island Museum of American Art, History and Carriages, Stony Brook, Long Island) or *Dancing on the Barn Floor*, 1831 (Long Island Museum of American Art, History and Carriages, Stony Brook, Long Island) or far less likely *Bargaining for a Horse*, 1835 (The New York Historical Society).

† Clonney, whose life and work is still relatively unknown, was featured at length for the first time in *M. and M. Karolik Collection of American Paintings 1815 to 1865*, (Cambridge: The Museum of Fine Arts, Boston, 1949) p. 166-185.

Following are several observations that give weight to the case for taking these four works away from Durrie and giving them to Clonney. I say "give weight" because while the case to reattribute these four paintings seems to me to be on balance convincing, there are a few unresolved questions that diminish the case for reattribution. And if this essay reads like a compilation of observations, it is because it is a compilation of observations.

\*     \*     \*

As noted earlier, there are two versions of *Settling a Bill*, both given to Durrie since the 1940s, or since they first appeared in the nascent, American art literature.* These two paintings have never been attributed to any other artist.

One of the two variants of *Settling a Bill* is oil on panel (Shelburne Museum), the other, oil on canvas (Private Collection). Both are the same size. *Sledding* is the same size as the version of *Settling a Bill* that is painted on panel, a medium Durrie chose with some frequency but Clonney, on no other known occasion.

The figures in *Settling a Bill* are caricatures of a rustic type, homely and silly, with open, toothy

James G. Clonney (English, 1812–1867). Formerly attributed to George Henry Durrie (1820–18630). Called *Sledding*, bearing signature *G H Durrie* and date *1851*, lower right. Oil on panel, 19.5 × 23.75 in. (Virginia Museum of Fine Arts, Richmond. Paul Mellon Collection)

mouths, broad, flat faces, bulging eyes, and overly large heads—traits Elizabeth Johns calls "pure Yankeeism."* Such goofy characters do not ever appear in Durrie's work, but they are a hallmark of the work of James Clonney. The same rustic figures appear in James Goodwyn Clonney's

* Settling The Bill (Private Collection) made its first appearance in the literature in *George Henry Durrie, 1820-1863, Connecticut Painter of American Life*, Wadsworth Athenaeum 1947, illus., no. 15.

* Elizabeth Johns, *American Genre Painting: the Politics of Everyday Life*, (New Haven: Yale University Press, 1991), p. 24. Johns illustrates the Shelburne variant of *Settling A Bill* and dates it 1851, p. 56.

James Goodwyn Clonney (English, 1812–1867),
*Fishing Party on Long Island Sound off New
Rochelle, 1847*. Oil on canvas 66 × 92.7 cm.
Signed and dated *CLONNEY 1847*, lower left.
(Museo Thyssen-Bornemisza, Madrid, inv. no.
1981.28)

George Henry Durrie (1820–1863), *Ithiel
Town's Bridge Near East Rock, 1847*. Oil on
canvas, 28.5 × 35.5 in. (New Haven Colony
Historical Society, New Haven, CT)

painting called *Sledding*, which is the same size as *Settling a Bill* and also painted on panel.

Hutson and Williams both assert that Durrie was a landscape painter incapable of genre and that even if he had attempted it, 1851–52 was far too early for him to have painted such an ambitious figure group. But why would Durrie have made entries in his record book for a painting, and a copy of that painting, titled *Settling a Bill* when that title would not seem to describe a landscape? And if Durrie did not paint these two pictures, where are the two works he recorded with the title *Settling a Bill*? And if, as I assert, Clonney was the author of the two works now known as *Settling a Bill*, what would he have called them and why would he have painted two versions, when making replicas was "unusual" for him?*

Comparing Durrie's *Ithiel Town's Bridge* of 1847 to James Clonney's *Fishing Party on Long Island Sound off New Rochelle*, also dated 1847, provides strong visual evidence that these two paintings are by two different painters with markedly different skills.

*Scene in a Barn* bears the date 1853. But the two variants of *Settling a Bill*, listed in the artist's record book as having been painted in 1851 and 1852, and Clonney's *Sledding*, dated 1851, are all far superior in execution. *The Sleigh Ride*, 1845, is also very finely painted, very much more finely than *Scene in a Barn*, which would suggest that either the date 1845 assigned to *The Sleigh Ride* is far earlier than the date of its actual execution, or the 1853 date now appearing on *Scene in a Barn* is far later than the picture's actual date of execution. For these reasons, I believe the picture once attributed to George Henry Durrie and referred to as *Holidays in the Country, The Cider Party* is more probably James Goodwyn Clonney's *Scene in a Barn*, 1843, by which title I refer to it in this paper.

Clonney paints his genre subjects in both "portrait" format, i.e., rectangle, long side vertical, and "landscape" format, i.e., rectangle, long side

James Goodwyn Clonney (English, 1812–1867), *Scene in a Barn*, 1843. (Formerly attributed to George Henry Durrie). Formerly called *Holidays in the Country, A* [or *The*] *Cider Party*, bearing signature *G. H. Durrie*, and date *1853*. Also inscribed *G.H. Durrie/New Haven/1853* on the reverse. Oil on canvas, 22 × 28 in. (Montgomery Museum of Fine Arts, Montgomery, AL. Gift of Ida Belle Young Art Acquisition Fund, 2010.15)

James Goodwyn Clonney (English, 1812–1867), *The Sleigh Ride*, 1845. (Not signed or dated.) Oil on canvas, 25 × 34 in. (Museum of Fine Arts, Boston. Gift of Maxim Karolik for the M. and M. Karolik Collection of American Paintings, 1815–1865)

* Lucretia H. Giese. "James Goodwyn Clonney, 1812-1867: American Genre Painter," *American Art Journal*, v.11, no. 4, p. 4. Giese notes that Clonney made a replica of his work called *Mother's Watch*.

Joshua Shaw (English, 1776–1861), *The Pioneers*, ca. 1838. Oil on canvas, 19 × 27 in. (Indianapolis Museum of Art, Indianapolis, IN. James E. Roberts Fund and Emma Harter Sweetser Fund).

Francis Blackwell Mayer (1827–1899), *Leisure and Labor*. Signed and dated lower right: *F. B. Mayer/1858*. Oil on canvas, 15¹/₂ × 22³/₄ in. (National Gallery of Art, Washington DC, Corcoran Collection, Gift of William Wilson Corcoran).

horizontal. Durrie paints his landscape subjects in the "landscape" format, or in the occasional oval, but not a landscape in the "portrait" format (one that was not an actual portrait) could I find anywhere in his oeuvre.

Durrie's winter landscapes almost always have an atmosphere infused with a grayish, golden-brown glow, which is not evident in either variant of *Settling a Bill*, *Sledding*, or *Scene in a Barn*.

Durrie's exfoliated trees are all handled in what we might call the *Craggy Elbow* manner, perhaps learned from another adherent, Joshua Shaw, a compatriot born Bellingborough, England, c. 1776, who immigrated to Philadelphia by 1819, but was frequently in Philadelphia, Baltimore, Boston, and New York until his death in 1860.[1] Such trees, virtually bristling with character over and above what a normal landscape might require of trees, became a signature phrase of Durrie's. Such trees are not evident in either variant of *Settling a Bill* or in any of James Clonney's known works.

The top hats Clonney puts on his men, much in evidence in *Scene in a Barn*, *Militia Training*, *Fishing on Long Island Sound*, and in both variants of *Settling a Bill* have a peculiar shape, rather more short and squat than tall and thin. Clonney also attires his men in down-at-the-heels, spatula-like shoes and patched or ill-fitting clothes, seemingly to dispose of the elegance the wearer of top hats, coats, and shoes wishes these articles to communicate about himself, and replaces them with something decidedly droll. Beyond giving them the appearance of plain folk, Durrie does not humble his men by attiring them in this way.

In what is virtually the only in-depth study of Clonney's work ever undertaken, Lucretia H. Giese astutely observes that Clonney habitually arranged his figures all in a row, parallel to the picture plane, much as the figures are arranged in *Scene in a Barn*, in *Fishing on Long Island Sound*, and in both variants of *Settling a Bill*.[2] There is also a striking similarity between the attitude of the man standing at the extreme left of *Scene in a Barn*, off to one side, observing the action, and the man who stands—or at least was standing until he succumbed to the influence of his cider—in much the same posture and in much the same place in the composition of *Militia Training*. This

man, or a similar figure whose role we might call observer-participant, appears by way of example at the right side of the composition in Francis Blackwell Mayer's *Leisure and Labor*, 1858. I mention this only because the observer-participant makes no appearance in Durrie's oeuvre.

There is no indication in Durrie's record book—or in the entirety of his extant work—that other than these four paintings, he ever ventured into genre, let alone into politically or racially vexed subjects. The inclusion of the black boy and his role in *Settling a Bill* and in *Scene in a Barn* would consequently be remarkable departures for Durrie, and since the inclusion of a black protagonist in a painting of the 1840s or '50s could never be a casual accident, his presence in these two works almost certainly rules out Durrie as their creator.* By 1851, Clonney and Francis Edmonds (1806–1863) had each produced compositions with a slavery subtext and, using the same catalog of other symbols, frequently laid their controversial message between the lines in their pictures.

To wit, the man in the center of *Settling a Bill* (both variants), with his back partly turned, is tallying some numbers on the barn door while the man on his right is counting out "cash on the barrelhead" under the bemused gaze of a young black boy, who not by accident occupies the center of the picture. The inclusion of a black subject, either man or boy, is virtually unobserved in the entirety of Durrie's known oeuvre but is a hallmark of Clonney's work.

Both variants of *Settling a Bill* display the partially obscured date *[1]832* on the barn, which, putting momentarily aside who painted them, were arguably painted in 1851 or 1852. The partially obscured date and the initials *N S* that appear on the side of the barn (the *S* in mirror image, such that the two are, like the dogs in the foreground and the horses in the barn, facing off against each other), are a general reference to the long simmering Donnybrook between the free states of the northern United States and the slave states of the South.

Assuming these works were created in 1852, it is worth noting that American author Harriet Beecher Stowe published *Uncle Tom's Cabin; or, Life Among the Lowly* in 1852, the same year the state of South Carolina declared that the federal government was encroaching upon its rights as a sovereign state and would vote to withdraw from the Union, the execution of which self-proclaimed right it deferred until 1861.

The letters and the date almost certainly refer to Nat Turner's slave revolt of August 1831, which culminated in the Virginia Slavery Debate of 1832 and in the same tempestuous year, the reelection of Andrew Jackson,[3] whose hastily drawn cartoon portrait appears on the side of the barn to the right, but in only one variant of *Settling a Bill* (Shelburne Museum). The two chickens in the barn, one white and one black, are none-too-subtle references to the alignment of northern and southern interests of the Democratic Party in reelecting Jackson, specifically how both factions of the party got—and since 1832 until the early 1850s when the pictures were ostensibly painted, continued to get—what they each wanted: the South, that the federal government would not interfere with slavery, and the North, that the extremely profitable transportation in Yankee ships of cotton from southern ports to European markets would not be interrupted. According to Elizabeth Johns, the open bunghole on the side

* A note in the Clonney files at the Museum of Fine Arts, Boston, for a work entitled *Waking Up* makes reference to a Currier & Ives lithograph called *Holidays in the Country: Troublesome Flies* but the composition differs in all respects from *Scene in a Barn*.

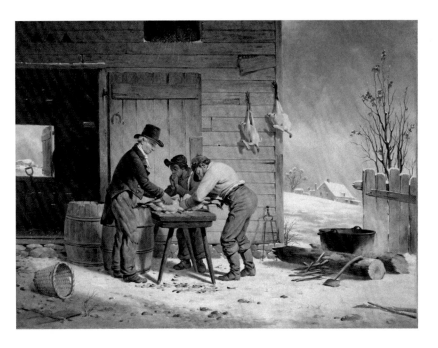

Francis William Edmonds (1806–1863), *Preparing for Christmas*, 1851. Oil on canvas. (Metropolitan Museum of Art, NY. Bequest of Mrs. Screven Lorillard [nee Alice Whitney], from the Collection of Mrs. J. Insley Blair, 2016.797.19)

of the barrel symbolizes "election entertaining," particularly of northern complicity with Henry Clay and the emerging "cider-associated" southern Whigs.[4] The rear ends of the horses, the only part of them we see, might refer to the sobriquet "Jackass Jackson," by which his opponents referred to him during the campaign.

*    *    *

We now divert our attention to a long-lost painting by Francis Edmonds, *Preparing for Christmas*, recently acquired by the Metropolitan Museum. Metropolitan Museum curators date this painting 1851–1852, ostensibly because Edmonds entered it in the American Art Union's disposal auction of December 1852.[5] The picture is well described in the AAU catalog such that there can be no uncertainty about its identification: "Two men in the open air, before a stable, are picking turkeys for the kitchen; a Negro is blowing his hands to keep them warm. The ground is covered with snow."

*Preparing for Christmas* is important to this discussion because it was undeniably composed before the very same barn in almost every detail*

---

* The barn siding in *Preparing for Christmas* is affixed horizontally instead of vertically, as in *Settling a Bill*.

as the one appearing in the two variants of *Settling a Bill*, the first of which its creator is thought to have painted in 1851 and the copy in December 1852. These three paintings all include the back end of a horse standing in the stall; a shovel, or in this case a fork, leaning against the far wall beneath an open window; a barrel, or in this case two; an overturned woven cane basket or, in the other case, two on the ground; a house in the distance to the right beyond a fence in the foreground; a tree not painted in the *Crooked Elbow* manner; chalk tallies on the barn siding; and a black boy at the center, all within a red, white and blue montage, strongly implying a North/South, slave or free state subtext, an occasional but ordinarily subtle feature in Edmonds's work.[6]

Edmonds's title *Preparing for Christmas* makes apparent reference to Andrew Jackson's wife, Rachel, whom Jackson's opponents viciously persecuted and, by extension, her husband. The chalk tallies on the jam of the barn door include the enlarged letter *R*, ostensibly another reference to Rachel, who died on December 22, 1828. In Jackson's view, Rachel had been prescriptively slaughtered and plucked like turkeys before a feast: "May God Almighty forgive her murderers," he swore at her funeral. "I never can." The title *Preparing for Christmas* undoubtedly refers to Rachel's burial, which took place on Christmas Eve.

Jackson, commander of US Army forces in the southwest region, whose "hatchet face" inspired his detractors to call him "Sharp Knife," a reference to the brutality he meted out to Red Stick Creek captives in the War of 1812, owned dozens of slaves, whose toil had made him wealthy and powerful. Admiration among southern slaveholders for his savage tactics against the British in the Battle of New Orleans of 1815 had enshrined him as a nationalist icon, which was undoubtedly the deciding factor for him in the election of November 1828. These same credentials would have made him fodder for the kind of satire on display in these three paintings.

In addition to picking cotton, slave owners obliged their vassals to shuck corn, which task the owners turned into an opportunity, so claimed their masters, for "community building" on Saturday

nights. Slaves from one plantation would "compete" against slaves from another. As incentive to shuck faster, the winning team was promised a jug of whiskey.

Slaves carried corn and their daily harvest of cotton in woven cane baskets, which their overseers would weigh and tally at each day's end. The woven cane basket, the corn, the chalk tally, and the hickory stick appear in both variants of *Settling a Bill*; the woven cane basket, the ax, and a pair of fireplace tongs* appear in Edmonds's variant. The ax, also included in twenty-year-old St. Louis painter Charles Deas's *Walking the Chalk*, 1838, a contemporaneous picture also filled with allusions to slavery, refers to the term *nègres de la hache*, or Slaves of the Ax, i.e., slaves whose weapon in the uprising of 1811 on the east bank or German Coast of the Mississippi was the ax. The woven cane basket also appears in *Sledding*. These items rarely if ever appear—at least not as symbols—in Durrie's work, the sole exception being *Red School House, Winter* (Hutson, fig. 54, p. 58). This picture, which the Metropolitan Museum dates 1858, includes on the side of the sleigh center foreground a chalk tally 5 3—perhaps to be read as 8, ostensibly the picture's date—alongside a signature, *G H Durrie . . .[or NH?]*, presumably original, and a woven cane basket not filled with corn but with cabbages.[7] I have no explanation for the cabbages or for the letters *L W* clearly picked out on two (or possibly three) bags in the sleigh.

Edmonds's work frequently impounds anti-slavery imagery even where he depicts only white subjects, e.g., the woven cane basket in *Sparking*; the woven cane basket, the fireplace tongs, and the chalk tallies on the wall in *Reading the Bible*; the woven cane basket and corn

Charles Deas (1818–1867), *Walking the Chalk*, 1838. Oil on canvas, 17³/₈ × 21³/₈ in. Signed and dated *C. Deas, 1838*, lower right. (The Museum of Fine Arts, Houston. Museum purchase with funds provided by the Agnes Cullen Arnold Endowment Fund)

shucking in *The Epicure* and *The Speculator*; the jug of whiskey in *Dame in the Kitchen*; and the ax in *Facing the Enemy* and *First Aid*.[8]

There is no mention of Edmonds or Durrie in the exiguous Clonney literature, no mention of Clonney or Durrie in the meager Edmonds literature,[9] and no mention of Edmonds or Clonney in the only volume in the Durrie literature. Of the three, only Edmonds rates a mention in Tuckerman.[10] All three exhibited regularly at the National Academy of Design and the Art Union in the 1830s, '40s, and '50s, from which it seems safe to conclude that Durrie, Clonney, and Edmonds knew each other.

We may well wonder whether Edmonds created *Preparing for Christmas* sui generis or whether he worked up his composition having seen one or the other variants of *Settling a Bill*; or, since *Preparing for Christmas* is not dated, whether Clonney and Edmonds worked side by side painting their own variations on Edmonds's theme. All we know for certain is that Edmonds entered his variant in the AAU auction in 1852. Edmonds entered one other painting in the auction titled *What Can a Young Lassie Do wi' an Auld Man?* and James G. Clonney entered two: *Grandfather's Visit* (no. 59), and *Waking Up* (no. 279).

* On January 30, 1798, Roger Griswold, a Federalist US House Representative from Connecticut, attacked Matthew Lyon on the floor of the House of Representatives hitting him with his hickory walking stick. Lyon, a Republican from Vermont, responded by grabbing a pair of fireplace tongs with which he beat Griswold in return. The underlying cause of the conflict was not slavery *per se* but the fireplace tongs became symbolic of the first recorded fight on the floor of the house, and emblematic of the way members of congress then settled their differences. *See* http://connecticuthistory.org/roger-griswold-starts-a-brawl-in-congress-today-in-history/

Elizabeth Johns, who reproduces the Shelburne Museum variant of *Settling a Bill* and dates it 1851, joins Williams and Hutson in accepting the attribution of these paintings to Durrie, none of them noting that this sort of highly charged political subtext, conspicuous to discerning audiences of Clonney's and Durrie's day, has never been observed elsewhere in Durrie's work.

Important for the purposes of this discussion, Durrie's record book lists no work titled *Sledding*, although there are entries for works titled *Sleighing*, *Winter Sports*, and *Youthful Recollections*, any of which might fit the narrative. Importantly, there is also no record that Clonney exhibited a work at the National Academy or the Brooklyn Academy by the title *Sledding*, although in 1845 he did exhibit a work at the National Academy called *The Sleigh Ride*.

*The Sleigh Ride* is both unsigned and undated, occasioning some in years past to doubt its attribution. However, the two preparatory sketches for the work in the collection of Clonney drawings at the National Gallery (Corcoran Collection, Gift of J. William Middendorf II), Washington, DC, should put such doubts to rest.[11]

The girl on the sled in *The Sleigh Ride* is taking a whip from her boyfriend, whose pants are held up by three buttons, two white the other black.* She is ostensibly preparing to use the whip to "coax" the black dog, looking pitifully unconcerned but seated importantly at the cen-

---

* The US Census of 1840, which comprised persons in all states, counted 17 million Caucasian inhabitants and 2.5 million slaves. The three buttons is probably a reference to the ratio of white Americans to slaves in the southern states.

ter of the picture, to pull her sled. The scene takes place at an open bar, a way from which the six rails have been removed, which is to say at the wide open interregnum between two fields. In this way Clonney delicately introduces a racially vexed subtext into an otherwise placid scene.

Durrie's record book, again important for the purposes of this discussion, lists no work called *Holidays in the Country: The Cider Party*.* But it does record a work of *Jan 1852* called *Barn Scene with Fiddler*, which, and because no other work with that title is extant, would appear to be a better "match" with the work's narrative. Hutson, while insisting that Durrie was not really a genre but a landscape painter, does not scruple to ask why Durrie made an entry in his record book for a painting with the title *Barn Scene with Fiddler*, when that title would not seem to describe a landscape.

Clonney exhibited a picture at the National Academy in 1843 called *Scene in a Barn*, which would also fit the narrative of this picture.[12] One explanation might be that *Holidays in the Country: The Cider Party* is Durrie's *Barn Scene with Fiddler*, 1852. But because it is crudely painted, it would have to be an early effort or, more probably, it is Clonney's *Scene in a Barn* of 1843, also early for Clonney but long before Durrie could have attempted it.

Like *Settling a Bill* (Private Collection), *Scene in a Barn* also includes a cartoon portrait of Andrew Jackson, chalk tallies, a woven cane basket (here inverted), a jug of cider or whiskey, and a black man, all symbols of the political struggle between slave and non-slave states being accepted into an expanding Union. Martha Hutson, now Martha Hutson-Saxon observes that the *OK* on the barn door refers to the OK Club, which was formed in 1840, when incumbent president Martin Van Buren was seeking reelection. The abbreviation referred both to Van Buren's nickname "Old Kinderhook" — based on his hometown of Kinderhook, New York — and to the new colloquial term

"OK" that was coined in 1839 and coming into wide use.*

The appearance and similar purpose of these symbols in both *Settling a Bill* and *Scene in a Barn* makes it highly probable that they are by the same hand, and while that hand could be George H. Durrie's, it is far more likely for reasons described in this paper, to be James G. Clonney's.

Johns and Williams both note Durrie's probable debt to William Sidney Mount (1807–1868). These writers, after introducing Durrie, both name James G. Clonney in the very next paragraph without acknowledging that racially charged content is nowhere else observed in the work of George H. Durrie.†

Detail: *Red Schoolhouse, Country Scene, 1858.*

---

* Hutson, *op. cit.*, p. 216, records that she never personally examined *Sledding*.

* See Martha Hutson-Saxon, Sotheby's Sale, American Paintings, Drawings and Sculpture, December 2, 2010, Lot 15, Catalogue Note, http://www.sothebys.com/en/auctions/ecatalogue/lot.15.html/2010/american-paintings-drawings-sculpture-no8684. Hutson-Saxon also speculates that the cartoon portrait is of Martin Van Buren and that the initials S.B. on the barn door might be a reference to the Free Soilers and the Barnburners. But since these parties were not formed until 1848, I must reject this idea, as it would be inconsistent with my supposition that this picture is not by Durrie and not painted in 1853 but is in fact James Clonney's *Scene in a Barn*, 1843.

† A critic writing for *The Knickerbocker* observed "Mr. Clonney is treading in the footsteps of William Sidney Mount." *The Knickerbocker*, June 1847, v. xxix, no. 6, p. 572

1 George C. Groce and David H. Wallace, *The New York Historical Society's Dictionary of Artists in America, 1564–1860,* (New Haven and London: Yale University Press, 1957), 132.

2 Giese, *op. cit.,* 4.

3 http://personal.tcu.edu/swoodworth/GoodyearFreehling.htm

4 Johns, *op. cit.,* 56–57, 109.

5 "Catalogue of Pictures and Other Works of Art, the Property of the American Art Union. To be Sold at Auction by David Austen, Jr., at the Gallery, 497 Broadway, on Wednesday, the 15th, Thursday 16th and Friday 17th December 1852," 5, no. 216, in *Bulletin of the American Art Union, no. 10, Supplementary Bulletin* (Dec. 1, 1852).

6 Edward Baptist, *The Half Has Never Been Told: Slavery and the Making of American Capitalism* (New York: Basic Books, 2014), 158–161.

7 Ibid., 55–68.

8 See Maybelle Mann, *Francis William Edmonds* (Richmond, VA: W. M. Brown & Son, for the International Exhibitions Foundation, 1975), for illustrations of these works.

9 Mann, *op. cit.*

10 Henry T. Tuckerman, *Book of the Artists: American Artist Life* (first published in 1867), (New York: James F. Carr, 1967), 411–414.

11 "American drawings watercolors pastels and collages in the collection of the Corcoran Gallery of Art," 1983. #201 *Recto*: "Black Man Dancing". *Verso*: "Girl on a Sled" (Study for *The Sleigh Ride*). And #203 *Recto*: "Stile with Rock Wall" and *Verso*: "Tree" (both studies for *The Sleigh Ride*).

12 Bartlett Cowdrey, ed., *National Academy of Design Exhibition Record, 1826–1860* (New York: J. J. Little & Ives Company, for The New York Historical Society, 1943), 83.

# Conclusion

Jules Prown advised his students (his sentiments, my words) that if they were looking for answers in the literature but spinning their wheels, they should quit the library and go back and look again at the painting. Using this wisdom as my guide, I have relied almost entirely upon observable phenomena to make the case for assigning these four paintings to Clonney. But there are a few questions it would be nice to be able to answer:

In 1851, Durrie made an entry in his record book for a painting to which he gave the title *Settling a Bill*; in 1852, he records that he, or perhaps his brother John, made a copy of this painting. The narrative in the two genre paintings under discussion would appear to comport with the title *Settling a Bill*; however we cannot be certain that these two paintings are the works to which Durrie gave this title.

Either by the same, unscrupulous person at the same time, or by different, unscrupulous persons at different times, the two variants of *Settling a Bill* were "matched" with works in Durrie's autograph record book, first as *Farmyard in Winter* then as *Selling Corn* and finally as *Settling a Bill*.

The dates now appearing on the two variants of *Settling a Bill* are both illegible and/or they have been reworked.*

*Settling A Bill* (Private Collection) was acquired by a private collector in 1974 from Hirschl & Adler Galleries, an historically reliable

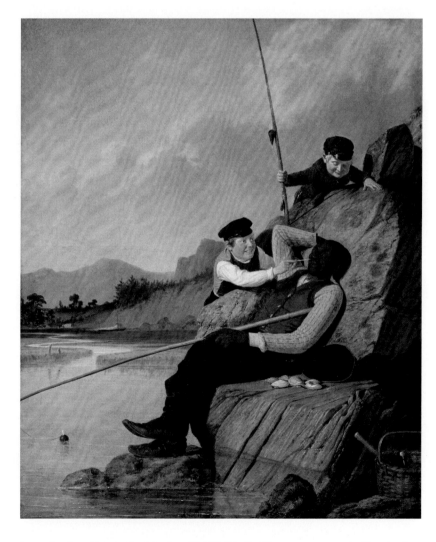

James Goodwyn Clonney (English, 1812–1867), *Waking Up*. Oil on canvas, 27 × 22 in. Signed and dated *Clonney 1851*. (Museum of Fine Arts, Boston, MA)

source, but as George H. Durrie's *Farmyard in Winter* or *Selling Corn*.†

James Clonney was a skilled draftsman and he made preparatory sketches for many, but not all, of his finished paintings (Museum of Fine Arts, Boston, and National Gallery of Art [Corcoran Collection, Gift of J. William Middendorf II] have several pages from his sketchbooks). There are extant preparatory drawings for Clonney's *The Sleigh Ride* (National Gallery, Corcoran Collection, Washington, DC) but none for *Settling a Bill*, *Sledding*, or *Scene in a Barn*.

Victor D. Spark (1898–1991), a New York art dealer in the 1940s to 1970s, is perhaps the only real link between Durrie and Clonney. Mr. and Mrs. P. H. B. Frelinghuysen, Manchester, Vermont, bought both *Settling a Bill* (Shelburne Museum) and *Sledding* from Spark both as Durries. The Frelinghuysens also bought James G. Clonney's *The Sleigh Ride* from Spark. Maxim Karolik also bought his Clonneys, *In the Woodshed*, *In the Cornfield*, and *The Sleigh Ride* from Spark. (Karolik bought his Clonney, *Waking Up*, from Spark's long-time partner, James Graham & Sons.) I do not suggest that Spark reworked signatures and dates to appeal to his customers' tastes but only that the practice was not unheard of in his time.

These speculations could mean any, or all, of the following: (1) Most, if not all, of the objections to changing the attribution of the four genre paintings from Durrie to Clonney are for Durrie scholars to overcome; (2) none are dispositive proof against an attribution of the four to Clonney; (3) Durrie's record book is not infallible; (4) the titles by which these four genre pictures are known today are generic, providing unscrupulous punters, in years gone by, the opportunity to "match" their narratives to titles found in Durrie's record book;* or (5) these four paintings are not by Durrie.

---

* Clonney's painting now called *In the Woodshed* (Karolik Collection, Museum of Fine Arts, Boston) once bore the forged signature of Winslow Homer and subsequently that of J. G. Chapman, with the date painted out. The third digit of the date of 1835 on *Black Boy Asleep*, is illegible, as are the dates on *Settling a Bill*, leading one to suspect that unscrupulous punters have manipulated signatures and dates on other of Clonney's works. See *M. and M. Karolik Collection of American Paintings 1815 to 1865* (Cambridge: Museum of Fine Arts, Boston, 1949), 166–185.

† *Settling a Bill* (Private Collection) was included in Hirschl & Adler's "Forty Masterworks of American Art" (October 28–November 14, 1970) as *Farmyard in Winter* or *Selling Corn*, p. 32, #19. It was subsequently included with the same titles in "Faces and Places: Changing Images of 19th Century America" (December 5, 1972–January 6, 1973), #23.

* The *National Academy of Design Exhibition Record 1826–1860* lists several of Durrie paintings all with generic, easily adoptable titles, for example: *Winter in the Country* (1857); *The Farmer's Home—Winter* (1858); and *Farmyard in Winter* (1860), any of which unscrupulous players might have assigned to paintings not by Durrie, and to which they then affixed "Durrie" signatures and plausible dates.

# Index

Gala Books, Ltd
Leicester, VT
galabooks@comcast.net

Fresh Perspectives on Grant Wood, Charles Sheeler, and George H. Durrie

ISBN 978-0-578-56218-6

Book design by Kyle Kabel

Printed and bound by Bookmobile in Minneapolis, MN